David Bailey's book of photography

How to take better pictures
David Bailey's book of photography

Photographs by David Bailey
Text by George Hughes

J. M. Dent & Sons Ltd
London Melbourne

First published 1981
Paperback edition first published 1985
Photographs © David Bailey 1981
Text © George Hughes 1981
Diagrams © J. M. Dent & Sons Ltd 1981

Photoset in 10 key Diatronic News Gothic by
Inline Graphics Services, London
Printed and bound in Great Britain by
Balding and Mansell Ltd, Wisbech, for
J. M. Dent & Sons Ltd
Aldine House, Welbeck Street, London W1M 8LX
Design by Mark Foster

British Library Cataloguing in Publication Data

Bailey, David
 David Bailey's book of photography.
 1. Photography
 1.Title II. Hughes, George
 770'.28 TR146

ISBN 0-460-02420-5

Contents

Acknowledgments

The authors and publisher would like to thank the following magazines: Italian Vogue, British Vogue, French Vogue, American Vogue, Ritz, The Observer.

They would also like to thank the following persons:
Martin Harrison, Daniel Donovan, Sara Lane, Alexandre Imai and Cezar de Paulo.

Colour photographs

Introduction

We would like you to think of what is in these pages as not so much a book but more as a conversation – a three-way conversation between yourself and us. The two of us share the view that photographic books are mostly more likely to give you mental indigestion than an honest appreciation of what photography is and how it works. We have therefore attempted to move away from anything which might be thought standard in format.

The idea of producing this record of our thoughts on the medium which has been so benevolent to both of us was born one night in Bailey's studio. The conversation was about the complex and confusing manner in which photography is so often 'taught', and we were looking for a way to sum up our feelings. In the distance, one of Bailey's fifty or so parrots gave out a great squawk, and that provided the perfect simile. 'Look', Bailey said, 'I can start to tell you all about the life style of the Moluccan lorikeet, and you'd accept every word I say because you don't know any better. But if an ornithologist walked in here the chances are he'd insist half of what I told you was a load of bull'.

We both believe that at least half of what is transmitted to people unaware of the more subtle points of photography but desperate to learn is, if not a load of bull, at the very best confusing – and consequently useless.

And so we set out on these pages. We were determined to create not a series of esoteric chapters proving how complicated photography is and how clever photographers are, but an atmosphere in which any moderately enthusiastic person could not help but understand what the art or craft of the camera is all about. We wanted to be sure that at the end of it all you would certainly know all about the life style of the Moluccan lorikeet, as it were!

You will find we go on a good deal about light. That is because understanding the nature of light is far more important than understanding the inner workings of a camera. You must feel light, as well as be able to assess its strength – it is, after all, your palette, to draw a comparison from the world of painters to which we frequently refer in these pages. But we have, of course, covered the mechanics and the machinery too, and the techniques involved in making the camera do what you want it to do. Great photographs do not just happen: they are made,

and the more you can interpret light and control your camera, the more you will be able to make them.

We have abandoned conventional, sectionalized teaching of photography. We are sure that most people who read these pages will want to enjoy looking at pictures as much as taking them. So we have spent quite large amounts of time on the really important areas of atmosphere and mood and design. But not all in one indigestible lump; no subject is treated that way. You will come across the same subject treated slightly differently in several chapters: the particular treatment will relate that subject to all the other controls and influences and mechanics in which it plays a part. That way, we feel that each chapter is as much an independent conversation as it is part of an unfolding awareness of photography. By all means read straight through the pages from start to finish, but be ready to skip back now and again, to browse a bit longer on one section than on another: photography is rather like a jigsaw puzzle (it is, after all, the most technological communications medium we have, while also being the biggest creative hobby interest) and that last piece is a great delight to fit in. We think that last piece should consist of your saying, 'Now I understand' – and we hope you will find it here.

London, David Bailey
May 1981 George Hughes

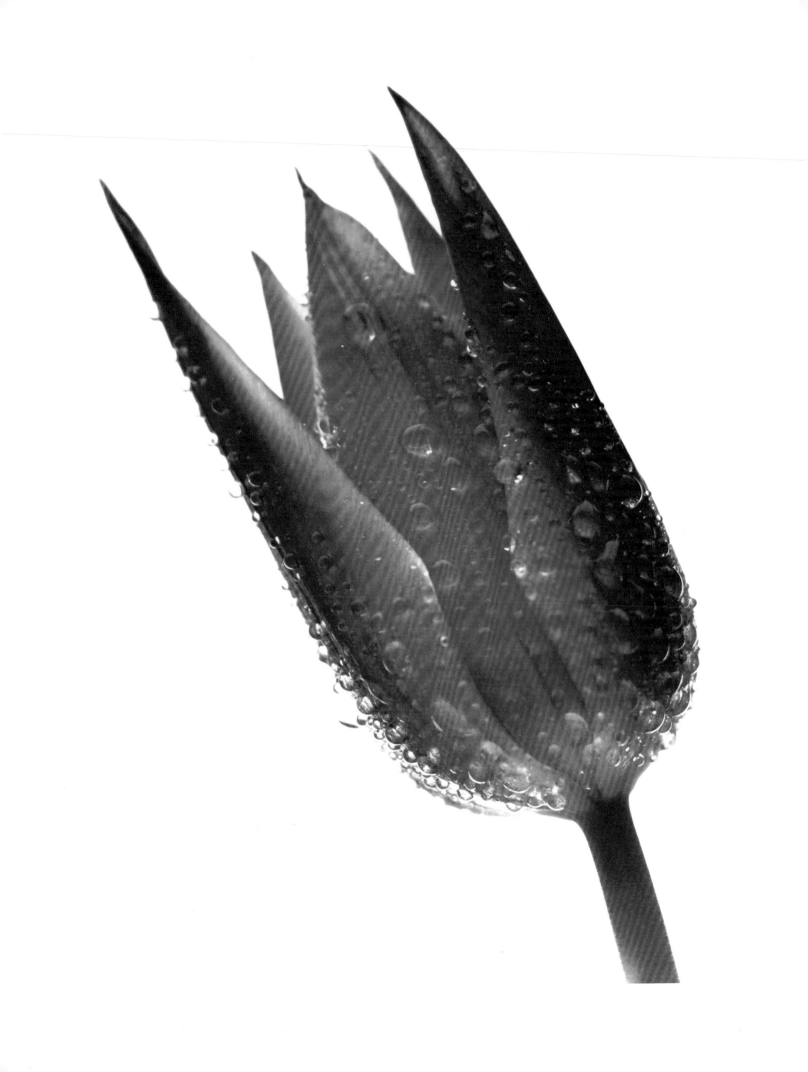

To Cezar

1

The camera

Photography, like radio or television, is nothing more than a system of converting energy particles, or waves, into something the bodily senses can experience. Light is visible, and photography makes it leave a permanently visible trace – a photograph. Rain, of course, leaves traces too – it soaks the earth – but rainwater soon evaporates and the pavements are once again dry. Light's effects last longer: fruit ripens, leaves go brown and drop, the body tans.

Though other light sources – house bulbs, candles, street lamps – radiate light so much less powerful than the sun's, their light is capable of permanently affecting things too: they, like sunlight, can change for all time the chemicals used in photography.

The camera itself began life as nothing more than a light-proof container for the material on which the image was to be captured. Right from the beginning that material has been sensitive to light, and any box – a shoe box, a tea-caddy, a match box even — could be used to take a picture if you put a lens on the front.

Even today, very simple cameras, especially the little pocket models using 110 film, are hardly more than that, for the core of photography has changed very little, though some of the machinery we use to make our modern pictures has changed, and greatly.

The importance of the lens is due to the simple fact that light particles change direction on entering transparent materials, such as water and glass, and change direction again on leaving it. In a lens, the degree by which light changes direction depends on the curvature of the glass surface presented to the advancing rays of light. Such variety of behaviour, though, is greatly controllable: by adjusting the curvature of the surface of a lens a designer can plot the course the light particles will take through it, and he can decide how far behind the lens the light rays will meet up again to form an image. The distance from a lens to the image it throws is its focal length. Modern developments – in zoom lenses and mirror lenses – are producing lenses which are physically shorter than their focal lengths, but this is due to optical designs which, for example, 'fold' the light path, bouncing it in a zig-zag line, as in prismatic binoculars. But to begin with, a long focal length requires a long lens body, and a short focal length requires a short lens body, or barrel – which is the metal mount holding the pieces of glass in place.

A long focal length lens throws a large image; a short focal length lens casts a small image. Very early in photography it became obvious that there were advantages in being able to change the lens on a camera body, to produce a larger or smaller image on the film at will. And there have always been cameras using that advantage. That flexibility, that freedom of choice, is at the heart of the massive popularity of the modern single lens reflex (SLR) camera. In this type of camera the photographer sees, by a reflex system using a mirror and a pentaprism, his subject through the same lens which passes the image to his film. He sees exactly what his film will see, and can arrange his subject, or his viewpoint – his position in relation to his subject – for precisely the effect he wants. The single lens reflex camera might therefore appear to be the only camera to buy, as it seems to offer so much – but look in any camera shop and you will see a huge variety of other kinds.

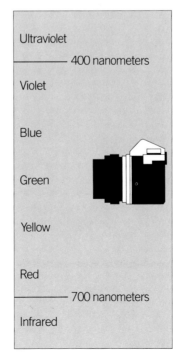

Ultraviolet

400 nanometers

Violet

Blue

Green

Yellow

Red

700 nanometers

Infrared

The part of the spectrum accessible to the camera can include the infrared and ultraviolet bands, both normally invisible to the naked eye

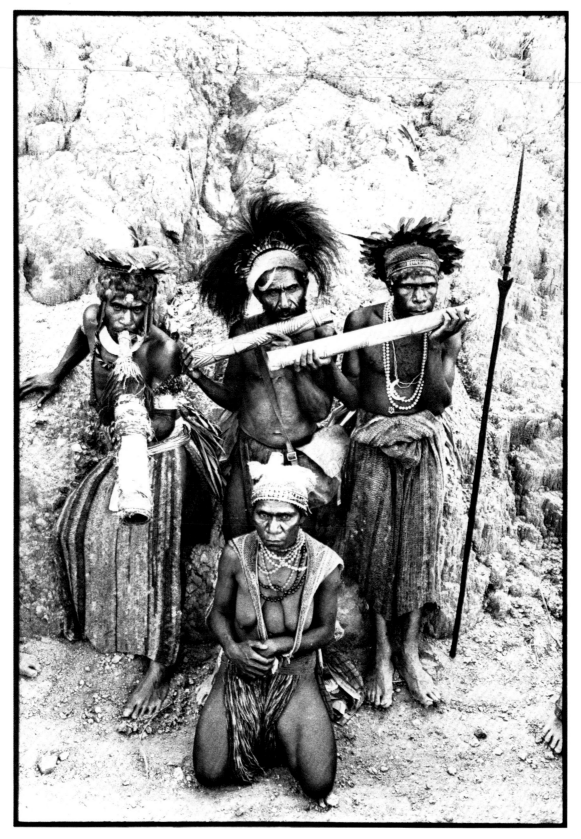

Lightness and flexibility make the 35mm camera particularly suitable for a wide range of subjects, such as this shot in Papua, New Guinea. Nikon, 50mm lens.

A variety of cameras

Much of the variety you find on the shelves of a camera dealer's shop is due to nothing more than free enterprise. In the Soviet countries the present manufacturing programme means that photographers have a basic choice of a mere handful of models, differing in what they will do, and how. In the West and in Japan society allows any manufacturer to make what he wishes; thus you will find makers like Olympus, Pentax, Nikon, Canon, Minolta, Contax, and more, all offering models which do the same basic job – but each of which, the manufacturer will endlessly persuade you, does it better than the other brands.

Such profusion and apparent duplication, though, is not as wasteful as it might seem. For in trying to stay ahead of the opposition the major manufacturers invest staggering sums in research, and they make advances which are pushing photography ever forward towards the ultimate, the perfect image – and one anybody can produce, at that.

Without doubt this is the goal of photography – the perfect image – but perfect in what? The answer depends on why the photographer sets out to take a picture in the first place, but another reason for the variety on dealers' shelves is that different designs of camera are more suitable for some photographic needs than others. So let us consider how some of the bits and pieces on a camera, and some of the different designs, have appeared in response to certain problems.

It is worth going back to the 1830s, to the first cameras used by Henry Fox Talbot, the man who discovered the basis of the process still used in modern photography. A squarish wooden box, with a removable back, and an ordinary microscope lens screwed onto the front – and that was it. Talbot would place his sensitized paper inside the box. But that paper was sensitive in name only: it required light to be projected onto it for thirty to ninety minutes. Today's simple snapshot cameras capture an image in something like a sixtieth of a second – much quicker than you can say 'click'.

Talbot's problem was not to keep light off his film, but to get enough onto it. What he therefore needed was not a shutter – a mechanical thing for momentarily uncovering his sensitized material – but a simple cap which fitted over the lens. By 1840 Talbot had improved the chemical mixture of his sensitized material, and one minute's exposure in bright sunlight was sufficient to produce an image, but this was still sluggish.

Towards the end of the 1870s, glass plates coated with much more sensitive gelatin bromide were introduced, and this substance required very much shorter exposure to light. Because the chemical mixture (the emulsion) could react so much more quickly to light, shutters were designed, and at first they were offered as accessories which fitted onto the front of, or behind, the lens. With the shorter exposure times, it became possible to take pictures of people moving – 'action pictures' – in which street life could be recorded as it happened; before then, photographers had required people to pose in ridiculous static and self-conscious arrangements. Materials went on becoming more sensitive, and shutter design kept pace, although by around 1895 shutters were no longer accessories, but an integral part of the lens or camera body.

With the shutter built into the camera body, as it is in most modern cameras which allow the photographer to change lenses to suit his needs, it becomes the norm to own several different lenses, and the cost of the shutter is borne only once.

Lenses, of all focal lengths, pass light through their entire area; obviously so, since they are of glass. But at the outer edges of the lens the light path is less precise than that through the central area, and the rays of light do not all come to a focus in exactly the same plane. The difference is fractional, but it is sufficient to cause a little confusion, and to diminish the sharpness of the image cast onto the film or plate. If the edges of the lens are masked, the image is immediately made crisper. The early photographers did the masking, or stopping down, by using a disc with a hole cut in its centre. The thing was called a Waterhouse stop (used from 1858) and several would be carried, to block off more or fewer of the light rays, the metal disc being dropped through a slot in the lens barrel to rest between the glass components, or elements, making up the lens. Photographers had quickly learnt that by using more than one element they could make each counteract certain faults in the way its neighbours passed light rays.

Stopping down a lens has other very significant effects. Since it cuts out some of the light passing through, it means that the film is struck by less light, and therefore needs to be exposed for a longer time to produce the required image. Or to put it another way, stopping down can be used to reduce a very bright level of light, to bring it down sufficiently low for today's very sensitive films, some of which are so responsive to light they they can produce an image of someone sitting in candlelight, and can do it in a fraction of a second. Of course, removing any stoppage of the light path through the lens allows more light to pass, which may be needed in very low light levels, when the slight softening of the image caused by using all of the lens area can be tolerated.

The stopping of the light through the lens has long been done by a diaphragm which consists of a series of hinged metal leaves: when they are swung inwards, towards the centre of the lens, they progressively lessen the aperture through which light can pass. The size of the aperture is very important, since it not only affects sharpness of image, but also the amount of light passing through it, and thus the exposure of the film to that light.

The metal leaves of the diaphragm are arranged to close inwards by fixed degrees, their motion being halted at a series of click stops, or f/stops – click because a definite click is heard or felt, but why f? Because the stops are spaced at

intervals which correspond to a simple sum or equation relating the diameter of the aperture to the focal length of the lens. A lens which has a focal length of 50mm (which would be 'standard' for a 35mm camera) and is 25mm across is known as an f/2 lens, since $50 \div 25 = 2$. The lens would operate at f/2 only with the aperture wide open, of course: f/2 is its 'maximum aperture'. Now close the aperture to the first click stop; its diameter has shrunk to 17.85mm, which divides into 50mm 2.8 times, and that stop is known as f/2.8. Click on, and you come to f/4, with the diameter of the aperture down to 12.5mm. Next stop is f/5.6, and beyond that f/8, f/11, f/16, and sometimes further, the aperture becoming smaller all the time. The mathematics of all this does not matter in actual picture-taking; what is important is to realize that each f/stop lets through only half as much light as the one before, and twice as much as the one following it: f/2.8 doubles the light through f/2, and f/4 is double f/2.8 and four times as much as f/2, and so on.

The modern shutter is also arranged to open and close in progressively longer or shorter steps. A camera with manual controls will have a shutter which opens for one second, then a half second, 1/4, 1/8th, 1/15th, 1/30th, 1/60th, 1/125th, 1/250th, 1/500th, 1/1000th, 1/2000th. This sequence is not completely logical, but the switch to 1/15th from 1/8th prevents such clumsy fractions as 1/16th, 1/32nd, 1/64th, 1/128th, 1/256th and so on; and in any case few manual cameras are so precisely constructed that their shutters will open for exactly the stated fraction of time. The pertinent point is that together shutter speeds and lens apertures allow you to control quite accurately the amount of light passing onto your film, and for how long it passes. At the same time they allow you to control the sharpness of your image – by dictating a condition known as depth of field.

The camera which has adjustable shutter speeds and a lens aperture control ring has them in order to provide you with control over light, allowing you to adjust the camera to suit different subjects. Very simple cameras do not have such controls, or have merely a limited number of settings: they will produce satisfactory results only when there is sufficient light for their lenses of small maximum aperture, or when the light is allowed to pass through the lens for long enough to affect the film – particularly basic models may have a single shutter speed of perhaps 1/60th sec, too fast for pictures in very low light levels.

The development of electronics has led to a separate breed of non-controllable cameras. They are the automatics, which compute the strength of the light reflected from any chosen subject, and adjust themselves to suit. If such a camera is designed to select both lens aperture and shutter speed it is 'fully programmed'. If it allows the person using it to choose the aperture only, it is referred to as 'aperture preferred'; and it is 'shutter preferred' if the user is able to select the shutter speed only. Such cameras do not make their automatic settings in fixed stages: they will not click stop from

f/4 to f/5.6, nor will they switch from 1/15th sec to 1/30th sec – they progress in smooth 'unstepped' fashion. That, of course, introduces the possibility of even greater accuracy of exposure than the stepped shutter speed or aperture ranges of a manually-operated camera provide.

Degrees of automation differ, but all cameras other than very basic models will feature light control mechanisms such as we have been discussing. Later we shall come to the occasions when you should use fast or slow shutter speeds and large or small lens apertures, for these are the variables that affect not only the quantity of light passing but the appearance of the finished picture.

Controlling light on film

The lens gathers the light

The diaphragm controls the amount of light passing through the lens

The shutter controls the length of time during which light passes onto the film

For the moment, cast your eye along the photo-dealer's shelves: big cameras, small ones, some with two lenses, some with bellows, some with sleek and trim outlines, hardly less shapely than a pack of cigarettes, and even some without lenses at all (you can buy those separately). Why so many different shapes and designs?

Around the end of the nineteenth century the first practical enlargers began to appear. Before then, cameras had gone through an even more astonishing profusion of designs: some were built into opera glasses, some looked like pocket watches, others like rifles, and some looked like nothing on earth. The 'novelties' all produced miniature photographs – the kind of thing you might very well fit into a locket or a brooch. But the serious photographers, searching for the highest quality images, used big solid mahogany and brass cameras loaded with sensitized glass plates of various sizes. Whole plate size was 8½ x 6½ inches; and there were bigger plates of 10 x 8 and 12 x 15 inches, and even larger, sometimes to the photographer's own specifications.

The negatives from these large plates were converted

into positive images by contact printing: the glass plate was placed on top of a piece of sensitized paper, and the 'sandwich' this made was exposed to a bright light (sunlight was commonly used), the paper then being developed in a way similar to the negative development. Good and large and full-of-detail pictures resulted, but the equipment was cumbersome and the large glass plates were fragile. The appearance of enlargers brought about the prospect of using a relatively small negative, and projecting the image onto sensitized paper to make a large-sized print – an enlargement. The age of the miniature camera (and the modern professional's 35mm camera produces a negative only 1 x 1½ inches) was relentlessly on its way.

The influence of film

For some time, though, contact printing continued. When the first Kodak camera appeared it too brought a revolution – roll film. The 100 exposure film was wound onto a spool, and produced negatives large enough to provide contact prints of suitable size for sticking in an album. And for years negative sizes were such as to produce prints around the size of a playing card, or a little larger. There was the choice – to contact print, or to enlarge.

That Kodak camera stimulated public interest in a big way, and photography ceased to be the province only of those with money and leisure in equally large amounts, and a knowledge of both chemistry and physics. When the film was used up the Kodak camera, still loaded, was returned to its maker, who developed and printed the exposed film. The

popularization of the image-making business was going fully ahead. And simplicity was the target.

You might still see box cameras of Victorian vintage on the second-hand shelves – machines with one lens aperture and a single shutter speed – but as the twentieth century progressed, cameras became quite compact. They would fold up into slim affairs for carrying, though when opened a set of bellows would extend, making them, in effect, collapsible box cameras. Nevertheless, the negatives remained relatively large, and still the professionals used large plate cameras.

The Leica revolution

Cine photography was being developed at around the same time, and the experimenters then were using long strips of perforated film, 35mm wide. And in 1914 Oskar Barnack, working for the Leitz Company, in Germany, made a still camera to use that film. It was the Leica (for Leitz Camera), fully in production by 1924, and offering the user the great advantage of interchangeable lenses by 1928.

The Leica set the world alight. It was small, very portable, offered all sorts of control by the user, and its tiny negatives were of sufficiently high quality to yield enlargements of huge proportions, 20 x 16 inches being the size enthusiastic amateurs made for exhibitions. But the Leica revolutionized photography as a reporting medium: magazines could now carry picture-stories of action, of tragedies, of exotic places. Anywhere man could go, his Leica could go too, and its fast shutter speeds and large lens apertures could capture just about anything the human eye could perceive.

The smooth, quiet action of the rangefinder Leica camera, which still bears traces of the 1925 prototype, makes it invaluable for reportage. Mexican boy, standard lens

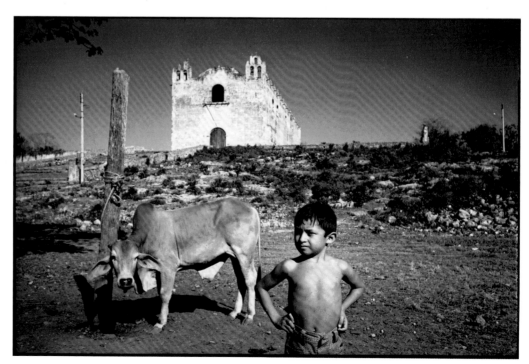

The Leica soon matured, and featured a rangefinder to allow its lenses to be focused accurately, so that its negatives were very sharp indeed. And today you can still buy rangefinder Leicas (though much-modernized), and rangefinder cameras of many other brands. The rangefinder works by superimposing exactly two images in the camera viewfinder when the lens is focused on its subject. The system is very accurate, even in low light levels.

The Leica did not really make anything obsolete, for even now you can still buy cameras which take large-sized film or plate. It does remain true that a large negative is inherently capable of containing more detail than a small one, and you will find cameras for 4 x 5 and even 10 x 8 inch negatives in most professional studios. What the Leica did was to expand greatly the uses of photography. It was, though, a time of innovation, and 35mm photography had proved so successful that other models were bound to follow Oskar Barnack's camera.

More flexibility

It is important to dwell for a moment on the significance of the Leica. Many of the bulky cameras before it had used reflex viewing for focusing: the light passing through the lens was diverted, by a mirror, up onto a ground glass screen where it formed an image. Other models simply allowed the light to pass straight through the camera, to a ground glass screen at the back, which was removed when the lens was accurately focused, a sensitized plate then being substituted for the actual exposure. That latter system is still very much in use in studios, and in technical cameras for industrial and architectural photography, and they are the ones in use when the photographer puts that black cloth over both his head and the camera in order to examine better the image on the ground glass. Reflex focusing and ground glass focusing had both proved very satisfactory. Some cameras, the simple snapshot jobs, had no focusing at all, and some merely provided a scale engraved around the lens, which the user adjusted by estimating the distance between his subject and his camera.

Lenses could not be changed at all on the simple cameras, but a number of makers had offered lens sets to fit the same mount, and some offered lenses which could be converted for different tasks by removing or rearranging the various glass components within them. The Leica offered a range of lenses of different focal lengths and of superb quality: they could be interchanged in seconds, mounting on the camera by a positive and precise screw thread. That flexibility set the future pattern for high quality 35mm photography, and in 1937 a 35mm single lens reflex camera (the Exakta) appeared, using the same reflex focusing system as the bulky studio cameras. Nearly twenty years passed before a pentaprism was added (Contaflex, 1954) which increased the

Light still follows the direct path through the lens, but deflection in modern cameras enables the photographer to examine and control the effects

Simple box camera

Hasselblad

Olympus OM1

35mm camera's ease of use, making it possible to operate it at eye level. In 1960 Asahi Pentax further improved the 35mm, introducing a system of light-measuring through the camera's lens – known as TTL (through-the-lens) metering. The domination of 35mm photography by Japanese designers has not faltered since.

Much of the variety you will find today is simply due to manufacturers' individual refinements on the basic 35mm SLR. Olympus, for example, made a huge impact with their OM models, which introduced OTF (off the film) metering; now others have taken up similar systems of very exact light measurement. Canon offer a model, the A1, which features no less than five different ways of operation, based on various methods of exposure metering.

It is important, and very much so, to remain aware that virtually all of the current variations are essentially concerned with ways of measuring light – with the pursuit of that perfect negative. But it is equally important to remember that no electronic circuit can assess the quality and mood of light as efficiently as the human mind with an understanding of the nature of light itself. And to unlock that understanding is the purpose of this book.

The 35mm camera is, for high quality photography at least, far and away the most popular instrument you can find

The modern SLR 35mm camera
can cope well with the unexpected.
Hawaii, Olympus, standard lens

For studio portraiture the twin
lens reflex 2¼ inch square
format is often ideal. George
Melly, standard Rolleiflex

in the photo-dealer's shop. But that old liking for the big negative, with all its capacity for containing fine detail, remains. Between the two world wars the German firm of Franke and Heidecke introduced a camera which, in its way, was as revolutionary and influential as the Leica. It was the Rolleiflex.

Large-sized roll film had been popular for some time, mostly for the primitive box cameras, and the widely-used folding bellows cameras, some with simple controls, some very competent, and still capable of good results today in sensitive hands. The Rollei was designed to use 120 size roll film, and to produce a negative 2¼ inches square. That

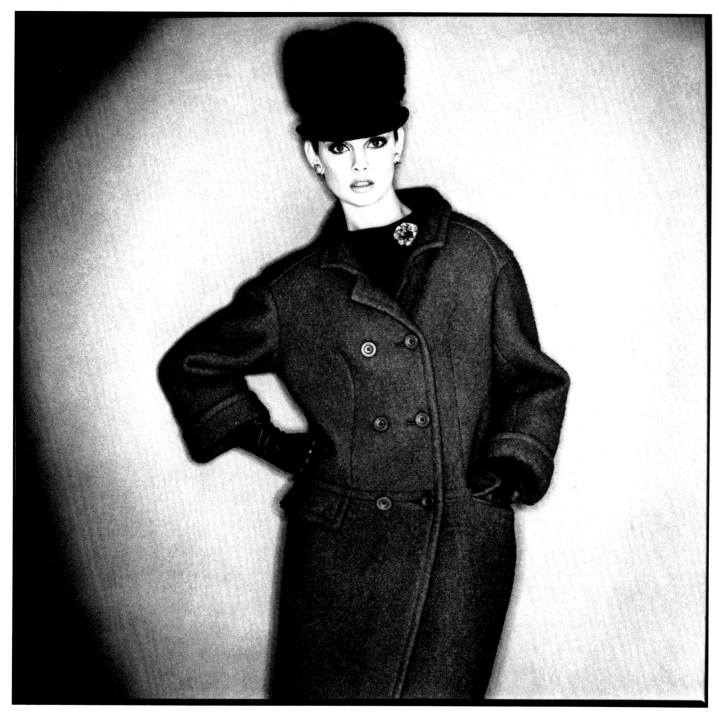

For maximum clarity and
rapidity of working, the SLR
2¼ inch square provides the
perfect solution. Jean
Shrimpton, for British Vogue,
Hasselblad

negative size caught on, and the Rollei remains very widely used, being still a particular favourite of portrait and wedding photographers. Designs similar to the Rollei followed. Labelled twin lens reflex cameras, the Rollei and its kind have two square 'boxes' stuck together: the top one focuses in the old style, in the well-proven reflex fashion, and the bottom box contains the film and takes the picture. Each box has its own lens, and they are coupled together so that focusing the top one automatically correctly aligns the lower one.

Serious competition hit the Rollei with the introduction of the Japanese Mamiyaflex. Also a TLR (for twin lens reflex), it features a removable lens panel, so that alternative lenses

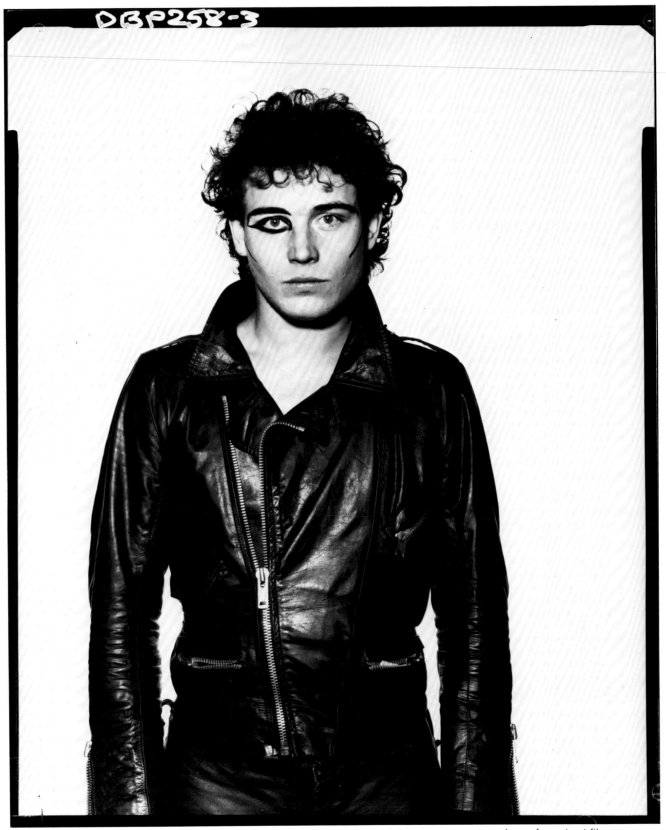

DBP258-3

Large format cut-film cameras are used mostly for still-life work, but they are also suitable, especially with electronic flash, for portraits. Adam Ant, 5 x 4 Cambo camera

may be attached, each set complete with its own front panel and shutter. The Rollei does not have this interchangeable lens facility, though separate wide-angle (60mm focal length lenses) and tele-Rolleis (135mm) were made to augment the standard Rollei (80mm).

The remaining important family of cameras (we are not yet discussing professional 4 x 5 cameras) consists of the single lens reflex models which use roll film. Rollei is represented, as are Hasselblad – considered the cream of them, and of Swedish make – and Pentax, with a model like a scaled-up 35mm SLR, the Japanese Bronica, and Mamiya, which brand offers the RB67, producing an even bigger negative than its fellows. These cameras all use the original reflex focusing system, the mirror behind the lens flipping up out of the way for the actual exposure, as in 35mm SLRs.

Instant photography, spearheaded by Polaroid, has made big advances, and in particular Polaroid's SX70 – a futuristic single lens reflex – is a contender for serious photography. Though there are highly specialized Polaroid films which produce negatives, the SX70 accommodates a film which does not: the end product is a finished colour print. The aim of instant photography is ever towards push-button simplicity, but the SX70 does offer considerable control, and is widely used by artists who reproduce their images – often adapted, or tampered with – in large sizes: the finished SX70 print is a shade larger than three inches square.

There are, you will realize, two distinct divisions within the profusion of cameras available. The first, and the most important, is made up of those models which are radically different in design because they offer specific features, such as a larger negative size, interchangeable lenses, or a particular focusing method. The second division consists of those cameras within each type which differ only in certain refinements offered by the various makers. Your first priority should be to get to know the different types – and why they are different – in division one. Only then should you concern yourself with the more subtle variations in division two.

What camera suits what kind of picture taking? Identify the kind of pictures you want to shoot, then read down the columns for advice on suitability

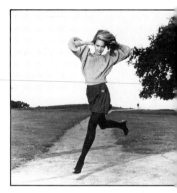

	Portrait	Landscape	Action
110	Quite suitable, but fixed focus models don't allow you to move close enough to subject for big image on negative. SLR models are, however, suitable: Pentax Auto 110, Minolta 110 Zoom Mk II.	Weak on rendering distant detail with adequate clarity. But when pictures are to be only of en-print size, would be suitable for mid-distance views, such as gardens. Those models allowing accurate focusing (even symbol focusing) best for detail recording	Mostly not suitable, as accurate focusing and high shutter speed recommended for best results. Bu with panning technique it is possible to produce acceptable results. SLR models best
35mm compact	Acceptable, but will produce best results only with full-length portraits. Usually fitted with wide-angle lens which shows its limitations if you go too close, as for head and shoulder portraits	Very suitable, especially if lens is of focusing variety. Fixed-focus models suffer from lack of ability to record distant detail. Buy a model which allows filters to be used – and see that they cover the exposure metering cell	Suitable where you can approach close to action, but the wide-angle lens renders too small an image o distant subjects. Fine for indoor action such as at parties and discos. Built-in flash extends scop
35mm SLR	Very suitable. With standard lens of 50mm a distance of 3 metres from subject brings a full-length portrait. For head and shoulders go for a lens of at least 100mm: too close an approach produces unnatural perspective of face. Allows use of multi-flash lighting	Ideal. Portable for trips into wilds, and each small cassette of film packs 36 exposures. Wide range of lenses and filter accessories makes it possible to produce many special effects while actually on location. Carry a tripod for really long lens work	Ideal, especially as motor drive an special 72 exposure film (or speci camera back allowing very long film lengths) mean you can shoot non-stop when action is fast and unpredictable. Wide range of lens can handle indoor and very distan action. Powerful flash available
Medium format	Ideal, especially for indoor portraits or location work in which a tripod may be easily used. Big negative allows great detail rendering and choice of many ways of enlarging image. Huge range of high-powered flash options available	Ideal, and much used for this purpose, though slightly less portable than the 35mm SLR. Wide range of lenses and accessories available. Interchangeable backs may be carried, pre-loaded, though again limiting portability	Suitable, but limitations of 12 or 2 exposure films inconvenient. But interchangeable backs do allow extremely rapid reloading. Large negative size good for detail, but insufficient to make this format superior to 35mm SLR for fast action
Instant	Larger formats are very suitable, but cameras for hobby use a bit less so. Important to remember that vital thing in portraits is that skin should look right – but small-format instant cameras are very much subject to vagaries of existing light, and can produce off-colour effects	Hobby models perfectly suitable for snapshots, but larger sizes, which take films offering retainable negatives, are very suitable indeed. Polaroid backs to accept 5x4 film may be fitted to wide variety of conventional cameras	Not really suitable, since too slow operation. Though hobby models may be used quickly, without user waiting to check result of each exposure

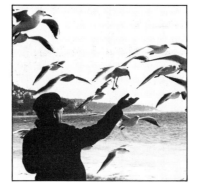

...ildren	Wedding	Wildlife	Close-up
...able of very pleasing results, ...ugh only SLR models allow close ...roach to subject. But ideal for ...ures of children playing on ...ch, or in garden	Quite suitable, but inherently in-capable of recording fine detail, so wedding dresses may appear as washed out white. Focusing models better. Suitable for flash shots indoors, as at reception, though direct flash picks up smoke and dust in the air	Not suitable, although could produce satisfactory pictures of the larger animals in zoos and wildlife parks	Only the SLR models can cope with the close and accurate focusing required
...ectly suitable, although few ...dels allow you to focus closer ...n one metre – so big head and ...ulder studies are out, unless ...go in for enlargements. Fully ...osure-programmed models will ...t you to slow shutter speeds ...ors, but flash is readily ...lable, often built-in	Very suitable. For shots inside the church buy a model with delayed action shutter release and rest camera on floor, or on a chair at back of church. Built-in flash a little slow to re-charge, so rely more on available light for chance-action shots	Suitable only for zoos and wildlife parks, since absence of inter-changeable lens facility does not allow large enough images of distant creatures, or close-ups of tiny animals. But close-ups of flowers can be got with special lens attachment (use with great care and measuring accuracy)	Not designed for this purpose, though close-up lenses are available to allow approach within a few inches of subject. But tripod and very accurate measurement of camera to subject distance then become necessary
...y suitable. Choice of wide ...rture lenses means background ...be easily thrown out of focus. ...nced flash technique readily ...lable for soft lighting indoors	Very suitable. The 400ASA films now common will allow shooting inside church if flash is not allowed. But go down to films of 100ASA or so for maximum retention of detail in wedding dresses out of doors when shooting colour in overcast lighting. Many flash options available	Eminently suitable for distant creatures and birds, as choice of lenses available covers all needs. Extremely good, too, for ultra close-ups, using extension bellows or tubes between lens and body. Special films available for startling effects – such as infrared	Very suitable. The unaided standard 50mm lens usually focuses down to 15 inches or so, but bellows or tubes may be used to obtain life-sized images on the negative of insects and tiny objects
...icularly good for in-studio ...k, but same limitations apply as ...action shooting. Ready ...lability of very powerful flash ...of bounced flash facility make ...itable for gentle lighting ...ors. Good for allowing choice ...ropping from large negative	Ideal – if you are in control and can ask bride and groom to pose. Large negative offers great rendering of detail, and between lens shutter allows much control over flash shooting. Usually standard lens is suitable for this job, and wide-angle lens can produce fine effects inside church	Very suitable indeed, except where much mobility over rough terrain is required. Especially good when tripod can be used. Wide range of lenses available, and with big negative size that means small creatures can be pictured with great fidelity of detail	Ideal, as same techniques may be used as with 35mm SLR, but larger negative renders detail even more accurately. Would be first choice for studio close-ups. Beware – TLRs suffer from parallax error
...y suitable for casual fun-...ures. But be prepared to have ...sion interrupted frequently, as ...ng subjects are fascinated to ...instant film develop to full ...our	Suitable enough, but a liability at times when you don't get a second chance. Perfectly satisfactory for family album pictures	Not really designed with this purpose in mind, but probably the inventive could produce satisfactory results. For most purposes, too uncertain	Extremely good in larger formats, or with Polaroid SX-70 SLR – which allows very close focusing. As long as you have a second chance you can keep shooting and checking till result is perfect

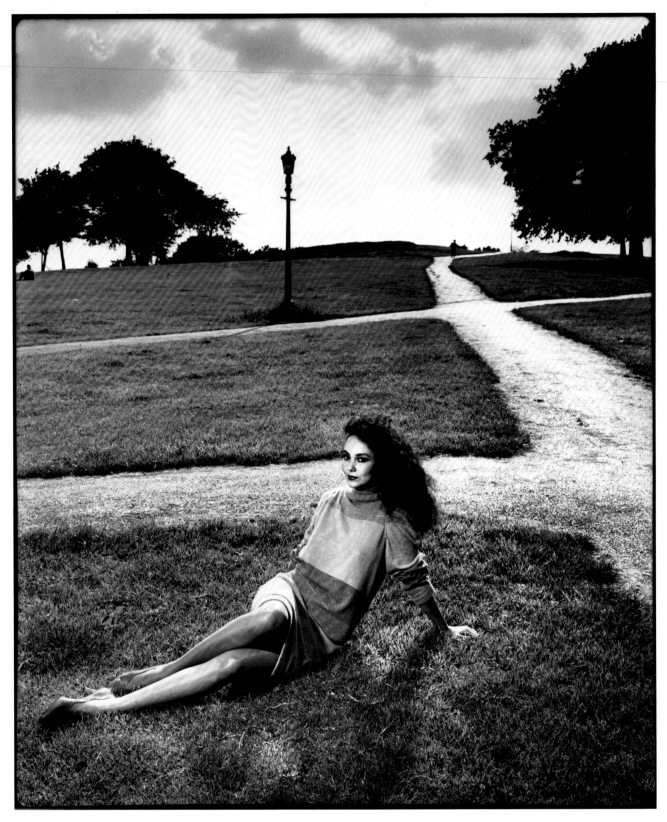

To retain the dramatic evening light, but still show sufficient detail on dress and model, a fill-in flash was used to balance the ambient light. Marie Helvin, for Italian Vogue, Plaubel camera

Light

Hardware – cameras and lenses and stuff – is all very incidental. The camera is no more than a means towards putting what you see before you onto a piece of photographic paper, or into a colour slide. The artist's paper and pencil are incidental in the same way, merely tools. You can spend a year and more swotting up on the specifications of different cameras – different types, different makes – and at the end of it you still won't be able to make a worthwhile photograph, one that will have people wanting a second look, unless you get to grips with light.

Light is fundamental to life. In fact, scientists still have not entirely discovered what it is, but Newtonian argument and the astonishing quantum theory of the universe put light somewhere in the region of being now particles, now waves. Whatever its true nature, it is energy, and very powerful energy too, when it radiates from the sun. The light rays from a candle, or a house bulb, would not burn you even when focused onto your arm by a very high-powered magnifying glass, but the sun's rays certainly would. Besides sunlight, the brilliance of lightning indicates the immense power of natural light. Artificially produced light can, though, be very potent: when sufficient rays are bunched together, as in the slender compact beam of a laser, they can cut through steel.

Imagine, for a moment, a football at one end of a soccer pitch, while at the other end there is a pea. The football, the sun, radiates light in all directions; the pea, our earth, is struck by a tiny fraction of these radiating light particles. In fact, so slender is the cone of light hitting earth that to all intents and purposes the rays reaching us are parallel. This is why in sunlight your shadow is never wider than you are: it may be longer, when the sun is on the horizon, but it's never wider. Artificial light is created here on earth and pours forth from a source much, much smaller than the sun: its rays diverge in every direction, just like the sun's, but the light from, say, a match in your hand strikes you with a large part of its output – and behind you, your shadow looms huge.

If that were it, if light radiated in straight lines and petered out when it hit something (other than glass, water, air, things transparent and translucent), this earth would be a place of shadows as black as midnight, contrasting with the vividly brilliant bits hit by sunlight. But light bounces, just as a thrown ball bounces from a wall. And whatever is hit by light becomes not only a reflector but also a radiator, itself spreading the light rays back out again in all directions. The more smooth the radiator, the more directional the light bouncing off it: a mirror sends it flying very straight, but the rough whitewashed wall of a cottage will send a positive spray of light into the lane opposite.

As distance doubles, light becomes only a quarter as strong, in accordance with the inverse square law

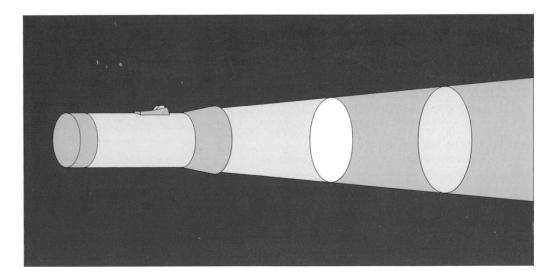

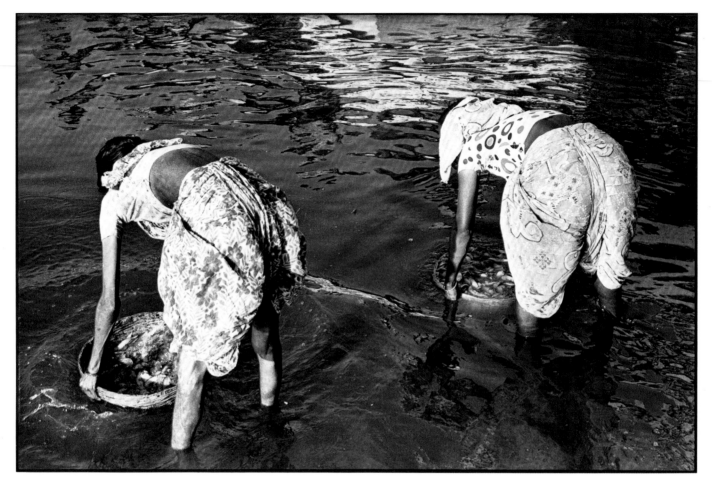

This simple shot of some
women washing fish has been
rendered very effective by the
evening sun. Goa, Nikon

Keep thinking of those analogies until you can practically
see the particles of light pouring down, much as you might see
the tracer bullets fly in an old war movie, or even much as you
might see the raindrops streak past your window. You must
begin to feel the presence of light, to understand its nature
and to recognize its strength.

Earth's atmosphere, with its clouds and its moisture
droplets, its dust, causes light to bounce all over the place.
On a day with a clear blue sky there may be distinct, and
harsh, shadows; clouds, on the other hand, reflect and diffuse
the sun's light so that it comes at you from all directions,
bouncing into every nook – and there are no shadows, or at
least if there are they are soft and delicate.

And yet, with all that light moving at great speed
everywhere, it is possible to measure it very exactly. It has to
be possible, otherwise our photography would be a very
imprecise affair, a real game of hit or miss and guesswork, as
it was when it all began.

When light strikes a photographic film it immediately
begins to affect the tiny particles of silver halides embedded in
the film and starts the process of converting them into black
metallic silver. Developing the film increases that effect and
creates the negative, with dense patches of black metallic
silver where most light has stuck. But just how much light does
it take to darken the silver to a certain degree?

Trial and error provided the answer in the early days.
A photographer would mix up his own sensitizing paste,
spread it on his glass plate, and expose it to a sunlit object for,
say, four minutes. If the negative was too dark (over-exposed)
he would try it for three minutes next time. If, on the other
hand, there was not enough detail on the plate (under-
exposed), he would give it five minutes. A little lacking in
scientific precision, perhaps, but that way led to better ways,
and even today accurate exposure of a film is due to
awareness of what will happen based on experience of what
has happened.

In the early days the strength or quantity of light wasn't
actually measured, it was calculated. But measurement of a
sort came quickly enough, and the first popular way of reading
the strength of light was by observing how long it took for a

Electronic flash in the studio can be an important aid, covering a wide range of lighting effects, from the darkly dramatic to romantic high key. Here the flash, bounced off umbrellas, provides the full tonal range. Arnold Newman, 1980, Rolleiflex

piece of chemically treated paper to darken (in the light by which the picture was to be taken) to a standard tint. The time taken was then applied to a set of tables which showed the camera settings to be used. That outfit, certainly the biggest seller of its day, was the Stanley Actinometer, of the late 1880s, and it was used with Hudson's Photographic Exposure Scale, the set of tables.

Many systems followed, and are still following. In the late 1970s there was an upsurge in the profusion of different tiny cells, each sensitive to light, built into cameras. Widely used as the 1980s opened was the gallium cell, but as yet there is no perfect measuring cell, as each varies in its speed of response to light, or in its reaction to different wavelengths of light.

The ASA system

The concern of the first experimenters was to find an image-receiving mixture that was sensitive to light – never mind how sensitive, just sensitive. Once that mixture, which we now call the emulsion, was discovered, it was time then to begin categorizing various strengths of sensitivity. Many systems of denoting sensitivity have been used, but the most universal one gives the emulsion an ASA rating. ASA is an abbreviation for American Standards Association (similar to the British Standards Institute), which body got to work in 1943 to rationalize the business of identifying, for all to understand, the degree of sensitivity of photographic film. The ASA wanted to make it plain to all how speedily a film would react to light, and the ASA rating became the measure of sensitivity by which we choose our films. And different speeds introduce different effects in the negative, which can in turn be influenced by the way the photographer develops his film. But for the moment let us keep very much in mind that the ASA rating is as valuable a guide for us as is MPH in the movement of traffic, or wavelength for radio: it identifies.

The ASA system is beautifully logical. It has been tailored to match the other logical sequences – progression of shutter speeds and of lens apertures or f/stops.

A film rated at around 100 ASA would be quite sensitive (or fast) enough to allow snapshot exposures of, say, 1/125th

Two 35mm shots of Helmut Newton, in differing light conditions: left, using electronic flash direct from the camera; right, using candlelight, with a very wide aperture

sec shutter speed and f/8 lens aperture in good daylight. But a film rated at 200 ASA is twice as fast as one of 100 ASA: this means that in good daylight the photographer can switch to a shutter speed of 1/250th sec, or he can close down his lens aperture to f/11. Effectively, with the faster film in his camera he now needs only half as much light to produce a satisfactory picture. And if he loads with film of 400 ASA he needs only half as much light as for 200 ASA, and quarter as much as for 100 ASA.

To put it another way, at three in the afternoon you can take a perfectly satisfactory picture with 50, even 25, ASA film in your camera. As the day progresses the light fades in strength. You can slow down your shutter speed, open up your lens aperture (both of which will allow more light onto your film) or you can change to a film of higher ASA rating, the increased sensitivity of which will make more use of whatever light is left.

Quantities of light can be accurately measured because light travels at a consistent speed. The light from the sun hurtles towards the earth at a staggering 186,000 miles a second. At sundown the light still reaches us, though diminished in strength: striking the moon, or even just earth's atmosphere, some is absorbed and some rebounds, and the remaining beams speed towards us, still travelling at 186,000

miles a second. Strike a match, light a candle, turn on the hall light, flip the switch of your car's headlamps, and those incredibly small particles of brilliant energy blitz outwards at the same speed. Candlelight is just as much light as is sunlight – it is merely the source which differs, not the stuff itself. But light will, depending on its source, have a higher or lower colour temperature; that is, light from varying sources may contain different amounts of red and blue. This is an important concept for the professional who is greatly concerned with precise colour rendering, for by using filters he can adjust the effect light will have on his film.

Colour temperature matters hardly at all to the hobbyist using only black and white film, though the colour enthusiast should know something about it, so we shall cover it in more detail later in this chapter. For the moment let us dwell on light's other properties.

Imagine a kitchen sink with not merely two taps, but a dozen. If one tap, when turned on, can fill the sink in twelve minutes, then all taps turned on will do the same job in one minute; six of the taps in action will fill the sink in two minutes, and so on. It is possible, once you know the constant rate of the water flow, to predict exactly how long it will take to fill the sink no matter how many taps are turned on or off. It is rather like one of those school problems in which 'ten men take

Electronic flash is by far the
commonest method of lighting
in studio fashion photography,
allowing unblurred quick move-
ment and subtle lighting effects

even at dead of night. Flash could be thought of as packaged light, or as instant light; you can take it where you will and produce it whenever it is necessary.

If, though, the hobbyist (and many professionals, especially those shooting sport, photojournalism such as at demonstrations, and outdoor action) can work satisfactorily by relying on a camera with a built-in ability to measure light and make adjustments, then why doesn't everyone do it that way? Why will a professional using a monorail camera in his studio fuss around (or his assistant will) taking separate light measurements from various parts of his subject? Because, ultimately, the very best technical quality in photography remains the product of thoughtful selection and arrangement and the fullest understanding of light: it is not an automatic outcome of using the most sophisticated camera with its built-in measuring system.

Light and shade

Any subject is made up of shadowy areas and light areas, patches and spots of different hue, all of which reflect back towards the camera differing quantities of light. This is easy to understand when one considers that white buildings reflect much of the sun's heat, keeping the interior cool, while a black building will absorb heat and have a sweltering interior. But think of a subject in a photographer's studio: suppose the photographer wishes to make a portrait of a writer or an actor. Perhaps the sitter may arrive wearing a grey suit; or he might have on a velvet jacket, or one of denim or leather. He might even turn up without a jacket, but wearing a white shirt or a brown suede waistcoat. All of those textures and tones vary in how much light they absorb, and consequently in how much they reflect. And then our subject may be blonde, or grey; perhaps he has a thatch of thick dark hair – and he could even display a shining bald head. More variation. He could be heavily suntanned, or he could be an intellectual who never moves far from his books and has pasty white skin. On film there will be a big difference. Then there's the background: the photographer may want it dark for a sombre portrait, light for something more flippant. From all points on, and around, the subject the intensity of the light streaming towards the camera will vary. The photographer knows, though, how each level of intensity will affect his film, because he measures the intensities, or at least the important ones, individually. To do so he uses what is known as a hand-held meter, and often it is a spot-meter measuring one tiny area at a time, as its name suggests.

What the photographer must decide is which areas of his subject are most important – which ones he will wish to show in most detail in the finished photograph.

A film emulsion has limited tolerance (and colour is even more intolerant than black and white), and only up to a point will it record detail in both dark and light subject areas at the same time. Thus, in the example we have just been

seven and a half days to dig a trench . . .', and the simple fact is that light, because of its constant rate of flow, is just as predictable as anything else. What light has to achieve for us is not the filling of a sink, but the adequate 'soaking' of a film emulsion – filling it with light and putting into that emulsion a 'latent image', which is later made visible by the chemical process of developing the film.

Professional photographers are today the only ones who need tax their minds in taking careful measurements of light quantity. The job is done for the hobby photographer by his camera, which first measures the light bouncing off the subject and then, by electro-mechanical linkage, makes adjustments to the lens aperture, or the shutter speed, or both, to ensure that the flow of light through the lens and onto the film is sufficient to produce a good quality negative or transparency.

The very simplest cameras do not measure light, nor do they make adjustments. They are pre-set, with a single shutter speed and a fixed lens aperture; this means they will provide satisfactory negatives only when the light is strong enough to affect the film adequately – and that will mostly be in strong or hazy sunshine, or when flash is used. And using flash makes the simple cameras more flexible, for pictures can be taken

considering, the film may not be able to record detail and texture in both face and dark velvet jacket if the light is so harsh that the ratio of brightness between those two areas is excessive. The photographer measures to find out just what is the ratio.

A black and white film is quite capable of recording detail throughout a scene in which the brightest part is some 120 times lighter than the darkest part. But the human eye can perceive detail all over a scene with a 1:500 brightness ratio, so that some scenes just cannot be recorded by film in exactly the same way the eye sees them. So, the photographer first measures the light to discover the brightness ratio of his scene, and then decides whether his film can cope, and if not, what he can do about it. Some films cope more effectively than others, and it is, in normal circumstances, the films with a high ASA rating which cope best with extremes of light and shade in the same scene. But a photographer can tame great brightness ratio, by adding more light to the dark areas, either by reflecting it from a white board or sheet, or by using more lamps. Equally, he can hold light back from the brighter areas.

And he can decide at which end of the brightness scale he wishes to retain most detail: he may adjust his camera so that he knows detail will record from the darkest areas of his subject, leaving the brightest areas to 'wash out' or 'burn out' – to go blank, showing no detail at all, or very little. He may adjust the controls, shutter speed and lens aperture, to record the brightest areas, leaving the shadowy areas and unlit parts to appear in his picture uniformly dark and without detail. He exposes for the shadows or for the highlights, according to his preference in how he wishes his finished photograph to appear.

The important thing to remember is that a photographer has the ability to choose the range of tones he wants to record: he may adjust his camera, or change his film, or adapt the development of his film, to encompass a surprisingly flexible scale of tones. You will no doubt have seen pictures which are predominantly dark, and have a sombre appearance: they make use only of tones at the lower end of the range of light brightness which a film can record, and are referred to as 'low key'. Pictures which are almost exclusively

To render the cloud effects more dramatic by darkening the blue of the sky, a deep red filter was used. Landscape, New Guinea, Nikon, Tri-X film

of bright and shadowless areas have a light and lively mood to them and are known as 'high key'. Both are possible because the photographer has adjusted something – subject, lights, camera, film or its development – to make the brightness ratio and the distribution of brightness suit his taste. Photography offers immense scope for control of the image, but you must be able to understand light fully in order to take advantage of that scope.

Almost all 35 mm cameras for serious photography (other, that is, than the little compacts produced for easy but high quality snapshot photography) now have through the lens (TTL) exposure metering: they have a built-in light measuring system which assesses the light coming in through the lens from the subject and computes the most satisfactory setting of the controls to allow just sufficient light onto the negative for a good quality image.

Through the lens metering systems:

Spot

Centre-weighted

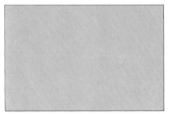

Average

How, then, does a 35mm camera's TTL system know which parts of the subject are most important, or how the photographer wishes the end result to appear? It doesn't. At its simplest, a built-in exposure metering system measures all the light from the subject, and sorts out an averaged exposure setting of shutter and lens: this means that excessively bright parts of the scene (and, equally, excessively dark areas) will have a strong influence on the exposure settings selected. For example, a very bright sky may cause the camera to choose a fast shutter speed and/or a small lens aperture, which may well cause the remainder of the scene to be underexposed. Designers have got round that to some extent by using more than one cell to measure light, so that certain parts of the scene are given more attention than other parts for the purpose of assessing exposure settings.

In the most efficient TTL systems the image which will appear on the film is assessed with a bias towards the importance of the central area (the system is then said to be 'centre weighted') or, better still, the measurement is taken from a tiny spot, marked by a circle in the camera's viewfinder. And where an exposure reading made from such a spot can be held (or locked), the system offers almost as much control over the end appearance as does reading by a separate hand-held meter, for the photographer can measure the light from any small area, and can then rearrange his subject in the viewfinder, still holding the correct exposure settings for the most important areas. And as soon as he has the composition right he can then shoot, knowing the exposure will be right for the most significant point of interest in his picture.

Colour temperature

You may never have thought of light as being either hot or cold, and it actually isn't so, at least not in the same way that you may feel hot or cold depending on whether or not there's a fire on in your room. But light does have colour temperature and that colour temperature particularly affects colour photography, though you could take pictures successfully, and for years, while completely ignorant of it.

We are always attributing coolness and warmth to light – expressions such as the warm glow of sunset, the cold light of day and blue moon all indicate our attitudes. The colour temperature of light relates to the way the light makes things appear. Our eyes can discern differences in colour temperature (things do look red at sunset, and by candlelight and fireglow, and blindingly brilliant at noon on a sunlit day, blue grey in drizzle and cloud) but the mind makes a correction so that we are rarely distracted by such colour variances. Photography does not automatically make corrections, and transparencies will faithfully record the coloration in which the world is bathed because of colour temperature. It must be said that at least in colour printing corrections can be made. Furthermore, filters may be placed over the camera lens when shooting, to compensate for excessively high or low colour temperatures, bringing the photographed effect to a neutral appearance, combating the overlay of colour brought on by the colour temperature.

Photographers who work a great deal with colour will often use the effect of high or low colour temperatures to put a certain mood into a picture: they will avoid using filters, either in shooting or printing, so that the result may appear exaggerated, but suggestive of a mood. And, indeed, some photographers have actually added warm coloured filters, when shooting in cold daylight, to introduce artificially the warm effect which the low colour temperature of sunset introduces naturally.

Just as the strength of light can be measured, so too can its colour temperature. And, generally speaking, light sources of low intensity (such as a candle flame, the weak sunlight at

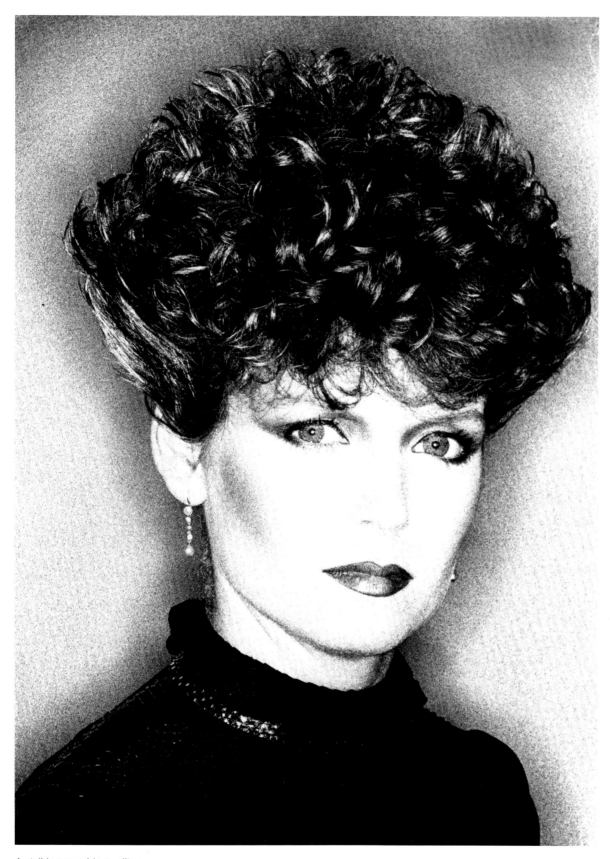

A striking graphic quality was
achieved with a ring flash and
overdeveloped Tri-X film.
Vanessa Llewellyn, Ritz cover,
1981, Olympus

sundown, which must force a path through a great deal of the earth's atmosphere) have lower colour temperatures than powerful light sources (such as noon sun, and professional electronic flash units).

Colour temperature is measured in degrees Kelvin and indicates whether the light is strong in blue wavelengths or red wavelengths, low temperature sources being rich in red, high temperatures strong in blue.

The colour temperature phenomenon exists because a body when heated emits light of varying wavelengths as the body is made ever hotter, becoming incandescent. For example, a heated iron bar will first glow dull red, then white hot. The intensely hot burning mass of the sun pours forth light which is high in colour temperature – noon sunlight is around 5500 degrees Kelvin – while the low intensity of a burning candle registers a mere 2000 degrees Kelvin, and is lacking in light at the blue wavelength end of the spectrum. Artificial light (such as that from house bulbs and special photoflood bulbs) falls between those two, while a powerful electronic flash unit may actually be higher in degrees Kelvin than noon sunlight.

When you are shooting in black and white the colour temperature of light will be virtually without effect, but it is important to know that fast black and white films (high in ASA rating) are a bit more sensitive to red wavelengths – common in low level light sources – which is what helps make them fast. However, colour temperature can be ignored for virtually all black and white shooting. It will, though, matter in colour, if you wish to become truly in control of your medium. Contemporary photography is particularly free and easy, and the colour bias introduced by varying colour temperatures tends to be readily accepted, since it does help establish mood, time of day, and even location (indoors or outdoors, seaside or inland, high lands or low level ground). At the sea and high on mountains there tends to be much more blue in sunlight.

Special filters are made which absorb certain wavelengths of light, or at least reduce them, while letting others pass through freely. What these filters do is return the light to the wavelength content for which colour film is balanced. Some manufacturers go further and make special films which are balanced to record accurately (that is, as the eye perceives them) colours seen under artificial light – tungsten and photoflood lamps. The tables published by manufacturers will show you which filters to use for which light source, but be warned that for most effective use of these filters you should know precisely which colour temperature prevails (and that will require the use of a colour temperature meter) and for which colour temperature your film is balanced. And colour film will hold its balance only if stored under ideal conditions, usually in a refrigerator, at a specific temperature. You will see now that concern over colour balance is essentially a matter for the professional who must produce perfect colour rendering, or for the purist.

The most significant thing to remember is that light may exhibit both variable intensity and variable colour content or temperature. And it may be highly directional, or scattered – bouncing indirectly from clouds, earth's atmosphere, walls, anything. Light is as variable as the ways open to a painter to paint his pictures. Study its effects and understand it; learn to use it, and to direct it onto film in the way, and in the quantity, you wish for whatever result you want to achieve. Light is the tool of the photographer and he must master it before he can begin to call himself a craftsman. Until then, he may enjoy a series of happy accidents, due to sophisticated and modern equipment, but he will not be fully in control.

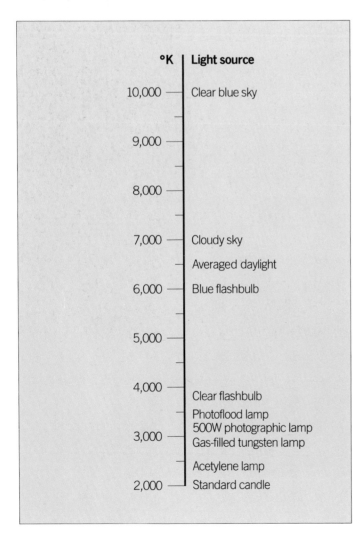

°K	Light source
10,000	Clear blue sky
9,000	
8,000	
7,000	Cloudy sky
	Averaged daylight
6,000	Blue flashbulb
5,000	
4,000	Clear flashbulb
	Photoflood lamp
	500W photographic lamp
3,000	Gas-filled tungsten lamp
	Acetylene lamp
2,000	Standard candle

Colour temperature scale

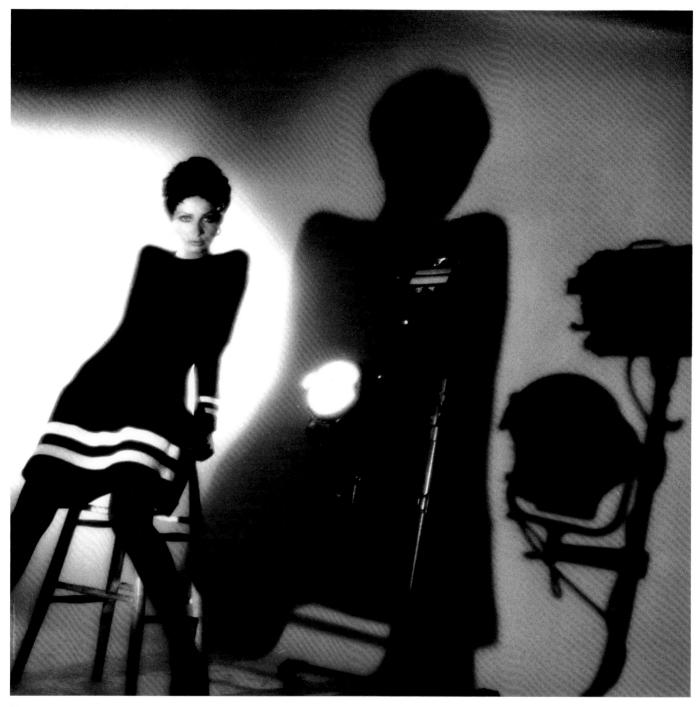

Tungsten light is used relatively
little nowadays, but spotlights
were used here to recall an
atmosphere of Hollywood
glamour. Sue Murray, for British
Vogue

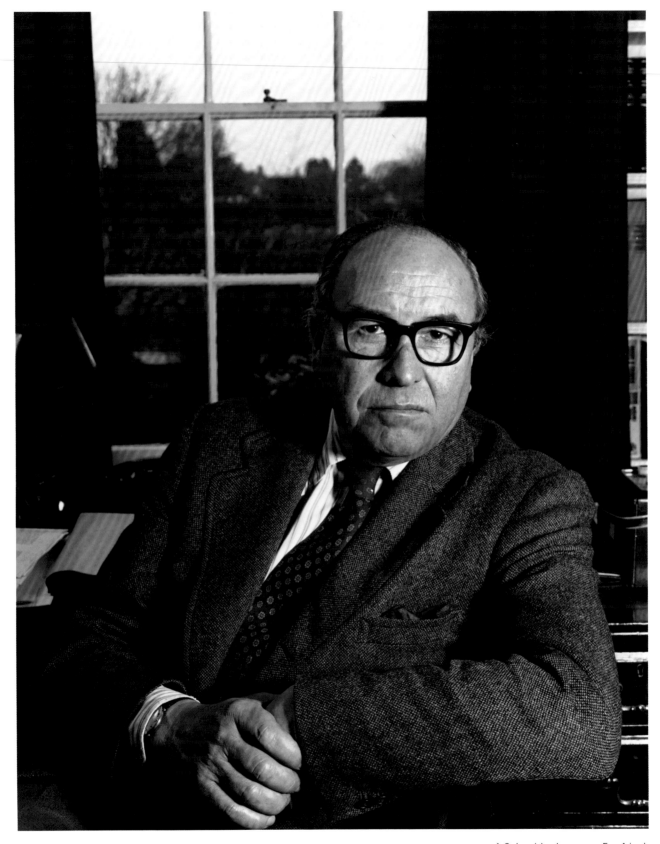

A Schneider lens on a 5 x 4 inch
Deardorff camera was used,
with FP4 film, to obtain this
sharp, grainless image of Roy
Jenkins, for The Observer

Film

The chances are that even if the pioneers of photography had come up with full colour pictures in the very beginning, we would still be shooting in black and white today. Someone would have devised a process which offered not garish (and remarkably often inaccurate) colour, but the simplicity of black and white. After all, black and white is capable of producing results like those of the famous charcoal artists, pencil portraitists, and the old engravers.

The search for an alternative medium – and it is an endless search, in every art – would not have been the only driving force which brought us to black and white: the high cost of photography's most basic raw material, silver, would have been sufficient persuasion.

As it happens, the very latest black and white films are based on colour photography technology, so we have come full circle. Behind the research programme leading to Ilford's XP1 and Agfa's Variopan film were two things: thoughts of producing a negative which contained no silver, and an attempt to improve the speed/grain relationship, which has also been a constant pursuit since lenses became inherently more capable of transmitting more information than everyday films could record. But the position today is far from final: it represents only the latest state of progress in the astonishing development of film.

How film works

All films work in the same way. They allow radiating energy to create some change within them, a change which can be made permanent, so that a record is made of the pattern of radiation. Whether the radiation be of X-rays, infrared energy, visible light waves, cosmic rays encountered by space travellers, or heat energy, there is a film which will record the pattern. And electronic translation of radiation is making it possible to record ever more incredible happenings. Using sonar pulses where X-rays may prove dangerous, it is now possible to examine an unborn child within its mother's womb. And using what is known as schlieren photography you would be able to photograph the delicate twirls of the air currents flowing from James Galway's flute. In a sense, therefore, air is not transparent as long as it is warm and moist.

What we actually see with our eyes, and photograph with our conventional cameras and film, are patterns created by energy from a very narrow slice of the entire radiating-energy spectrum.

Obviously, black and white film has to be simpler than colour film. For the image you see in a colour picture is constructed by taking light apart, splitting it into its components and recording each separately, and then putting the components back together again.

A modern black and white film is built up from a number of layers (for scratch protection, to aid stability, to prevent curling); but the two important ones are the base, of cellulose-acetate, or triacetate, and the emulsion, which contains silver halides embedded in gelatin. Early plates were sensitive only to the blue end of the spectrum, rendering everything beyond green as dark grey or even black. Orthochromatic film followed, with greater sensitivity. It would record green well enough, but it still rendered yellow, orange and red inadequately. Finally, along came panchromatic films, used almost exclusively for today's black and white photography. Panchromatic is able to record the entire visible spectrum, and even reacts to energy some way into the ultraviolet radiations. It can be made hyper-sensitive to red, which is abundant in artificial light, such as house bulbs; when treated in that way the panchromatic emulsion offers added film speed – it is fast, and can take pictures in light levels which seem low to the human eye.

All those varying sensitivities of black and white film are, of course, recorded on one single emulsion; it does not matter whether light is strong in blue or red, the effect of it on the film appears in how much or how little of the negative has been affected. And on a black and white print it will show in how dark a certain tone is: a red dress would look black in a print made on orthochromatic film, grey in one from a panchromatic film.

The silver halides in the emulsion may vary in size. All are microscopically minute, but emulsions containing enlarged halide grains react more readily to light, making faster films. When light strikes a silver halide grain it immediately begins to convert it into metallic silver – which is black, not shiny and bright. But the conversion is painfully slow, much too slow to

Enlarged grain from part of a
black and white print

be of practical use to us, and it has to be speeded up by a
process of development. What the light puts into the emulsion
is a latent image, and it stays latent until dunked in the
developer.

Let us now leave black and white film for a while, with its
latent image in which light-struck silver halides have sprouted
a mere few atoms of black metallic silver, and look at light and
colour.

Light and colour

White light, which is what sunlight certainly is, contains a
mixture of three primary colours – red, green and blue.
Various combinations of those three can reproduce all the
colours of the visible spectrum. If you were to take three
ordinary emulsions and make them sensitive to the three
primaries, by filtering out each of the other two primaries in
turn, you would have a record of whatever you photographed
all complete in natural colour. But your record would be in
three pieces: one negative would contain the photographed
scene only in its red light component, one in its green, one in
blue. By projecting all three, in superimposition and using an
appropriately coloured projecting light for each negative, you
would recreate the original scene. This is what James Clerk
Maxwell did in 1861 to produce the first ever colour
photograph. That method, adding different amounts of the
three primaries together, is known, not surprisingly, as the
additive process, and it was experimented upon by many
hopefuls. The Dufaycolor and Autochrome processes were the
most successful – particularly Autochrome, which produced
beautiful results reminiscent of the French impressionists'
pointillist technique.

The prominent grainy effect
here was achieved by rating
Tri-X film at 800ASA and
increasing the development
time. The birds were taken on a
second exposure of the same
negative. Nikon

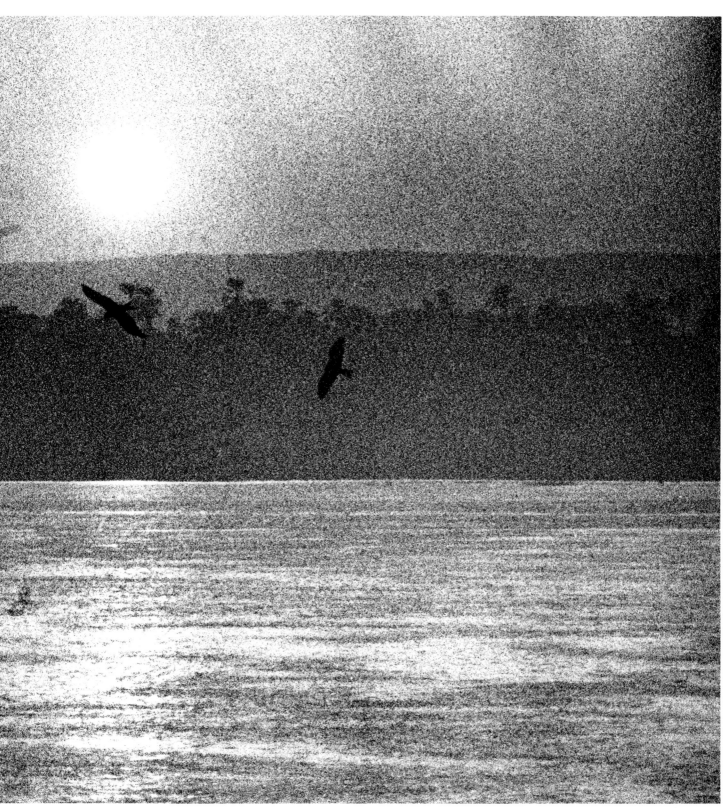

In the end, the additive process, which always required some sort of very complex filter arrangement through which all three components of one negative or positive could be projected, was overtaken by the much more straightforward subtractive process.

Subtractive colour photography was pioneered by a Frenchman, Louis Ducos du Hauron, but came to its supremacy only with the introduction of Kodachrome in 1935. Things did not stop with Kodachrome – they were only just beginning. Now there are many colour films which produce 'snapshot' colour pictures, either as reversal images for viewing by projection onto a screen, or as negative colour which produces colour prints. And now colour film is as fast, or sensitive, as black and white, and can be used to shoot action even in low light.

Modern subtractive colour film is most easily understood by imagining it as three black and white films, piled one on top of the other like a triple-decker sandwich. There are other layers in the sandwich, as in black and white film, but those which concern us are the three – basically similar to black and white – which record the colour. They also contain silver halides. The top layer of the sandwich, the one facing the camera's lens, is sensitive only to the blue portion of the spectrum; the centre layer is sensitive only to green; the bottom layer, of hypersensitive panchromatic emulsion, responds only to red.

When the colour film is exposed to a subject, the silver halides in each layer begin to be converted into metallic silver, each set of halides reacting only to light of that colour to which it is sensitive. By the time the camera's shutter closes after the exposure there are three latent images.

Black and white processing

Now we can return to black and white film with its one latent image. It is very easy indeed to make that latent image thoroughly visible. All you need is a developing tank, a thermometer, some developer, fixer, and about fifteen minutes of your time.

The necessary tank is lightproof, and contains a spiral. The film must be fed into the spiral in some dark place – completely dark, for sensitive film will fog very quickly if there is any stray light about. As soon as the film is loaded and the lid is on the tank, you can work in the light. Instructions with the tank, perhaps even stamped on its base or lid, will tell you how much developer is needed for each film format. Make ready the right quantities of the developer and fixer liquids, and use the thermometer to check their temperature is right: it should be 20 degrees C with virtually all black and white films. Pour the developer quickly into the tank and immediately start timing the development process.

From here on what you do next – or rather, for how long you do it – will vary, depending on several factors, such as the type of film, the type of developer, how you exposed the film, and the degree of contrast you require the negatives to show. But developing rarely takes less than four or more than twenty minutes. To check on timing use your watch, or a clock which accurately counts minutes.

Immediately the developer is in the tank and timing has begun you should agitate the tank: swish the developer around and get rid of any air bubbles which may be clinging to the film surface. Do this for fifteen seconds, and by inverting the tank (which is arranged so that no liquid can be spilt). At the end of every minute invert the tank again: the idea is to agitate the developer so that it does not become exhausted where it is in contact with an area of the film requiring particularly strenuous development.

When the development time is up pour the liquid quickly back into its container. To make sure developing stops instantly, rinse the tank with water, or pour in a special stop bath, which is reusable and chemically halts the action of any developer remaining clinging to the film. After this process pour in the fixer. Swish it round a bit, then leave it for ten minutes or so – less if it's a 'rapid fix', which kind usually hardens the negative emulsion as well, protecting it against scratches. When the fixing is over pour out the solution and wash the film while still in the tank. You can wash either by pouring in and out some dozen or so changes of clean water or (for a better, more durable result) by rinsing continuously in running water for half an hour.

That is all there is to it. After washing you can take the film out of the tank, swab off the excess water – very carefully – and hang it to dry. Let the film dry naturally, not in front of a fire or fan heater: there are special drying cabinets which professionals use, but they are well dustproofed, for dust causes specks which look terrible when negatives are enlarged. When your negatives are dry, cut them up into strips and put them into special transparent envelopes which you can buy in any dealer's shop.

So much for processing a black and white film. Within minutes, literally, of shooting your pictures it is possible to be examining a sparkling set of negatives. In fact, so straightforward is the process that in newspaper offices they have organized it to such a high degree that they can not only develop the film quickly, they can also print at high speed, so that the picture editor is actually able to see finished photographs only ten minutes or so after his press photographer has arrived back from an important assignment.

As soon as developer comes into contact with exposed film in a developing tank it begins to magnify greatly the effect light had during the exposure. It seeks out those silver halides struck by light, those with a few atoms of metallic silver in them, and begins to convert them entirely to silver. Where no light fell, the developer leaves the halides unchanged. Halides heavily struck by light, as from the brightest highlight areas of the scene photographed, sport most atoms of metallic silver, and are most readily converted entirely: those marginally struck, as by light from shadowy or dimly lit areas of the

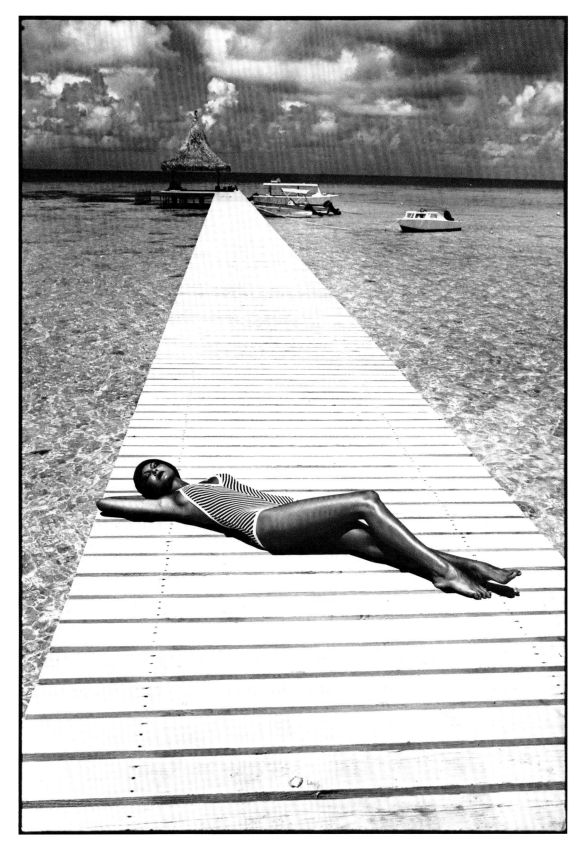

Grainless effects can be attained
with 35mm by using the slowest
films, such as Panatomic-X,
developed in D-76. Marie Helvin,
for Italian Vogue, Olympus

picture, convert more slowly. Soon, the latent image is beginning to take on the appearance of a negative, with substantial build-ups of black silver where the original scene was brightest, modest amounts where light was low, and no silver at all where no light was reflected from the subject. But all those areas of developed silver may still be surrounded by millions of unaffected silver halide crystals if there were very dark areas in the subject. If exposed to light at this stage they would rapidly become affected, and the whole image would fog, or even blacken all over. The fixing liquid takes care of this by dissolving the halides, so that they may be safely washed away: you will understand how important adequate washing is, for remaining halides will create a fog over your negative even when it is hanging to dry.

	Black and white	Colour reversal (Kodak E6)	Colour negative (Kodak C41)
First developer	11	7	
Wash		2	
Exposure to white light		2	
Colour developer		6	3¼
Stop bath/conditioner	1	2	
Bleach		7	6½
Wash			3¼
Fix	10	4	6½
Wash	30	6	3¼
Stabilize		1	1½
Total time in minutes	52	37	24¼

Film processing times

You can see that all film follows a broadly similar processing pattern, though timings and individual baths differ. Changing the times and the temperature can affect the ASA rating of a film. Black and white fixing time may be reduced by use of a high-speed fixer: and in professional darkrooms, as newspapers, the negative is sometimes printed wet, long before the 30 minutes washing time is up. The developing time varies considerably with different black and white films: 11 minutes is average for Kodak Tri-X in D76 developer

Colour processing

If only colour processing were as simple as black and white! The same kind of latent image exists in each of the three layers in our colour film, but bringing it to visibility is a slower process, one involving more steps, and demanding considerable accuracy in timing and temperature control. So critical is the process for some films that manufacturers do not make home-developing kits available, and the films have to be returned to laboratories, or processing houses, where everything can be kept strictly under control, and results

monitored. There are, of course, many colour processes which can, with patience, be undertaken by the hobbyist. It is worth saying here, though, that precious few professionals process their own colour films: since little can be done to control the end result (unlike black and white processing, which offers great control), there is little point in taking time and expense when the job can be done more economically, and in a more controlled environment, by a laboratory. The hobbyist with less concern for time, and a genuine interest in the mechanics of his medium, might well choose to try home colour processing, and to take advantage of the fact that colour reversal films can be influenced: their speed can be altered by a relatively simple adjustment. But while black and white films may be processed without harm in any black and white chemicals, the same is not true for colour: films of different formulae require treatment in solutions designed for them, so take care that you do not ruin valuable exposures by mistake or by misguided economizing.

The first stage in processing colour film, negative and reversal, converts the latent images in each of the three layers of the film into black and white negatives. There the similarities end, except one.

It is during this first stage, the first development, that reversal, or slide, film may be 'pushed' – its sensitivity may be increased. It is not unusual for Kodak's Ektachrome films to be pushed by two or even three stops: the 400ASA Ektachrome thus delivers a sensitivity of 800 (one stop), 1600 (two stops), or 3200ASA (three stops). Be careful, though: excessive pushing of colour film will make the result drift off true, usually moving towards a rather grainy over-blue appearance.

After first development colour reversal film is then fogged, either chemically or by exposure to light. A second development follows, during which the originally unexposed, now fogged, silver halides are turned to silver, and they create a positive image. Positive because the light areas of the subject have already been rendered as dark silver masses in the three emulsion layers, and it is now the originally dark areas of the subject which are indicated by darkened silver. But this second development also releases coloured dyes, which are deposited with the positive image. The dye in the first layer is yellow (complementary to blue), in the second layer it is magenta (complementary to green), and in layer three it is cyan (complementary to red). Thus each layer now has a dye-coloured image complementary to the colour to which that layer was originally sensitive.

The next stage is to bleach away all the blackened silver, leaving only dye-coloured positive images.

When white light passes through the reversal film (which is now a transparency) the positive images filter out, or subtract, their complementary colours from the white light, leaving a more or less (depending on film quality and processing care) accurate portrayal of the original colours of the subject. And that filtering (or taking away) process gives this kind of colour photography its name – subtractive.

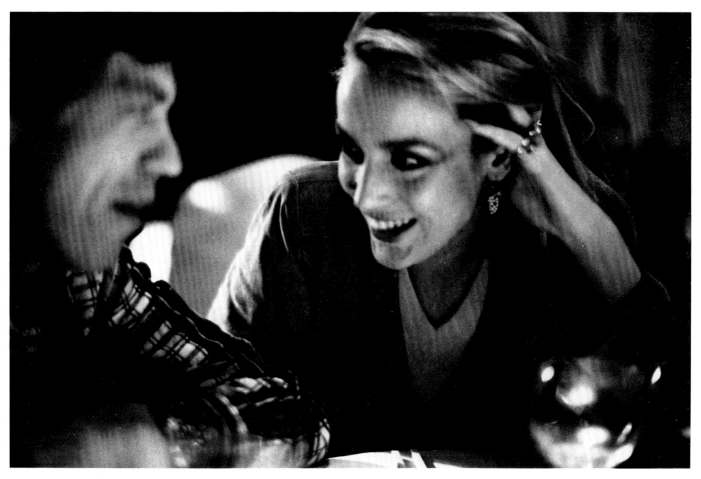

In a dimly lit restaurant this shot of Mick Jagger and Jerry Hall was made possible by overrating Tri-X film, with an exposure of 1/15th sec at the Leica's maximum aperture, f/1

Colour negative film also depends on dyes for its operation, but there is only one developing stage, during which the dyes are released. Since the latent images were negative, it is obvious these dyed images will be negative too, once all the silver is bleached away. But they are not only negative in tone (light where the original was dark, and vice versa), they are negative or complementary in colours too: the film's originally blue sensitive layer contains a negative image in yellow dye, the green sensitive layer is now magenta, and the third, red sensitive layer now displays a cyan negative image. Overall is a murky-appearing orange cast, which has been found to tame certain garish excesses of this particular process, and helps produce more accurate colour rendering at the next stage – the making of a colour print.

New processes

Taking advantage of colour film technology, both Ilford and Agfa Gevaert introduced in 1980 black and white films which produced negatives made up only of dyes, the silver being bleached away as in both colour reversal and negative films. In particular, Ilford's XP1 offers a number of advantages over black and white films of conventional construction, the most spectacular being a remarkable diminution of grain when XP1 is exposed at 400ASA or slower.

Ilford's film has two layers, an especially sensitive one on top, nearer the camera lens. These layers are converted into silver negatives as in colour film; the colour couplers used then infuse a dye which in the final negative appears in differing gradations of a plum shade, the silver being bleached away entirely. The film yields huge enlargements of up to 60X, and displays less grain than conventional silver-bearing negatives. It also suffers less from excessive or inadequate contrast when exposed at settings other than its recommended 400ASA, the two emulsion layers apparently introducing a very long tonal range.

Ilford produce a special processing kit for XP1, but the film has been known to give superb results when commercially processed in the C41 chemicals used for Kodacolor negative film.

The striking effect in this
picture, for French Vogue, is due
to infrared film developed in
D-76

stops. The push-development also increases grain and exaggerates contrast. By reducing developing time, effective film speed can be lowered, a dodge often used because of its characteristic of reducing contrast. However, either of these two techniques would affect all other negatives on the same roll of film, so that one latent image already high in contrast could be rendered nearly unprintable by the pushing, while another relatively low in contrast might benefit. Reducing development time to control one particularly contrasty subject might ruin another shot already low, or average, in contrast by making it unacceptably flat.

The grainy effect of the Tri-X film used emphasizes the texture of the concrete in this shot of a building at The London Zoo

Agfa-Gevaert's 'silverless' film is Vario-XL professional and they say it can be exposed at any rating between 125 and 1600ASA, and all on a single roll of film, without introducing any great deviation in tone and contrast. The film appears to be similar to XP1 in use of technology, and Agfa-Gevaert suggest it can be processed in Agfacolor F, AP70, and C41 chemistry.

If claims and results from early experiments are indeed borne out where these new black and white films are concerned, then a revolution has happened.

Conventional black and white film can be varied in sensitivity and in the negative contrast, but the treatment affects all negatives on the same roll: it cannot be used to modify one single image. For example, by increasing the development time the ASA rating of a 400ASA black and white film can be pushed to as much as 3200ASA – that is, three

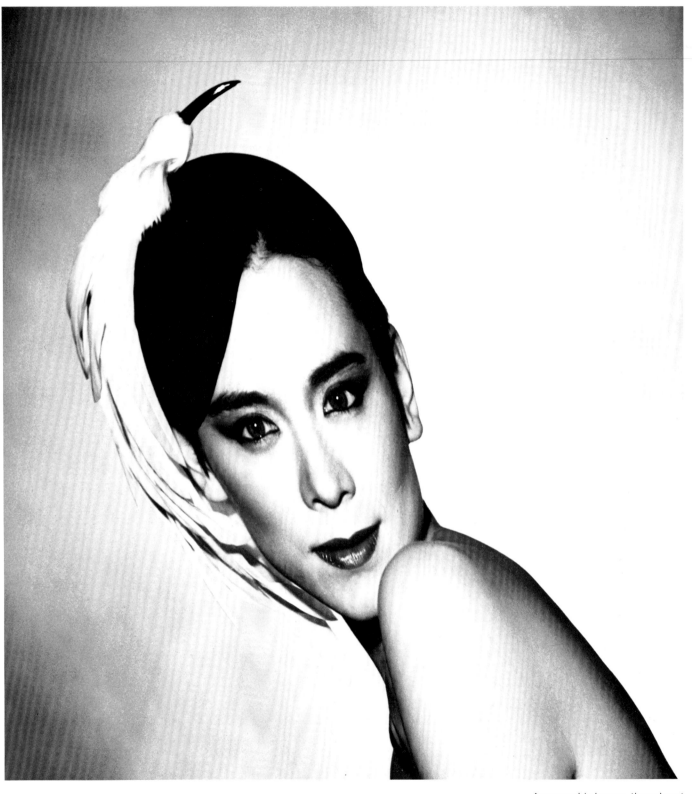

Anamorphic lenses, though not very common, can be used for special effects of this kind. Tina Chow, for Ritz

Lenses

Much of the character of photography has been shaped by the influence of the brush and canvas. Today there is no argument about the importance and the persuasiveness of the photographic image, but in the beginning it all stemmed from the artist's desire to record quickly and permanently – and accurately – any scene to which his sketching skills could not adequately do justice. And the biggest problem facing the less-than-accomplished pencil artist, even now, is how to depict scale and perspective convincingly.

Scale is understandable enough – it is the ratio between the size of one thing and the size of another – but why has perspective caused so much trouble?

Art historians believe that it first arose around 400 BC, when Greek philosophers put forward a system of drawing which would make a two-dimensional image appear to have as much depth and spaciousness as a three-dimensional scene 'in nature'. The technique, however, was not explored then and it was only much later, during the great artistic activity of the Renaissance, that the architect Filippo Brunelleschi took the advice of those Greeks, and the drawings he produced were breathtaking in their realism. The Renaissance painters flocked to use Brunelleschi's system, and they changed for ever the way artists pictured the world. Brunelleschi had made perspective a tool for realism – a realism unmatched by the flat and strange drawings of the Egyptians, the Chinese, the Japanese. When the artists, including Leonardo da Vinci, began painting in the effect of distance haze, the 'aerial' perspective they created, added to the 'linear' perspective of Filippo Brunelleschi, made the reality complete, but it required considerable skill – and a control over geometry which not everyone has.

What Brunelleschi had used was simply a system of having the horizontal lines and planes of his subjects converge as they ran into the distance. By this means – effective, but nowhere near so much as human binocular vision – he was able to suggest space and distance in a very realistic way. The camera lens does exactly that for us. Again, not as effectively as the human eye, which delivers a true three-dimensional impression to the brain, but there are systems of photography capable of creating 3D.

Not only does the camera lens give us the greatest accuracy of perspective – the most natural – on a two-dimensional surface (photographic paper, or transparency), but it also controls the size of the image put onto that suface. However, lenses of focal length greatly different from standard tend to do rather odd things to the appearance of perspective.

The most natural photographic view, one which most equals the eye's impression, is that given by a standard lens. And a standard lens is one with a focal length similar to the diagonal measurement of the negative for which it is used. A 35mm negative measures 24 x 36mm along its sides, and 43mm across its diagonal. In fact that figure has been rounded up, and 50mm is considered the standard, or normal, lens for 35mm cameras. It covers a field of view very similar to that which the eye intelligibly perceives: as a result the scale of objects, their relationship to each other, and the perspective within the picture, all appear very natural indeed. Looking at a picture taken with a standard lens is remarkably like looking out of a window at an actual slice of the world.

Lens and image size

If the standard lens is so natural, why does anyone bother using a telephoto lens or a wide angle lens? The straightforward answer is that a telephoto lens is used when a subject is so distant that its image on the film would be too small to show any significant detail, and a wide angle lens is used when it is necessary to cover a wider field of view (to get all of the subject in) than a standard lens provides. But there are other reasons: because lenses of other than standard focal length apparently alter perspective (though this is an illusion) and impression of depth and distance and scale, they can obviously be used by the photographer to control just what impressions of those things he transmits to his viewers. Let us look at the wide angle lens first.

Imagine yourself in a darkened room, one with barn doors. When the doors are swung open sufficiently to give you an angle of view of the outside world of approximately 48 degrees, you see what your camera's standard lens would see from the same position. Now if the doors are swung wider,

The apparent relative sizes of elements in a picture are influenced by the distance of the camera from the subject: from close up, (a) seems much taller than (b); from a distance, their heights appear more similar

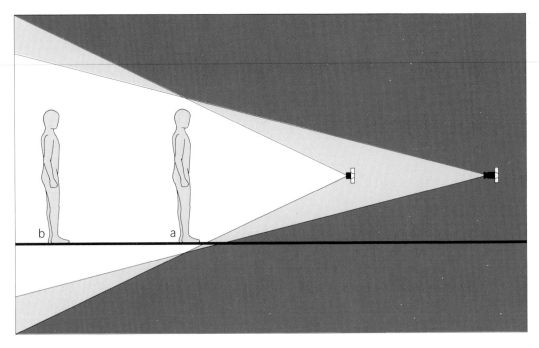

to increase your angle of view, you begin to get a wide angle view. Suppose the doors widen to allow you an angle of view of around 75 degrees. You can see more of the world – in fact, about the same as a 28mm wide angle lens would see. But to see more you have enlarged the slice of the world you are looking at; and each and every slice of the world you photograph, no matter how large or small it is, has to go onto a piece of film of the same size. And to get those 75 degrees of view onto a 35mm negative your 28mm lens reduces the scale of reproduction – everything appears on the negative much smaller than it would with the standard lens in place on the camera. Nothing else changes – not the perspective, and certainly not the relationship of the objects within your picture area – and why should it, if the camera position has not changed? All the apparent changes are the result of altered scale of the image.

Now, though, let us assume you wish to use your wide angle lens in order to record the scene with its major component (perhaps someone standing just outside the barn) rendered the same size as it would be with the standard lens. You must move forward, closer to the subject, to almost half the distance. And now you do begin to upset the relationships between objects within the picture. Those things close to your camera will appear much larger than distant objects, more so than they did when you were using the standard lens from further back. The impression will now be that the closer objects are actually further away from distant objects than they were before: it is this effect which brings to the wide angle lens its habit of making relatively cramped scenes look much more spacious than they really are. And since you have moved closer, the perspective of the scene before you will change, as it always does whenever you move the camera position, no matter what lens is fitted.

While we are in that darkened room with the barn doors we can look at telephoto lens behaviour. Suppose the doors are swung closer together, limiting your angle of view of the outside world to a mere 18 degrees. Now your view equals what you would get on film by putting a 135mm lens on your camera, which is a very popular telephoto focal length. Of course, the view has shrunk in its dimensions. So your telephoto enlarges it, stretches it in all directions, to bring it back to the same actual area your standard lens delivered, so that it will fit neatly onto your 35mm negative. There is an oddity here, though, and it is one that is seldom realized, since the majority of cameras for the serious hobbyist have through the lens metering which automatically adjusts for any exposure needs. Here is the oddity: your telephoto lens may enlarge part of the scene, but it cannot increase the light being reflected from it; in other words, by filling the negative with a smaller part of any scene than would a standard lens, the telephoto has also to make fewer light rays do the job of making the picture. For that reason you may often find that telephoto shots require more exposure than shots taken with standard lenses; however, we have already pointed out that most modern cameras take care of that automatically. But the telephoto lens has one characteristic you cannot fail to notice . . . so back to our barn doors.

The eye is not a camera, nor is that otherwise quite versatile creation, the brain. Consequently, whatever the eyes perceive they expect to follow the everyday rules of normal vision. So when they examine a photograph of a scene (no matter how your sophisticated intellect tries to persuade them to make allowances because this is a telephoto shot), they will expect to appraise it as if it were the product of normal viewing; that is, viewed across the 48 degrees which is the standard human angle of comprehensible viewing. And in

trying to stretch the view the brain will come up with the impression that objects in the picture are really much closer together than they actually were. What your mind will do when confronted with a telephoto image is to stretch it laterally, and in doing so it will greatly reduce the depth of the scene. Perspective will not have been altered, though your mind tries to talk you into accepting that it has. And if you were to move further back when shooting from that barn, in order to render the main parts of your subject on the same scale as would the standard lens, then you would exaggerate that effect: you would upset perspective, and you would upset the ratio between camera to subject distance and subject to background distance. The longer the telephoto lens the narrower the angle of view it takes in (only 5 degrees with a 500mm lens) and the more the apparent squashing up of the depth of the subject area.

Different focal lengths of lenses produce different subject, or image, sizes, as you now know perfectly well; but they do so to a very simple formula. A 100mm lens will produce an image size twice that of a 50mm lens, half that of a 200mm lens, and so on.

The lines emerging from the camera lens represent fields of view of three different focal length lenses. To maintain the image size on the negative it is necessary to move your view-point for each lens. And that is where distortion comes in: if you slide a coin nearer the lens on the diagram, you can see how the distortion increases as less of the coin is presented to the camera

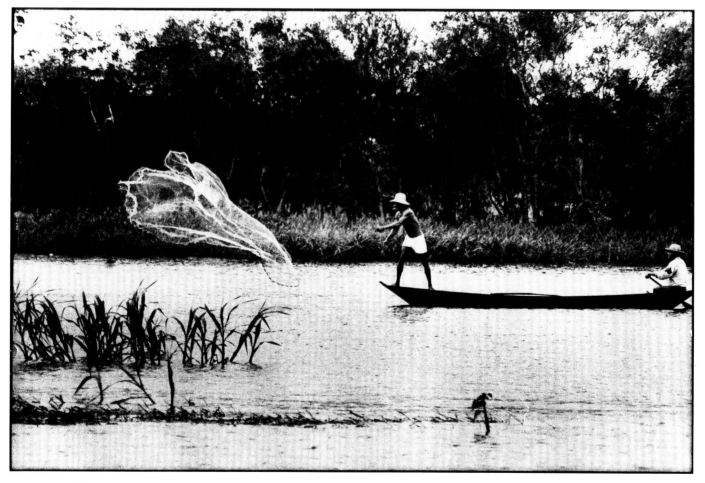

The Olympus 135mm lens gives compressed perspective in this scene of Amazon fishermen

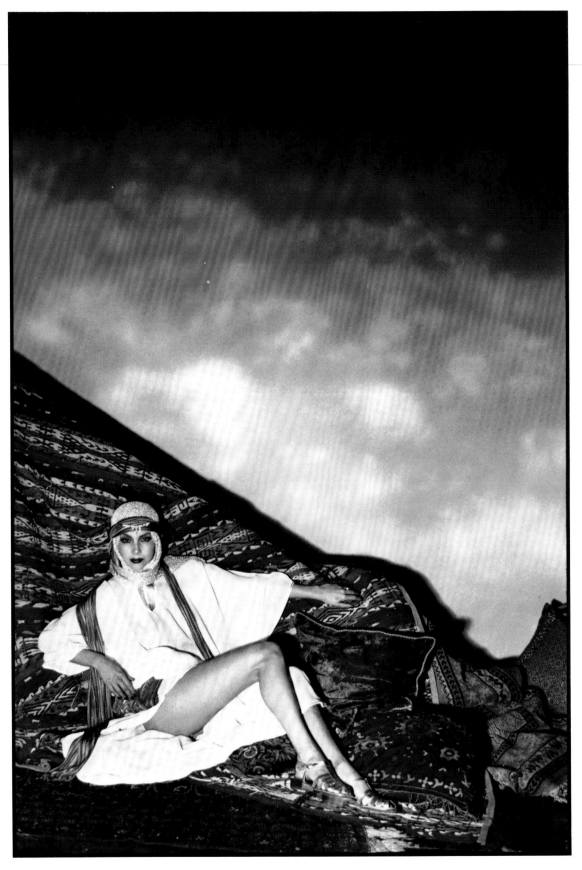

The zoom lens, here used on a
Pentax, gives considerable
flexibility, from 80mm,

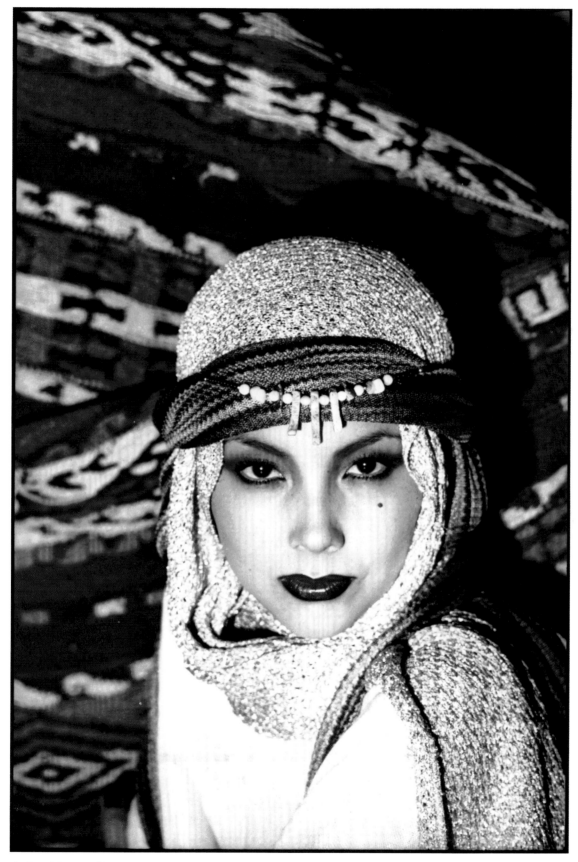

closing right in to 200mm.
Marie Helvin, for Ritz

Lens quality

Some lenses are of better quality than others, and as with all consumer goods the quality is generally reflected by the price you pay. But what are the variable qualities of a lens (for every one ever made is capable of producing some sort of a picture)?

To begin with, the construction of lenses varies, and so do the materials from which they are made. Even relatively simple lenses have three glass pieces, or 'elements', though ultra simple snapshot cameras make use of one element, which is sometimes made of plastic. The spacing of the glass elements is vitally important, and when you realize that a modern zoom lens may contain many more than three – and sometimes in excess of a dozen – then you can see the importance of careful engineering and building of the lens. And glass varies, too, in the way it transmits light, because of the ingredients it contains. New glasses are being developed all the time, but one containing calcium fluorite, much used in scientific optics, looks like being ready for application to camera lens manufacture; with it, a very high degree of colour correction is possible – chromatic aberration is much reduced.

Correction is needed by every single element used in the lens, and by the combination of all together. Differing glasses, differing pairings of different glasses, and differing placements of the elements within the lens all introduce certain distortions of the image, which can never be entirely corrected; cure one and you aggravate another, you might say. But with careful choice of particular glasses, and very accurate grinding and polishing of the surfaces of the lens elements, designers have reduced the distortions, or aberrations, so that you would have to have a very dud lens indeed to notice any of them. But that does not stop endless arguments about lens quality. In fact, your needs from a lens are two: that it provides a sharp image, and that the colour rendition is accurate.

Sharpness first. The most common measurement of this is how many lines per millimetre (LPM) the lens will reproduce, usually measured by photographing a lens testing chart. But the findings will depend on which film is used, and how it is developed: standardized tests make use of very fine grained film, such as Kodak Panatomic X (32 ASA) or Ilford Panatomic F (50 ASA). In theory, a very good lens such as the Pentax SMC Takumar 50mm f1.4 can resolve up to 300 LPM, but even those super fine grained films will not allow that degree of definition to be valuably used. In fact, the best lens ever tested by What Camera Weekly magazine was a 50mm f1.4 Planar, which showed almost 150 LPM on Panatomic X film, and the worst was a 50mm f2.9 Domiplan which could record only 45 LPM. Those measurements were taken from the central area of the negatives, and from images made when the lenses were stopped down to provide optimum conditions for sharpness. But even the Planar could record only 95 LPM at the edges of the image with the lens opened wide. A lens delivering 75+ LPM can be considered very satisfactory for all

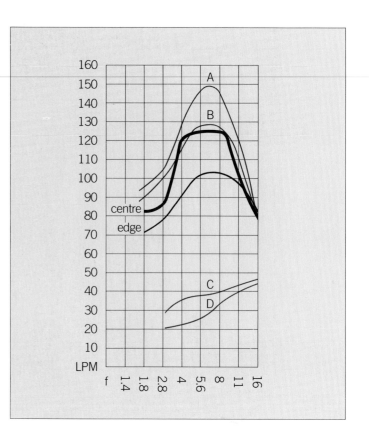

Lens test graph

The sharpness of a lens is often assessed by its ability to record a certain number of lines per millimetre, at both the centre and edge of its coverage. Here, in this graph prepared by What Camera Weekly, the Canon 50mm f1.8, as fitted to the Canon AE-1 Program SLR, is compared with a Zeiss Planar 50mm f1.7 lens, and a Domiplan 50mm f2.8 – respectively the best and worst lenses ever tested by the magazine. A and B show centre and edge figures for the Zeiss lens, C and D show centre and edge figures for the Domiplan. Figures for the Canon lens are marked centre and edge

normal shooting outside scientific work, which might require precise measurements.

Unfortunately, the biggest single destroyer of lens quality is the photographer himself. Even the slightest quivering of the camera while the shutter is open will drastically reduce the sharpness of the image. If you are in any doubt whatsoever about your ability to hold your camera rock steady, then use a good quality tripod or rest the camera on some solid support. And use shutter speeds of 1/125th sec and faster. Do note, though, that once you are aware of camera shake, and take sensible precautions to prevent it, you can take perfectly satisfactory photographs at slow shutter speeds – even 1/8th sec with both camera and yourself firmly braced.

Over-exposure tends to reduce the apparent sharpness of a lens, by exaggerating the grainy structure of the film (though modern films such as Ilford's XP1 and Agfa's Vario-XL suffer much less) and obliterating fine detail. Under-exposure, allied to an increase in apparent contrast of the image, will appear to enhance the sharpness.

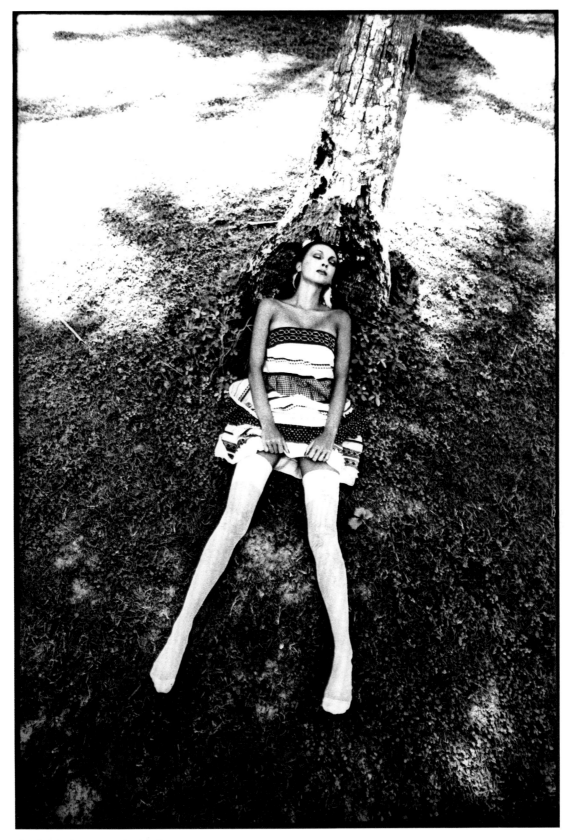

The 24mm lens accentuates the
length of Marie Helvin's legs,
creating an elegant fashion
picture. Tahiti, for Italian Vogue,
Olympus

Lenses and colour

When it comes to colour rendition there are two considerations. A lens may display a distinct colour shift: it may produce an image more cool (blue) than the original scene, or it may be warmer (redder) than the original. Minor errors of this sort are easily taken care of in colour prints, as the imbalance can be corrected by filters in the enlarger when printing. But for transparencies you will need to correct with a filter on the camera lens, or by using a film which exaggerates colour in the opposite direction. For example, some photographers find that Kodachrome films give a somewhat cool (not unpleasing) colour rendition, while Agfachrome 50S has a reputation for being rather warm, though again not unpleasing. Perfect colour rendition, overall that is, is really quite rare: films made for professional use are more accurate than those the hobbyist buys, but they have to be stored under refrigeration, and even then the professional will test a small sample of each batch to assess just how much 'off colour' his stock is.

The second potential fault in colour rendition has to do with those lens aberrations we spoke of earlier. Chromatic aberration refers to the inability of a lens to bring differing wavelengths of light to exact focus at the same plane. And white light refracted through a lens splits up into its red, blue and green wavelengths. More often than not red is the culprit, and comes to a focus marginally distant from the blue and green wavelengths. To correct that involves a very expensive process, which is quite fully justified for the very accurate work needed in the printing industry, during high quality copying of art work for very high quality reproduction. A lens with correction for red, green and blue wavelengths is known as apochromatic. If yours is not, then don't worry – few are on the enthusiasts' market! But one which is apochromatic is the Sigma 300mm f4.5, and the diagram here gives an idea of just how this correction affects the lens performance and increases the image sharpness.

The bizarre patterning and unusual shape of this brothel ceiling in Bombay are given more impact by the use of a 28mm lens on an Olympus

Sigma lens graphs

Apochromatic correction brings red, green, and blue colour wavelengths to focus much closer together than in an uncorrected lens. The result is a sharper image – as indicated here in graphs showing lines per millimetre resolving ability of Sigma 300 and 400mm apochromatic lenses. Particularly, the 300mm lens holds its resolution capacity extremely well across a 35mm negative: the thick line indicates central resolution, the thin line shows edge resolution. Compare these resolution figures with those of the Zeiss Planar 50mm f1.7 lens, shown on page 42

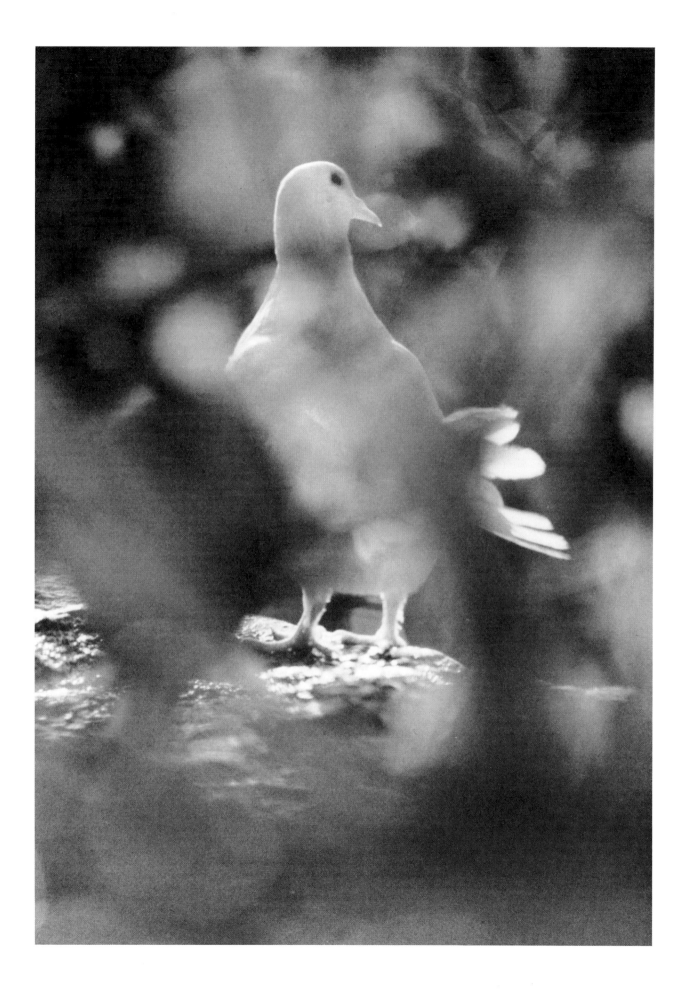

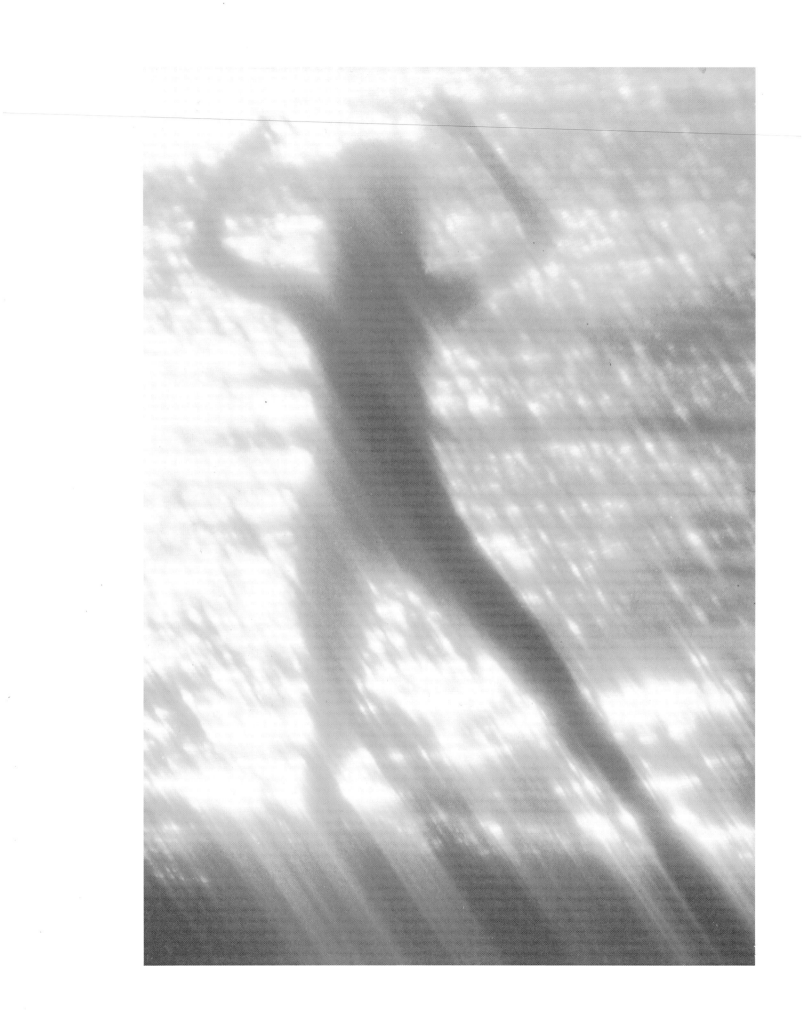

The surreal juxtaposition of
these two images in Goa was
achieved with a normal lens on a
35mm Olympus

The view of David Bailey's darkroom shows the layout of the wet and dry benches

Printing and enlarging

If you never see one of your own photographs blown up really large, you will never know how good a photographer you are. Size impresses, and not just because of all the extra detail it brings to the attention. Looking at a big enlargement is like looking out of a window – there is a sense of being there, a much more realistic impression than is possible when viewing a small enprint from a commercial processing house. It is no mere extravagance that makes the professional photographer present his clients with pictures of at least 15 x 12, and often 20 x 16 inches: he knows that the size of the image will bring its own persuasive power, and his client will probably approve the job straight away. Few professionals ever show their contact prints, those tiny pictures the same size as the negative, to anyone. Instead, they make proof enlargements of a few of the best, for the tiny contact is merely a guide for the photographer himself, his blueprint from which the finished product will be constructed, and it has to be read with understanding.

The easiest way to view your own pictures in giant size is to buy a projector and shoot only colour transparencies. Even in quite a small room you can project images several feet across. But the image on a screen is not permanent (though it can be put back there any time, as long as the room is dark) and it suffers from one serious drawback: once a transparency has been processed, little can be done to improve or dramatize the image. It is possible to sandwich more than one transparency together to produce some unusual effects, and any transparency can be copied, and can be cropped (a portion of it being enlarged). But those are limited influences; they do nothing to alter the strength of the tones, the inter-relation of the colours within the picture. Printing from negatives (or from transparencies) allows those controls and more. Once you opt for darkroom work as part of your hobby, you open very wide indeed the door which admits choice – choice exercised by you over how the finished picture will look.

Do not let the idea of a darkroom put you off; you can easily set yourself up for home printing in quite a small space, as small as three or four feet square with care and planning. And the space does not have to be black all over; what is important is that it can be made light-tight. If you do not have such a corner at home, you could use the bathroom or the kitchen, draping the windows with black plastic sheeting when you want to make prints. At least these rooms will have a water supply, which you will need for washing prints. Modern enlargers are made in very compact sizes, and it is even possible to fold them away into a unit not much larger than a briefcase, so you can persuade the family you will not be permanently taking over any communal territory.

Plan of a typical darkroom

From the top downwards: enlarger, developing and fixing trays, safety light, tray for washing prints, rubbish bin, blacked-out window; sink on right

Contact printing

Before you begin thinking about enlarging, you really should tackle contact prints. Not because they are an end product in themselves, but because they are invaluable in guiding your decisions as to how various negatives should be treated. If you intend printing from colour transparencies you could begin straight away; however, contact prints are still a good idea, for a projected image, or one examined in a hand viewer, will almost invariably show a greater range of tones than a paper print, and it is as well to check by contact printing just how much of a transparency is likely to reproduce satisfactorily. But you would need to do that before the strip of transparency film is cut up into individual frames for mounting: the job would be much too fiddly otherwise.

Photographic printing paper works in the same way as film, and colour paper has three sensitive layers of emulsion, black and white paper has one. The paper emulsions also contain silver halides, though their sensitivity is many thousands of times less than the film emulsions. The processing stages of paper and film are broadly similar too, and time and temperature are again critical – less so for black and white papers, some of which can be manipulated (mainly for contrast control) like the negative.

To begin with, making only contact sheets, you will not need an enlarger. And any light source will do, as long as you can control the intensity (perhaps by moving the light) with which it falls on your paper, and the duration of the paper's exposure to it. Since paper, even though relatively slow, is still sensitive enough to be fogged by room lighting, you will need to work only by the glow of a special safelight. The best kind is one which allows you to slot in different coloured filters, to suit the sensitivity to coloured light of whatever material you are working with. An orange or red light is fine for black and white work.

To make your contact sheet you will need some 10 x 8 inch paper, a piece of plate glass or a proper contact printing frame – a good investment if it prints reference numbers on the paper, and provides a space for identification details. You will also need developer and fixer, and two trays in which to process the paper; as in film processing you may wish to use a stop bath to halt development (it also helps prolong the life of the fixer) and you will then need a third tray.

By the glow of the safelight place a piece of printing paper on the table, or in your contact printing frame, and arrange the negatives on top of it, in strips. Either close the frame, or place the plate glass on top of the negatives: they must lie absolutely flat, in contact with the paper. Now make the exposure, by turning on a bright light for a few seconds (trial and error will help you get it right). At this stage put the paper into the developer, emulsion side down, to soak the emulsion quickly, avoiding uneven development. Immediately turn it over, and begin gently swishing the developer around – rock the tray, use your fingers, or get special print tongs. After the appropriate time, which is usually about two minutes, transfer the paper into a water rinse (or the stop bath) and from there, after a few seconds, into the fix bath. After fixing, wash and dry.

A colour contact sheet is made in the same way, though the processing is as for colour negatives, and you will probably not be able to use the safelight – paper manufacturers advise which lights, if any, can be used with their materials.

Whatever you do, do not imagine that what you see on a contact sheet is exactly how any picture will appear when enlarged, for printing allows great control. In black and white you can change the shape of the picture, the contrast, the density, and in colour printing you can do all that plus altering the colours, for you then print through filters. Once you get to know what is possible in the darkroom you will be able to 'read' a contact sheet and assess what to do to produce the result you want. And you will even be able to change the content of a picture.

Enlarging black and white

You need an enlarger to begin making blow-ups, and it is as well to get one at the outset which will handle both colour and black and white printing. As long as it has a filter drawer, or some other way of putting coloured filters into the projected light beam, it will handle both; without a filtering facility of any sort you will be limited to black and white printing. A few models can be adapted for colour later – but check before buying.

An enlarger can easily cost as much as a first-class camera, and it will affect the end result just as much as the camera does. If it is too flimsy it will shake and quiver, causing blurred prints; make sure the column, on which the working parts are mounted, is as sturdy as you can afford. The illumination source may vary a good deal, the cold cathode type being much favoured by professionals since it delivers a less harsh effect than condenser illumination – another popular type, especially suitable for maintaining maximum contrast. The trouble is that untamed contrast can produce prints on which every tiny blemish, scratch or dust spot on the negative is enlarged bitingly crisp, and that means laborious retouching. For home darkroom work a less complex diffusion illumination system is usually employed, sometimes with an opal tungsten lamp shining straight through one or two condensers, sometimes with a tungsten halogen lamp bouncing its light output off the inside of a matt white 'diffusion box'. We shall probably have a variety of enlarger light source arrangements with us for many years to come, since they do affect the appearance of the image. But from there we move into an area in constant change.

The basic principle of enlarging is that you project a negative image onto a piece of paper, and the image becomes positive when the paper is developed. It is the reverse of what

This 2¼ inch square picture of
Kirk Douglas was printed on a
contrasty paper with the use of
a cold cathode enlarger

A tungsten enlarger was used to give stark, high contrast to this photograph of a Kumbi tribesman, Goa, shot on Tri-X 35mm film

happens in your camera, where the lens projects a positive image onto a piece of film in the camera, which becomes negative when the film is developed – or positive following the complex processing of colour reversal film which, remember, first creates a negative and then a positive image following second exposure and second development. To do its work your enlarger head sends an image of the negative through a lens, onto the baseboard, on which lies the printing paper – preferably held steady and flat in a proper enlarging easel. The lens can be stopped down, to control the intensity of the light, and the enlarger's on/off switch controls the time for which the light falls on the printing paper. This is the traditional way.

But things have a habit of developing rather speedily, and the basically simple enlarging process is now subjected to improvements – electronic and otherwise – almost as rapidly as new camera models follow each other. In black and white printing, it begins with contrast.

When the printing paper has been exposed in the enlarger's light beam it is processed just as is a contact sheet. In theory, there is one precisely accurate time for which

conventional paper should be processed, a time which gives a 'fully developed out' image. But photographers are resourceful people, and they have long 'snatched' or 'cooked' the paper – shortened or lengthened the developing which, coupled with slight adjustments in the exposure time, affects the density and the contrast of the image. Control here is every bit as available as when processing negatives, and made much more flexible by varying grades of contrast in the paper. Though not all manufacturers provide the entire contrast range, there are traditionally seven grades, with 0 representing low (compressed tonal range) and 6 representing high, or hard (extended tonal range, and readily producing prints of pure black and white, usually with sacrifice of some of the grey tones in between). The variety of grades allows you to combat excessively high or low contrast in negatives: a very harsh negative will print acceptably on a soft (low) paper grade, and vice versa.

This traditional system of choosing the degree of contrast desired, simply by selecting the appropriate grade of paper, remains very much in use. But to take full advantage of

it the photographer has to buy boxes of paper in all grades – unless he is consistent in his camera work and negative processing, and can guarantee that all his negatives will print satisfactorily on one grade, or at most three, every time. Of course, such precision is relatively rare, and there is still much snatching and cooking of paper, even in professional darkrooms.

To solve the problem, Ilford came up many years ago with Multigrade, Kodak with Polycontrast. They are variable grade papers. Progress in their technical development was shelved for a long time, but Ilford are now committed, and aggressively, to exploitation of Multigrade. A variable grade paper has coated upon it two layers in one of emulsion (for black and white printing), part of which is sensitive to blue in considerable degree, the other part to green – the blue sensitive halides being capable of delivering a high contrast image, while the green sensitive halides offer a much lower contrast. By using filters to control the blue or green content of the enlarger's light beam the contrast is thus varied, each part of the emulsion reacting to a greater or lesser degree.

Ilford produce a filter pack which will give seven contrast grades with Multigrade; but they also offer a special enlarger head with built-in filtration which stretches that to nine grades. And does this all-in-one paper really solve all the photographer's problems? For many it does, since it certainly aids economy, and print quality is good; but conventional printing is still held by seekers of ultimate quality to yield the

Examples of different results with various filters and grades of Ilford Multigrade papers

very best tonal range in black and white printing. And Ilford cater for those perfectionists too (as do other manufacturers) with an especially luxurious paper known as Ilfobrom Galerie. It is fibre based; that is, it is not the resin-coated material which has latterly become so predominant (very quick drying) but is conventional paper, though with a very fine emulsion, and is offered in three grades. But Galerie's recommended developing time is between 1½ and 2 minutes, giving plenty of opportunity for fine control in the contrast department.

So – there is no best. There are merely different ways of printing, for different needs. And when you realize that it is a simple matter to tone black and white paper the most delicate shades (sepia, well done, is a joy) you will see that in no way is the monochrome printing process lacking in creative and aesthetic alternatives. There are even papers available which are already toned – in vivid colours for startling effects, and in silver for subtle impressions. There is also linen, coated like paper, on which you can print images for highly personalized tee-shirts, lamp shades, dresses.

Enlarging colour

Colour enlarging is, by the very nature of the three-layered emulsion involved, more complex than is black and white. But – and it is a very big but – giant steps are being made to simplify it. To understand the impact of those steps, let us consider a recent development.

The development is one being pursued by several companies, and it is one which involves both Kodak and Polaroid Instant picture materials for colour. Even at this stage, the development offers a degree, though limited, of enlargement onto Instant material. We shall look at the Polaprinter Type 100 slide copier; in its way, it could be the most important new product to be introduced in recent years (it was first shown during the Photokina trade fair in 1980).

For a very brief moment, let us dwell on some background to the potential impact of the Polaprinter 100. As recently as a dozen years ago it was quite common to enlarge black and white negatives by placing the negative at one end of a box – about shoe box size – and a piece of printing paper at the other end. Between negative and paper was a fixed lens, which enlarged the image by a fixed degree, to postcard size. All the user did was shine a light through the assembly, and then develop the paper. It was an easy matter, by trial and error, to work out the exposure required; and it was just as easy to work out where to hold a small flash unit to provide just sufficient light for a good exposure, consistent every time. This very simple postcard enlarger was greatly popular, simple to use, and fell into disuse only as enlargers became ever more available at reasonable prices, and as swelling affluence led to more of us having more space at our disposal, in which a small darkroom could be constructed. Now back to the Polaprinter 100.

It is a table-top unit, about a cubic foot in bulk, and

provides an Instant colour enlargement from a 35mm transparency. Exposure is by flash, and exposure assessment is electronically, automatically, controlled, though there is a lighten/darken control of the kind on Instant cameras. The user is able to adjust the contrast he requires in the enlarged print, and he has a limited degree of control over the cropping of the image. Virtually no photographic experience is required to operate the unit: pressing a button sets it in action, and the print, made on Polaroid Instant film pack, is removed from the machine in the same way a print is pulled from a Polaroid camera using the peel-apart process. Black and white and colour enlargements can be made, but the size of enlargements is controlled by the film pack, at 3¼ x 4¼ inches (Polaroid Type 668 and 665 film packs).

So, the Polaprinter produces what are essentially enprints – similar to the prints millions of hobbyists get when they send negative film to be processed by a professional laboratory. But even those are acceptable, and there are many potential uses, not least for book designers and graphic artists. The Polaroid machine (at least the original model) is not intended as a hobby product, though a modified version, at a more reasonable price, could easily become so. However, the principle of Instant enlarging, and in colour, has been proven; and the very high quality of Instant prints of 20 x 24 inches is discussed elsewhere. Add to that handful of facts the information that Kodak has for some time been working on an Instant paper for darkroom work, to be used with ordinary enlargers, and you will appreciate that we are on the verge of a revolution in the way we do things. Few will wish to splash around with chemical solutions, and under time and temperature restrictions, when Instant enlarging is a reality.

It cannot be emphasized too much that the events which take place in conventional (as opposed to Instant) enlarging between the photographer lifting his exposed paper from the enlarger baseboard and examining the finished print are routine, mechanical, and allow very little, if any, scope for influencing the appearance of the image. What does introduce influence is (for colour and Multigrade enlarging) the arrangement of the filters the operator inserts into the enlarger's light beam, and for how long he allows light to shine onto the paper, coupled with whatever he does in the way of dodging, shading, double printing. And all the while any enlarging system allows such controls, it will continue to be used by perfectionists in preference to one which does not.

Controlling colour

The manufacturers of printing paper and chemicals supply detailed instructions for processing, and provided you observe the proper timings and temperatures it is a foregone conclusion that you will produce a result. And the consistency of results will be all the more assured if you invest in one of the drum processing systems, which are designed to use

relatively small amounts of solutions, and to make it easy to maintain them at proper temperature level. Drum processing, with the exposed paper contained within a light-tight drum (as film is contained inside a developing tank) allows you to work in ordinary room lighting once the lid of the drum is in place. Another worthwhile buy is a ring-around chart, which is a mosaic of colour prints – with a perfect result in the centre, and examples of slightly varying colour drifts radiating from it – and which helps you identify what adjustments need to be made in the arrangement of your filter pack when colour printing. The manufacturers naturally make these charts in relation to their own materials, but Kodak do a particularly informative kit.

As you will realize, colour processing is a bit like cooking: follow the recipe and you cannot go wrong. But a cordon bleu cook will produce pure magic against someone else's pedestrian offering, because of the little touches he or she introduces. And the quality of your printing results will depend on how you exercise the controls available to you before you begin processing the exposed paper.

The first control you have is in composition, the way you crop the image to fit it onto the paper. And there we run slap into solo flying. Nobody, absolutely nobody, can teach you how to compose a picture, any more than you can be taught how to write a great symphony or a four-line poem. You are on your own. Everybody reacts to different shapes in different ways, as there are people who love the mountains, others who are distinctly uncomfortable when they leave the city behind. What does matter is that you should approach your compositions with simplicity as your aim. Do not go in for odd picture shapes; compose your images, for greatest acceptance, within a pleasingly proportioned rectangle of, say, 5:4 proportions. Outside those shapes you move into the unusual – and it is easy to go so far that the shape itself will obscure the message of your picture. That message ought to be simple too. Do not try to make each photograph a volume of suggestion: go for a straightforward and simple impression – put one powerful idea into your pictures and leave it at that. And the fewer the design elements of the picture, the easier that will be. Crop away anything that is incongruous or distracting near the picture edges; bludgeon your viewer with what you believe to be important and ruthlessly trim away whatever is not – no matter how pretty the extras may be.

The weight of your picture, in tonal values, is an important influence: a dark picture will produce a different impression from a light one. And that control is effected by the exposure time. In black and white and colour negative printing you can control small areas of the print, making them proportionately darker, by giving more exposure, lighter by giving less exposure. Those techniques are respectively referred to as burning in and holding back.

Burning in is most easily done by using only your hands, cupping them into whatever shape is required to cover the area being treated, but it is a good idea to make a series of

To retain detail in this Kumbi woman's dark skin tones, her face was 'dodged' or held back during printing. Olympus 35mm, with direct electronic flash

In order to make already dramatic lighting even more striking, the billowing clouds have been emphasized by burning in during printing

cards with different shaped holes cut into them, through which light can pass to burn in oddly shaped areas.

A bald sky can be treated by a variation, or extension, of the burning in technique, by first preparing a piece of card as a mask, cutting it into the shape of the horizon. Next print the main part of the picture as normal, then cover up the printing paper (use the enlarger's built-in red filter when printing in black and white) while you remove the first negative and replace it with one which does show a good sky. Make sure the paper is not moved during all this, or the two images will not be in register. With the second negative in place now begin a second exposure, placing the mask over the paper in such a way that the already exposed area is protected, and only the sky area is now burnt in. Keep the mask either a little way from the paper, or constantly in motion, to blur its hard edges. You can combine any other elements in this way too. But burning in is more often used simply to make darker any little area of the image which would be too obtrusive if left light in tone. Backgrounds are often vignetted – in other words, given a dark halo around the edges of the print – by burning in.

Enlarger beam with mask, which can be used to stress cloud detail. The mask can be raised on matchboxes to prevent hard shadows, or held and moved slowly to and fro

An evening shot of Cezar, with fill-in flash and careful printing to retain detail. Rolleiflex

Holding back is quickly done with the hands also, but here again you can make some tools to help. One particularly useful one is nothing more than a wodge of cotton wool on a piece of wire: the cotton wool can be teased into any shape to suit the area requiring treatment. You will occasionally find you need to hold back a face in a picture which has been slightly underexposed, the thin negative being very liable to render the face too dark.

Burning in and holding back are hugely effective techniques and can entirely alter the impression a print gives. But their use should not be proclaimed by unsightly slabs of light and dark tone: the burning in and holding back should be done in such a way that the doctored areas blend smoothly with their surroundings – and there's the magic the cordon bleu cook brings. The ability to mould your hands or fingers in just the right way to affect a certain area, the ability to avoid hard edges between tones, and the wit to recognize when enough is enough, are as valuable to you as the most expensive piece of photographic equipment, for these are the abilities which bring the image entirely under your control.

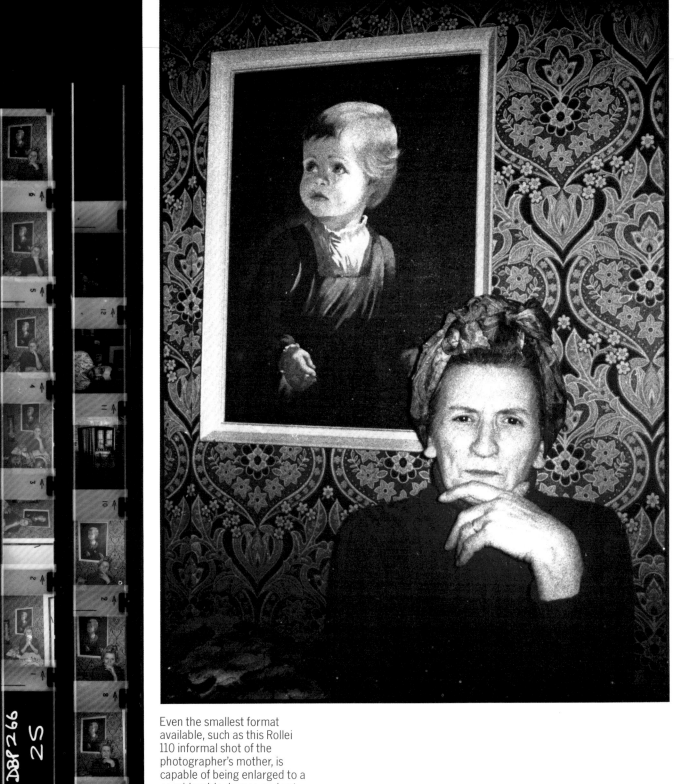

Even the smallest format
available, such as this Rollei
110 informal shot of the
photographer's mother, is
capable of being enlarged to a
considerable degree and yet
retaining sharpness

Formats

There is no single correct answer to the question 'What's the best camera?' Different models have evolved in response to varying needs, but one factor which has had perhaps more influence than anything else over camera types is format, or film (or plate) size. A camera which produces tiny negatives, as do the little 110 size pocket models, would be quite useless for the sort of picture required by, say, a jewellery maker who wants to advertise his products in a high quality glossy magazine: he would want pictures showing his products larger than life and full of the crispest detail. Equally useless would be a huge and bulky studio camera if you were off to record an expedition to the top of a mountain.

The various needs have long since been identified, of course, and today's camera maker sets out to design his equipment for use in specific fields. Thus, he adds, or leaves out, certain features because he knows full well whether or not they will be required. For example, the motor drive which the sports photographer considers necessary has no place in the studio where a large format camera is used to photograph unmoving objects; yet a studio photographer may well use a motor drive if he is shooting a fashion model, and wants to keep the session moving along at a very fast pace, in which case he will work with a 35mm SLR camera, or a 2¼ square model such as the Hasselblad 500EL/M or Rollei's SLX with its motor drive operation built in.

When Fox Talbot, the father of modern photography, produced his first negatives in 1835 he did so with very tiny cameras and lenses of short focal length (he used simple microscope lenses), and his negatives were about an inch square. Since enlarging was not yet practised, Talbot's earliest pictures were made by contact printing; you can imagine that a picture of only one inch square contained precious little detail. To get more detail required a bigger piece of paper (he used sensitized paper for his negatives) and that in turn required bigger cameras – an easy enough job for a carpenter. But lenses have an important limitation – their covering power. A lens throws a circular image which is brightest and sharpest within its central area, rapidly falling off in both those qualities towards the edges of the central area. There comes a point at which both brightness and sharpness are considered not adequate for photography, and the lens can only be used

successfully with a piece of film which fits inside the acceptable limits of brightness and sharpness. Thus, the lens may cover a piece of film of one size, but not – with acceptable results – film of a larger size. Talbot therefore had to change his lenses too, in order to cover his larger negatives. But you will still see many vintage photographs with dark vignetting around the edges, caused by lenses of inadequate covering power for the plate size used.

It is obvious that a lens designed for a very large negative will function well enough with a small negative; but a lens designed for small negative work, such as 35mm, may very well fail to cover any negative size that is larger. Indeed, it would make modern 35mm photography lenses a good deal more expensive if manufacturers were to make their useful covering power significantly greater than is required to cover a circular area of 1½ inches in diameter, since that is the dimension of the longest side of a 35mm negative. Notice, by the way, that the covering power of a lens has very little to do with whether the lens is of wide angle or telephoto design. Professional photographers will often use a lens designed for one film size larger than that with which their cameras are loaded. This is because a professional's studio camera has movements which allow the lens to be moved off its axis, and which therefore also shift, on the film plane, the location of the area of acceptable covering power.

Size of negative

You can see that, early in photography, it was the need for the bigger negative, or glass plate, and its detail-recording capacity which led to bigger cameras and specially designed lenses with great covering power. Portraitists such as the much respected Julia Margaret Cameron worked with huge glass plates of 15 x 12 inches, well over 1000 times more negative area than is provided by those modern little Minox cameras, the sort of spy camera you can see in James Bond movies.

Starting from those huge negatives by Mrs Cameron and her contemporaries, the continued progress of miniaturization has taken us to the 8 x 11mm negative of the Minox, and the hardly much larger 12 x 17mm of the hugely popular 110 cameras. But so much has film emulsion been improved that a

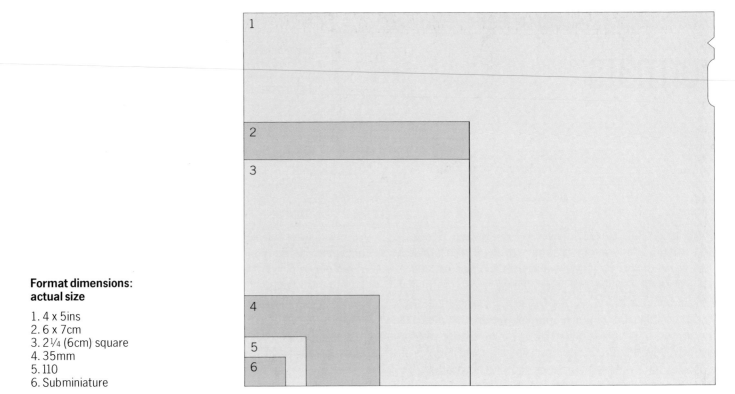

**Format dimensions:
actual size**

1. 4 x 5ins
2. 6 x 7cm
3. 2¼ (6cm) square
4. 35mm
5. 110
6. Subminiature

negative from a modern 35mm camera is capable of giving more quality, by enlargement, than one of Julia Margaret Cameron's plates could provide by contact printing. Why then doesn't everyone use 35mm? Because the improvement in film has not been limited to 35mm. And it is plain that if there is a limit to how much a 35mm negative can be enlarged while offering satisfactory image quality, then that limit can be exceeded by a negative larger than 35mm – say one of 2¼ inches square (120 film), or of 5 x 4 inches, and so on. The great American landscape photographer Ansel Adams makes many of his pictures by contact printing from 10 x 8 inch 'plates' – or sheet film, since glass is not used today – and the detail and quality are superb.

It is important not to be persuaded into thinking that bigger is automatically better where negatives are concerned. The very latest films such as Ilford's XP1 will yield a satisfactory enlargement of fifty or more times: that is, a print of 4 x 6 feet from a 35mm negative. But degree of enlargement available is not the only criterion to be considered when discussing formats: shape of the negative is another, and whether or not you want to retouch the negative, also the features you want from a camera.

The smallest available negative today is the 8 x 11 format of the Minox camera, a size which is beautifully in proportion with the A4 document size; that is the size used for typing office memos and inter-company letters – which, you might think, makes the Minox a natural for industrial espionage. The 12 x 17mm of the 110 camera's negative is also a nicely proportioned size, and perfectly suits the needs of the

majority of its users, who simply want laboratory-produced en-prints of suitable size and shape to fit either album or wallet. In contrast, being more elongated, the 35mm negative is an ungainly thing, with its 1:1½ dimensions.

Though it is 35mm film which is used in the commercial cinema, and which puts those giant pictures up there on the screen, each frame is actually turned on its side, and represents only half the size of the 35mm negative of still photography. Thus, a cine frame is 18 x 24mm instead of 24 x 36. But that change in dimensions also brings about a change in proportion, from 1:1½ to 3:4, altogether a more aesthetic shape, less long and thin. When the 18 x 24mm size is used in still photography it is known, for obvious reasons, as half frame. Unfortunately, the many cameras once made for that format have now vanished, and Olympus is the only maker now producing a model for the popular market. But the format is still much used in a rather specialized way, for micro-filming, photographing documents and book pages on a much reduced scale for storage; very much smaller than half frame copies are also made, modern copying films having a very high capacity for recording and reproducing fine detail.

The 35mm format is most often seen in its 'raw' state in transparency form; projection screens are tailor-made to suit it. Mostly, a slide show consists of a series of 35mm transparencies in the horizontal, or landscape, format, so that the longest side of the picture runs from left to right. When 35mm pictures are reproduced upright, or vertical, they are in the portrait format; mixing formats in a slide series leads to an uneven and jumpy impression.

The 5 x 4 inch format is more often used in the studio for still-life work, but is occasionally suitable for portraiture when a high acutance, grain-free image is required. Fashion designer Ossie Clarke, for Ritz, Cambo

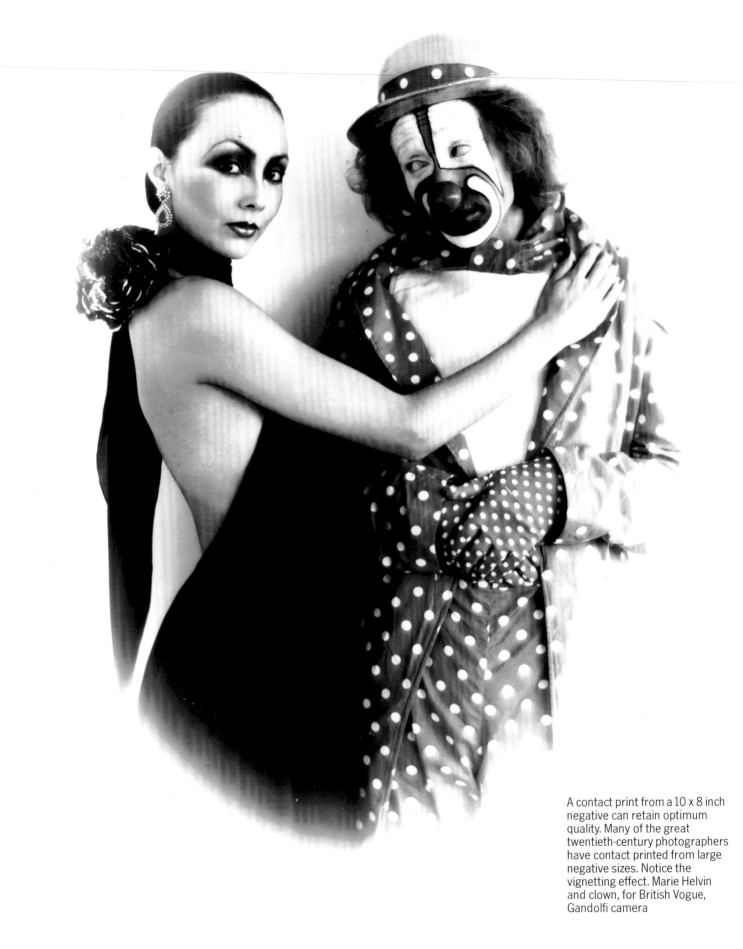

A contact print from a 10 x 8 inch negative can retain optimum quality. Many of the great twentieth-century photographers have contact printed from large negative sizes. Notice the vignetting effect. Marie Helvin and clown, for British Vogue, Gandolfi camera

The half-frame format, which gives 72 exposures on a 35mm film, has never been immensely popular but is particularly suitable for rapid-fire snap shooting. Penelope Tree (centre) and John Swannell (right), Turkey, Canon Dial camera

Interestingly, there are no photographic printing papers made in exactly the same proportions as 35mm negatives. The popular paper sizes (though a move is afoot to have us all using metric sizes, and it will happen) are 10 x 8 inches, 15 x 12 inches, and 20 x 16 inches: proportionately, they represent a ratio of 5:4, which is the film size, in inches, most often used in professional studios. The professional can thus enlarge the entire area of his negatives, wasting not one square centimetre of information-carrying film. When composing his picture before shooting it, he can do so precisely, knowing that whatever he visualizes can be reproduced.

Many photographers use nothing but 35mm, of course. The consequence is that they must fit their pictures onto the existing paper sizes, leaving some paper area uncovered, otherwise they must crop their pictures when enlarging them. There are not many books or magazines printed in the 1:1½ ratio, so that invariably either the 35mm photographs are cropped for publication, or the designer has to leave a certain amount of white space on the page. This ultimate alternative of cropping will obviously much influence the 35mm photographer when he is composing his pictures in the viewfinder of his camera. Some, like the legendary Frenchman Henri Cartier–Bresson, insist their pictures must never be cropped for reproduction, and they always print the entire area of the negative; as you may imagine, that creates headaches for magazine and newspaper designers, and sometimes precludes altogether the use of uncroppable 35mm photographs. It must be said here that probably the majority of photographers, both hobbyists and professionals, are fully prepared to crop their 35mm pictures, for the world does not come conveniently packaged in views of precisely 1:1½ proportion, and it is rather precious to insist that it does.

Flexibility

The 35mm format has one supreme quality, a facility which is unchallenged by any other format capable of very high quality reproductions: it is the portability of the equipment involved. A single lens reflex 35mm camera with standard lens weighs little over a pound, and slings easily around the shoulder. Adding a couple of spare lenses, or one zoom encompassing several focal lengths, adds not much more in weight, so it is possible to go off on a day's arduous hiking, or news gathering, without fear of becoming exhausted or ending up with a drooping shoulder. Also, 35mm cameras are exceptionally easy to handle in any circumstances, and can be used in very low light without the use of a tripod, which might be required by bulkier instruments. These advantages far

The 35mm format has long been a favourite with amateurs and professionals alike. For the latter it is especially useful when shooting live figures and action. Bridal wear, Olympus

outweigh the minor disadvantage of the awkward negative shape – a shape born, remember, of convenience during Oskar Barnack's experiments which led to the first 35mm camera, the Leica. And by cropping just 3mm off the left and right extremities of his negative the photographer can bring his 35mm images into that 'popular' 5:4 ratio, while a relatively small degree of enlargement will still give him prints large enough for most purposes.

Especially flexible is 120 size roll film, the modern descendant of what the first Kodak camera was loaded with, a hundred years ago. Roll film in 120 size (and 220, same width, but twice as long and thus offering twice as many pictures)

has made other roll film sizes all but obsolete. The choice of formats offered by it, and hence the choice of differing possible camera designs, has kept it very much to the forefront as a sort of workhorse; it is such an adequate material in between 35mm and 5 x 4, being substantially larger in area than 35mm, but capable of use in cameras far more portable than those designed for 5 x 4. In addition, many of the studio view cameras which will accept 5 x 4 film, and other sheet film sizes, may also be fitted with a roll film back, which allows the use of 120 film with cameras featuring sophisticated movements for influencing the appearance of perspective and sharpness.

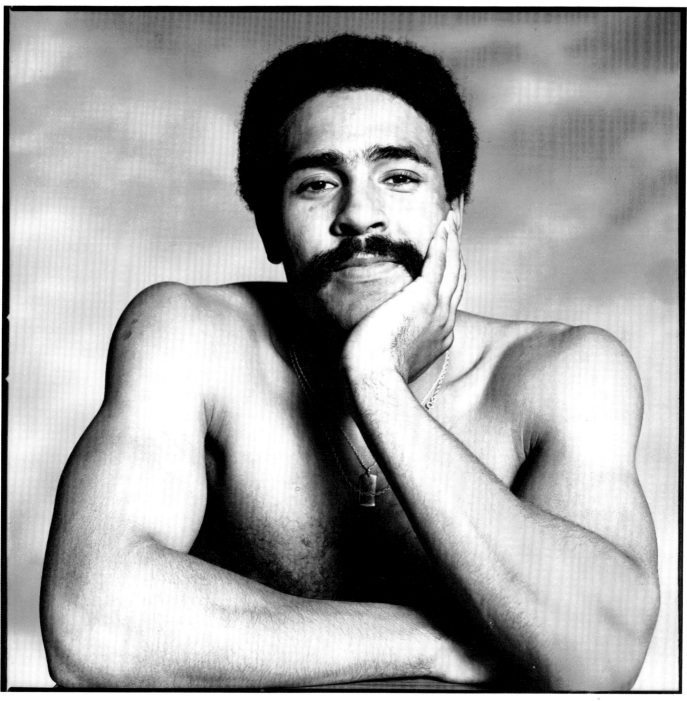

The 2¼ inch square format, though generally more cumbersome than the 35mm, still provides many of the benefits of roll film format and has the advantage of technical superiority, making it particularly suitable for professional work. Daley Thompson, for Ritz, Rolleiflex

The width of the negative in the four formats made available on 120 film is always approximately 2¼ inches, marginal variations being due to differences in camera manufacture. But the negative's other dimension may be 1⅝ inches, 2¼ inches, 2¾ inches, or 3¼ inches. In photoparlance, metric style, those negative sizes are referred to as 4.5 x 6, 6 x 6, 6 x7, and 6 x 9.

In recent years the 6 x 7 and 6 x 9 formats have been developed to combine the advantages of the larger negative size with a height to width ratio that ties in more closely with magazine page formats, eliminating the need to crop. Alan Parker, private shot, 6 x 9 Horseman camera

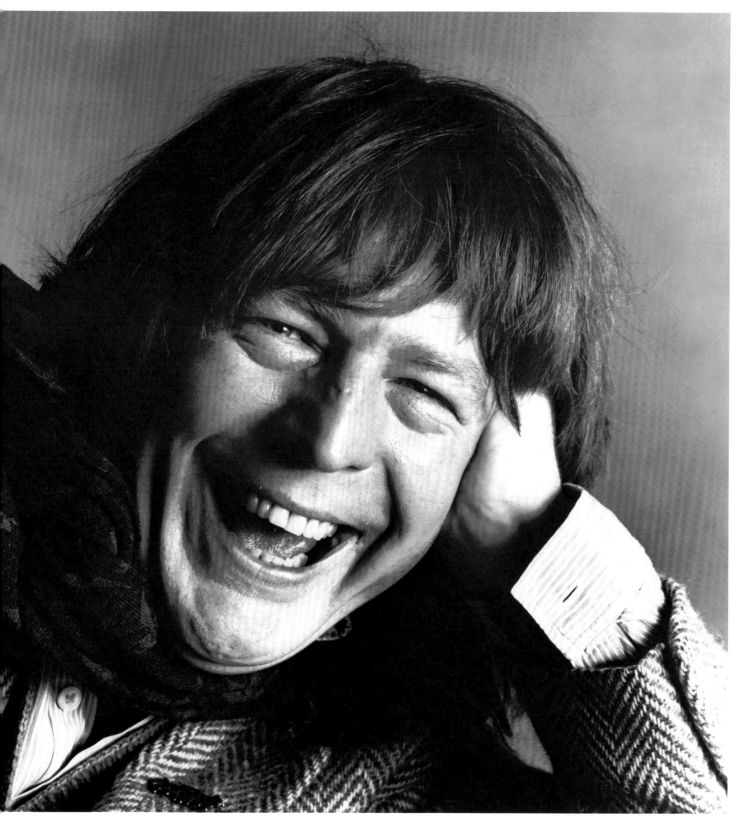

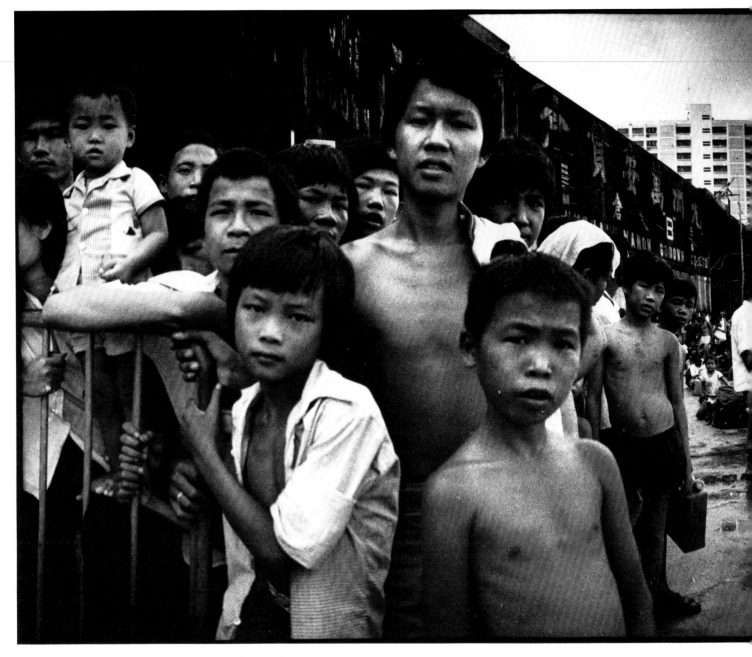

Panoramic cameras are used quite rarely and for most photographers they fall into the luxury category, but they can give striking effects, as in this shot of some boat people

The 6 x 6 format, popularized in professional studios by cameras such as the Rolleiflex, Hasselblad and Mamiya, was for a very long time the supreme roll film size. But while the square negative allowed great flexibility when it came to cropping the image during enlargement, it suffered one serious drawback: the problem was, once again, ratio. For rarely are pictures printed in square format, except perhaps on LP covers, and this meant that a quite large percentage of the square negative area had often to be cropped away. Even so, the quality produced by the remaining area was, and is still, pretty staggering. However, at the end of the 1960s the Japanese introduced what they called the 'ideal format' – a negative of 6 x 7 size, measuring 2¼ x 2¾ inches, its extra size meaning that only ten such exposures could be produced on 120 film instead of the dozen provided by the 6 x 6 format.

The so-called ideal format has proved very popular, and there are several cameras of quite different design which provide it; most unusual is a scaled-up version of a 35mm single lens reflex camera, made by Pentax. But 6 x 7 is finding many outlets in studio work: enlarging the already big negative

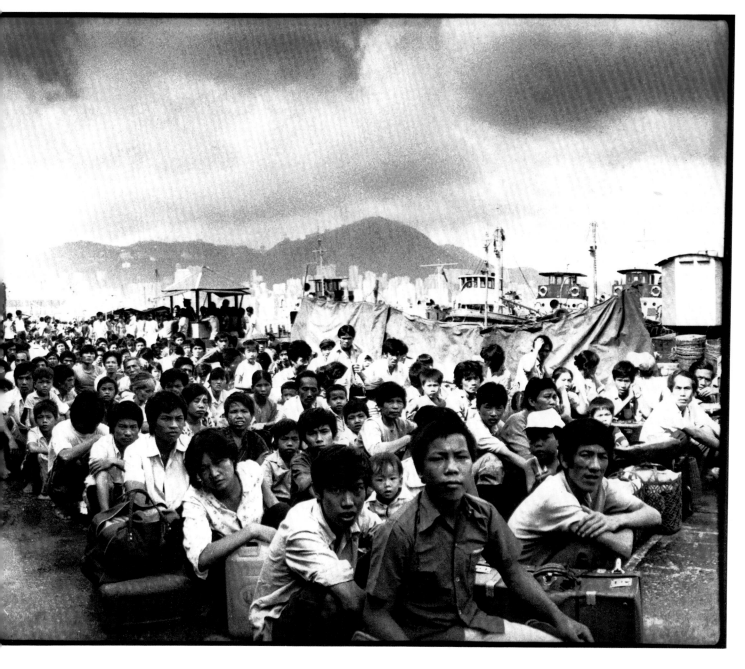

in a way which fits the pages of a magazine requires only a sliver of a mere few centimetres to be trimmed away from each of the long sides of the picture.

You will appreciate how the photographer's choice of format will influence him while he is composing his pictures on the camera's viewing screen. With one format he must be very much aware that a certain area of his negative is going to be dead – unproductive; with another format it will be another area he must prepare to lose, and so on. But loss begins to matter less and less as you climb the format scale. The logical

move upwards from 120 film is to the sheet film size of 4 x 5 inches, at which stage quality on enlargement is more than adequate for advertising posters: where the ultimate in detail-holding is required – as it would be in a photograph blown-up to cover a huge hoarding – the photographer will move up to 10 x 8 sheet film.

Sheet film, loaded into a special holder which slides into the back of the larger cameras used, invariably introduces a different pace to shooting – it has to, since it is a one shot at a time technique. The image is composed and focused on a

ground glass screen at the back of the camera, occupying the place which the film will occupy when everything is ready for the exposure. But it is the number of camera movements provided which really sets the view cameras apart, and which gives so much scope for compositions the roll film and 35mm models could not handle.

You will recall that every lens casts a circular image area, and that for sharp and properly exposed results the negative size in use must fit comfortably inside that circular area which represents the limits of the covering power of the lens. You will also recall that professional photographers use lenses designed to cover one negative size larger than the one they are using, which effectively provides a circle of covering power of large area. Using the various camera movements – there are four – allows the photographer to swing that circle of covering power all over his negative area without the negative protruding beyond the covering power; and that allows him to modify the shape of this subject, to alter its apparent position, to change the way his lens renders certain areas in sharp focus.

The 35mm SLR camera has its lens and its film plane fixed so that the film plane is precisely at a right angle to the axis through the lens: everything is squared up, and the lens axis strikes the film plane exactly in its centre. The studio view camera allows both planes, through the lens and the film plane, to be moved upwards or downwards, shifted from side to side, tilted forwards or backwards, swung from side to side so that the lens 'rakes' the scene before it, as a Hollywood gangster might rake his victims with his machine gun. In fact all this mobility has proved so valuable that there have been attempts to introduce it into 35mm photography, but it has proved feasible only for side to side shift, which also allows rise and fall when the mount of the lens is rotated through 90 degrees. Lenses allowing this control in 35mm photography are known as perspective control lenses. They are expensive and offer only limited movement.

Movements of the view camera give great flexibility for manipulating depth of field and perspective

Swing

Tilt

Shift

Accessories and technique

To a certain extent the accessories available for use with a certain format will persuade the photographer in his choice, especially since modern films in the small formats will enlarge to huge size, and cropping when printing still dictates the appearance of the final picture. For 35mm photography there is a huge range of add-on bits, some of which do come quite close to allowing the sort of flexibility the movements of the view camera bring. Let us look at just one example, which concerns depth of field.

Even when a lens is stopped down a good deal it will not produce an equally sharp rendering of objects very close to the camera, in the foreground, and in the distance. But the view camera photographer can make it do so, by using the tilting movement. If he arranges his camera so that the film plane, the lens plane, and the subject plane all intersect he will have sharpness all over the subject: to achieve this he only

has to tilt the lens panel forward. An approximation to that effect can be achieved when using a 35mm camera, by fitting a split field accessory to the front of the lens. This has a half of a close-up lens built into it, while the other half of the mount is empty. The accessory effectively changes the focal length of that part of the camera's standard lens which is covering the foreground, leaving the remainder unaltered. But here the photographer is rendering two separate planes in sharp focus, instead of rearranging things so that the subject plane is all in sharp focus, as the view camera allows; so the technique does not necessarily tackle all that the view camera can. However, the example serves to underline that choice of format has two criteria: the first is aesthetic and technical – will the picture need to look pinsharp to be appealing? – while the second is mainly technical, allied with convenience – will this or that format allow me to overcome certain problems?

Retouching is often necessary, at least in commercial photography. And if a photographer has to provide his client

with many prints (perhaps for publicity handout) it may be more time-saving to retouch the negative than to go through laborious and expensive handwork on each print. Such a circumstance would dictate the use of a large format, since the tiny negative of 35mm, or even 120 film, would not permit sufficiently accurate brushwork, and flaws would be greatly magnified on enlargement. Where just one picture is required, as for a press advertisement, it would be quite feasible to retouch the print, and the photographer may justifiably go for the portability and convenience of 35mm photography, especially if he is required to shoot the picture in some difficult location.

It is not necessary for every photograph to be so sharp as to show the pores on a face and every eyelash. Many a picture is deliberately produced to obscure detail, since what is required may be no more than an impression. It is possible to obliterate detail on any photograph, by printing it through some sort of texture screen, or by printing it very dark, or in excessively high contrast – so high that all the grey tones are lost, leaving only black and white.

Colour pictures are less often subjected to high contrast treatment, the detail-softening process usually being introduced by soft focus techniques, or by huge enlargement. And this appearance of the picture will be another consideration in deciding which format to use. By blowing up as little as an eighth of a 35mm negative or transparency you can produce an extraordinary image, in which the grain of the film clearly shows, resulting in a texture something like the pointillism of the French Impressionist painter Georges Seurat, though the effect remains thoroughly photographic, and is in no way (or should not be) an attempt to mimic the entirely different medium of painting. This is not a soft focus technique, but one in which the impact comes from the breaking up of the image; best results are got when a really sharp lens is used in the first place, so that the viewer is made aware of a crispness trying to peep through the veil of grain. To get the effect would be very difficult with anything other than high quality 35mm or 120 film equipment, with 35mm having the edge, and not simply because Kodachrome, a very suitable film for the technique, is available only in that format.

Film format is just one of many tools the photographer has at his disposal; in everything his choice should be dictated by one requirement – how he wants his pictures to appear.

Imagination is as important after shooting a photograph as it is before. This picture was printed in such a way as to include the partly fogged sprocket holes to give special effect

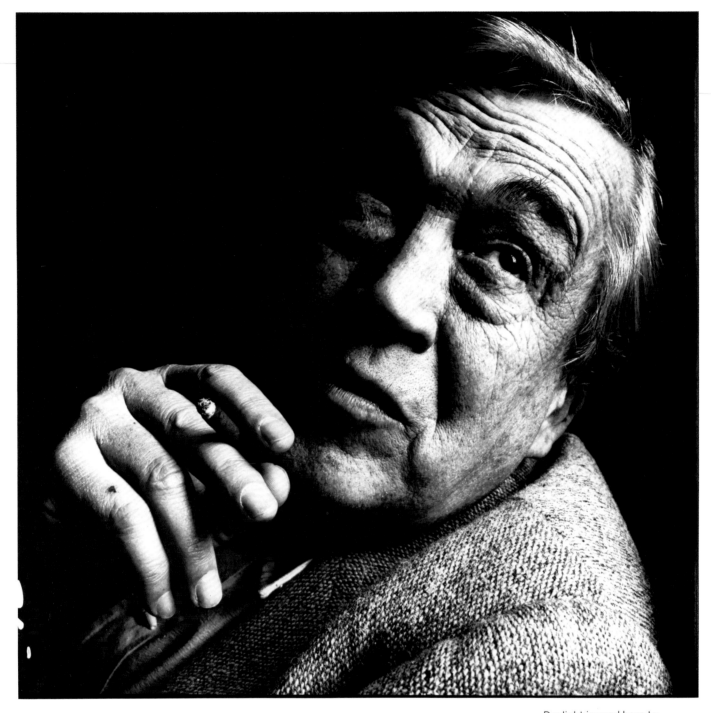

Daylight is used here to
emphasize the characterful face
of John Huston, for British
Vogue, Rolleiflex, 125ASA film

Portraits

There are two kinds of portrait – those which set out to flatter the subject and those which do not. And the difference between them is that to create one the photographer must be in control, to create the other the subject calls the tune. Even a flattering portrait can be a very impressive thing, for portraiture is not really about how good looking or otherwise a person is: it may have been so for a large number of the portrait painters of the past, and it may therefore have given us a less than accurate view of the people who made history, but even an aesthetically bad photographic portrait can be a reasonably accurate reproduction of what a person looks like. Generally, though, portraiture is most satisfying when the photographer plans the thing himself.

The minute someone in front of your camera says 'Hold on while I comb my hair' or 'This isn't my best side' you are in trouble: you have lost control, and what you turn out just will not be the unadulterated product of your own imagination – unless, that is, you quickly make it plain you are having none

of it. So, first of all, be very clear as to why any portrait is being taken. If it is merely a quick likeness for a friend's passport, or for any other of his or her needs, then you can without shame accept the role of button pusher and nothing else. But such portraits are seldom of any interest to anyone other than the two or three people involved in recognizing the map of the face the camera produces. If you want to make portraits which appeal to all, and which do not essentially matter for their success on recognition, then you will have to analyse what you are doing – and do it to your own plan of campaign.

Many a contemporary portrait photographer – and the critics too – will possibly confuse you with their insistence that each portrait should say something about its subject's character, his inner self. Yet the same people will happily accept a beautiful photo of a flower which depends only on the physical shape and colouring of the bloom. And does anybody talk of the inner spirit of the Laughing Cavalier, the Mona Lisa,

An informal snap-like 35mm portrait in a Japanese home setting. Olympus

Margaret Thatcher in a formal,
symmetrical pose, for British
Vogue, Rolleiflex

Another example showing the imprecise distinction between snap and portrait. Man on a sculptured camel, China, Nikon

even Rembrandt as seen in his self portraits? The Laughing Cavalier? His eyes follow you everywhere. Mona Lisa? Her smile is an enigma. And Rembrandt? There are warts on his face. All of those famous faces are familiar to us for a physical characteristic. Even Hitler's face comes to our recall as topped by a slicked-down quiff and decorated by a tiny moustache, not as a study in megalomania – which it becomes only when one is aware of history.

Portraits as caricatures

Portraiture with the camera has much more affinity with caricature than with character analysis. And if it seems true that certain physical characteristics do accurately indicate certain behavioural traits, then that is the result of evolution, of our seeking out certain behaviour to justify our beliefs, and of hindsight.

Confusion reigns in this business of the face telling the nature of the man. Nobody, it seems, is free from that confusion. Some years ago John Liggett, senior lecturer in

psychology at the University of Wales, wrote a fascinating book called The Human Face: in it Liggett made many telling observations, and quoted from endless sources, his aim always to expand his readers' understanding of the importance of the face and its expressiveness. Not surprisingly, Liggett found that Shakespeare had something to contribute on the subject. Macbeth says: 'There's no art to find the mind's construction in the face'. Straightforward enough; but Shakespeare does not leave it there. In the very same play others mouth Shakespeare's thoughts in these ways: 'Your face . . . is as a book where men may read strange matters' (Lady Macbeth); 'False face must hide what the false heart doth know' (Macbeth); 'There's daggers in men's smiles . . '. (Donalbain); 'We must . . . make our faces vizards to our hearts, disguising what they are' (Macbeth). So, even the understanding Shakespeare tried to have it all ways – now the face reveals everything, now it does not.

John Liggett, in a welter of illuminating argument, observes that 'modern research [into recognition of emotion] concentrates on moving film or television records . . '. What

have we here, then; a stake in the heart of still photography? Is the still image of no value as portrait? Of course it is. But the point is made: should you set out to portray 'inner character' in a photographic portrait you will find your aim is a will-o'-the-wisp. For our most accurate impression of a person is gained by knowing that person, and out truest appreciation of his state of mind at any one time comes from the sum of his gestures – which may well include a whole range of facial expressions. Caricature, on the other hand, coupled with bold graphic design, will bring out an instant response.

At this point let us clearly define caricature as it relates to photography. And the way it relates is not that far removed from the way it relates to drawing with pen and ink, or pencil, except that photography offers us even greater scope than does the pencil, because of its ability to get nearer reality, and thus to be more convincing. But like the sketched caricature, the photographic version must present its impression simply, with few elements.

The very simplest drawn caricature will exaggerate something physical. The artist will concentrate attention on an already large nose by sketching it massively bulbous; or he will draw protruding teeth like a line of tombstones. He may take a gesture his subject frequently makes and exaggerate it – as Harold Wilson's pipe used to be sketched over-large, and wreaths of smoke were drawn around his head. The outcome of a really successful caricature, as seen daily in the papers, is that the subject is always immediately recognizable for some physical property or characteristic trait. That too is the photographic portraitist's best target, though with greatly different tools.

It is easy, with all the techniques and tools available, to emphasize by photography any physical aspect of a person. It does not necessarily have to be done crudely, with the purpose of ridiculing the subject – there are kind and unkind adjustments which can be made. By using a very wide angle lens and moving to within a few inches of a face you could make the nose seem enormous; by using a telephoto lens and moving far back you could give greater prominence to jug ears; by shooting from low down, almost at floor level, you could make a girl's legs seem much longer than they really are; by shooting from above your subject's head level you could make his baldness seem much more drastic; by shooting in one way you could emphasize a double chin and by shooting in another way you could disguise it. Now those are all physical adjustments, but each will affect the way people react to your portraits. And just as influential will be the way in which you decide to render your subject's complexion: using a blue filter, or loading the camera with orthochromatic film, will emphasize red – making lips, and any blotches or veins, dark and prominent (in black and white portraits). This gritty impression may add a sharp-edged appearance to male portraits, but would be quite unsuitable if you were trying to enhance the femininity or mystery of a female subject; then, you could achieve your aim by using one of the soft focus

The stark contrast and grainy effect of this 35mm shot underline the dramatic bearing and gesture of the surrealist painter Salvador Dali. Paris, Nikon

The lighting in this studio
portrait of space age rock star
Gary Numan has been carefully
controlled to give a suitably
ethereal effect

techniques. But by using a soft focus technique when
photographing a man you are caricaturing, you are effectively
making him look less harsh, more of a romantic figure,
possibly even a bit effeminate.

Controls

Possibly nothing will as effectively demonstrate how much
control is yours as will examining the effect on a human face
while you move a lamp around. Photography is a two-
dimensional medium, and shadows (or lack of them) play a
very important part: the way they fall across a face indicates
the shape of that face. It follows that you may suggest
different shapes in the face by the way you exert control over
exactly where the shadows fall. This is so important that you
should make a point of carrying out that simple exercise
before you read another chapter. It would be simple enough,
but enormously time-consuming, to describe the effects on
the face of placing your lamp at different points, but one
example will suffice.

Suppose your portrait subject is a man with a much
furrowed forehead and bags under his eyes. With a light
directly above him each furrow will be prominent, with
highpoints lit, folds shadowed. The subject will look haggard.
If the light is now moved to a position directly in front of him,
shining fully onto his face, the shadows will disappear – and so
will the haggard look, bringing instead a relatively smooth
appearance, possibly dominated by the subject's eyes.
That and much more you will notice when you move that lamp
around in front of a face, above it, below it, to one side and
then the other: notice how certain features are made more, or
less, prominent depending on the positioning of the lamp.
Even so, we are nowhere near exhausting the methods open
to us of controlling the presentation of a portrait.

Blur and double exposure are fluent controls, used singly
or jointly, in helping to make vividly graphic observations, and
in endless ways. Slightly blur a face through moving the
enlarger head while printing, and then print in the eyes very
crisply – by burning in – and you will have caricatured the
original image, creating a strong and positive emphasis. Use a

A ring flash was used to give an
incisive and highly detailed
portrait of restaurateur Peter
Langan. Olympus

Placing this old Japanese lady
behind a screen of diaphanous
cloth softened and flattered her
features. Daylight, Olympus

slow shutter speed while your subject moves and you suggest
a dancing movement, or a swaying of the body such as a
singer might exhibit; double expose, picturing two different
expressions, and you can suggest extremes of personality –
even schizophrenia (see how important it is for you to be in
control, making the decisions as to what is to be shown by the
portrait).

Emphasizing the grain inherent in all films is an effective
way of breaking up the photographic image, reducing detail
and concentrating the attention on slabs of tone or shape.
And by printing through a screen, which introduces any one of
several textures, you can also break down detail – but here
the screen itself will influence the effect.

Simple repetition of the image sounds somewhat basic,
and unlikely to be of much intellectual value, but it can be as
potent as anything else in exaggerating an impression
(caricaturing again). Print one face many times and you could
be suggesting that this person is bland, has little variety to his
character: it all depends on a number of factors – the
expression, how it is printed, whether the repeated images are
the same size, how each relates to the other images.

Screen effects: the 10 x 8
texture screen goes on top of
the printing paper; the texture
screen negative is put flush
against the negative being
printed. Negative screens are
easily made by photographing
any interesting texture

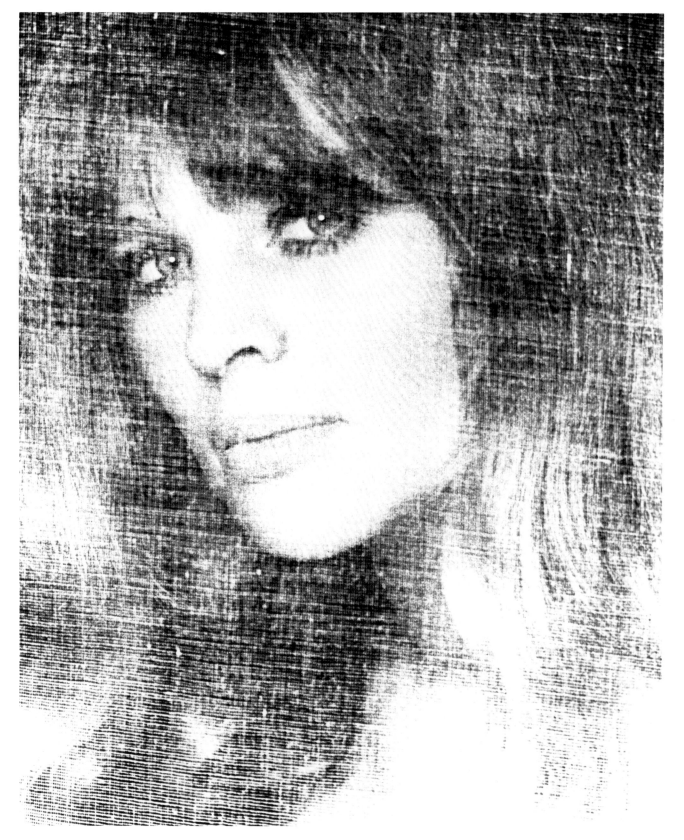

A tapestry-like effect was
achieved in this portrait of
actress Julie Christie by
shooting through a cheesecloth
screen. Hasselblad

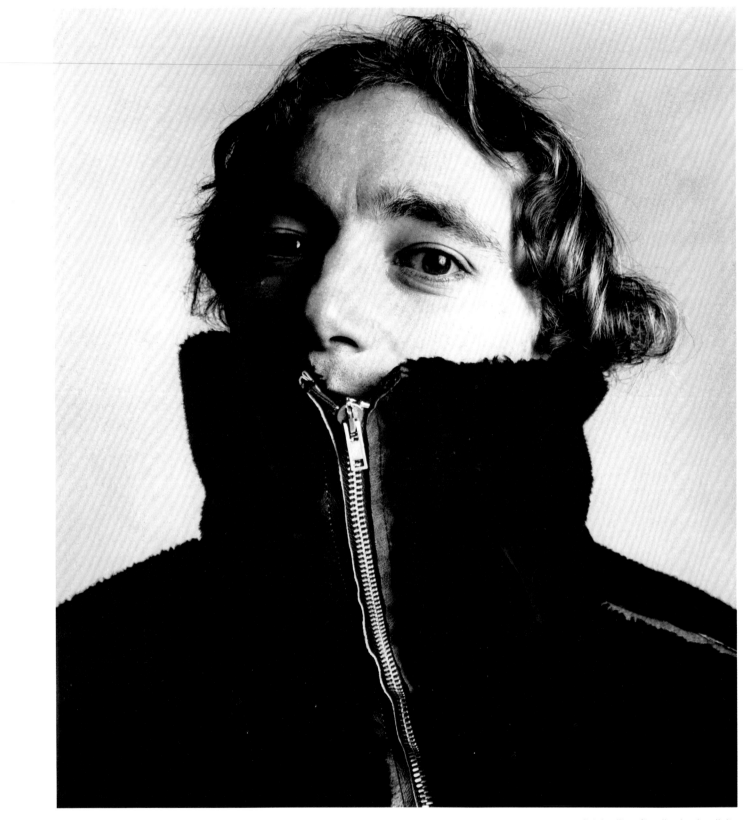

Originality often lies in simplicity,
as in this striking and classically
lit portrait of actor Michael
Feast. Rolleiflex

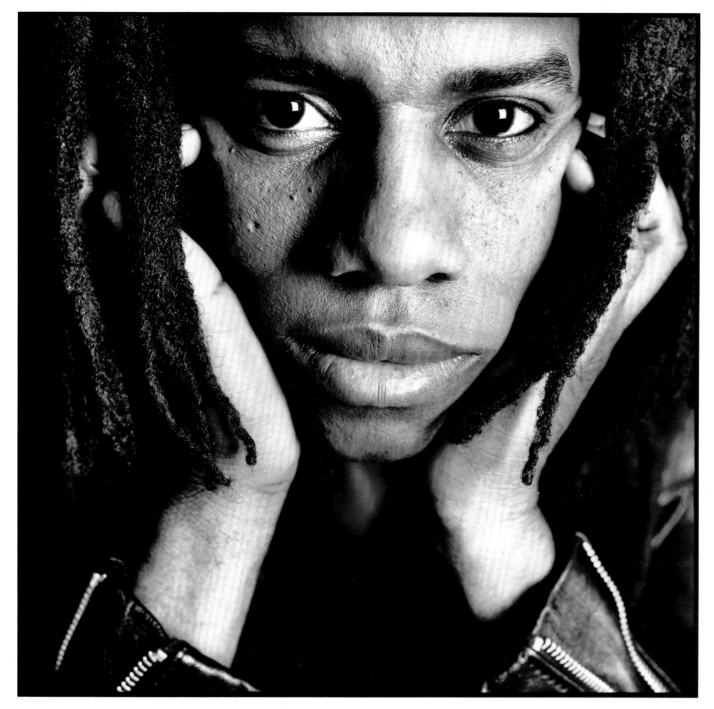

This strong but moody shot of Eddie Grant has a deliberately short depth of field and draws attention to the eyes

Shoot and print in very high contrast and you will destroy detail in light areas: this could be used to create an image of a face in which only mouth and eyes appear – the nose being 'eliminated' by flat frontal lighting – and which might place great emphasis on the big limpid eyes of a girl, especially if the high contrast image is now subjected to some soft focus treatment that softens the outlines of any remaining detail.

And still we have controls left to explore As influential as anything else is the actual shape of the image, and where it is placed within the frame of the picture. And the depth of tone, from darkest black to silver grey, in which the image is printed, is persuasive too. We have not touched on the all-important business of how you pose your portrait subjects, and that can speak volumes, but we have perhaps dwelt

sufficiently on available controls to leave nobody in any doubt at all that caricature is not only a most descriptive way of approaching photographic portraiture, but is also very much more positive than obscure and esoteric fumbling to try and pinpoint 'character and inner spirit'. Photographers who become trapped in the desire to peel away the layers and display the soul invariably become bogged down in using more and more props to suggest persona. Thus, an artist will be shown surrounded by his works, or a musician will be portrayed with his instrument or with a sheet of music: and the picture can go on becoming ever more cluttered without yielding a jot more insight into the subject – instead it becomes laboured and biographic, an especially pointless direction when the subject's profession is already well known.

Indoor and outdoor portraits

Mostly, portraiture is an indoor affair, for there it is much easier to keep everything under control, and this is particularly important when it comes to light. Of course there are successful portraits taken outdoors, but the photographer must adjust his camera, choose his film, position his subject to suit the light; indoors he chooses the light to suit everything else – a most important and significant difference. Hastily, let us make it plain that indoor portraits by window light can be very pleasing, and allow a certain degree of control; but they are a poor second to studio shooting, where everything is possible and any fantasy may be played out, any impression built in.

Does a studio rule out all who do not have acres of space to spare and endless pounds to invest in a forest of lights and tripods and bits and pieces? Emphatically, it does not. By far the majority of the portraits here were shot in a studio about the size of an ordinary living room, and many were taken with the help of just one light.

The elements of successful studio shooting are few. You need space, you need light – and that's it. But how much of each?

A 35mm camera with standard 50mm lens needs to be about ten feet from a person to produce a full length portrait. Add four feet behind the subject to allow for background, and three feet behind the camera for the photographer to move around and work the thing. That's seventeen feet, which is hardly a wilderness, and well within the size of many living rooms. But less space is needed if the portraits are to be concentrated on head and shoulders, though it is not wise to move too close to the subject, for the one-eyed perspective of the lens then begins to distort the face. But shooting from five or six feet would be acceptable, so that you would need as little as twelve or thirteen feet in which to work. Do not in any circumstances skimp on space behind the subject: if he or she is too close to the background you will now and again find it very difficult to use certain lighting arrangements, as they will throw shadows which are intrusive.

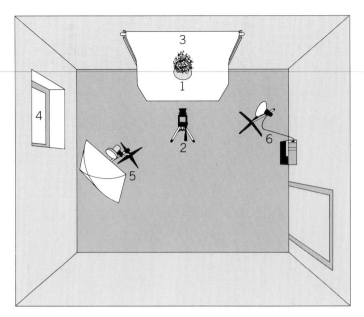

Plan of a typical small studio

1. subject
2. camera
3. background
4. natural light from window
5. flash into umbrella to give fill-in
6. flash for highlight, with slave

You can get by with one light. As a matter of fact you would do yourself a favour by deliberately beginning with only one light. Make it the best you can get – for home photography go for one of the electronic flash units specially built for studio use, by Bowen or Courtenay: both makers produce models for smaller studios, at reasonable cost, as well as very powerful units for larger studios such as professionals might use for complex subject arrangements. Importantly, they also provide modelling lights: that is, a bulb illuminates the subject the entire time, so that the photographer may judge the effect of his light's position before firing the very high speed electronic flash, the effect of which is impossible to see until the pictures have been processed. (This is one reason why professionals use Polaroid instant film as a check.) In addition, the units can be fired into a white (or silver or gold coloured) umbrella-like affair, so that the flash is bounced from this relatively large and concave surface to bathe the subject in a soft light which avoids harsh shadows with crisply defined edges.

With one such light providing the options of bounced flash and direct flash you can accomplish much. Every extra light you add will cast more shadows, and create more confusion, making your pictures look very unnatural unless you become very skilled at handling multi-lamp set-ups. But simplicity in lighting is the norm today; the multi-light arrangements seem to belong to the Hollywood days when every trick in the book was pulled to make the stars seem glamorous.

A wide angle lens was used to accentuate the heads of these boys and the vertical nature of their pose. Goa, Nikon

A charming outdoor reportage-type portrait is here rendered more effective by careful composition. Tokyo, Olympus

British pop artist Peter Blake
photographed in his home
setting with some of his
favourite objects, including a
sculpture of a black boxer

Background and other effects

Keep it simple, too, when it comes to the background. While you will have to make the most of it if shooting portraits anywhere but in the studio, you should still avoid too many elements behind your subject. A confusing collection of shapes and tones and colours will put paid to any chance you may have of remaining in control of the overall design of the picture. For maximum impact by the subject the best background is perfectly plain. In the studio you can use a piece of hardboard, though to be big enough it would have to be quite bulky – at least six feet wide and eight feet tall for full length portraits, and that would be very heavy. You could use a smaller piece if you want to shoot only head and shoulders. Alternatively, you could use a piece of canvas, or a proper background paper, which comes in rolls nine feet wide, and needs a stout support. Colorama is a popular brand. The background may be any colour of your choosing, and there is no doubt that different colours – dark green, dark brown – bring different effects into colour photography. But the most

versatile colour is a light grey; it can be made to appear very dark, almost white, and virtually any colour you like, depending on whether, and how, you apply light to it.

To vary the background effect while owning but one roll of paper or canvas, you will need a second flash unit, which will light the background and nothing else. The flash goes behind the subject, out of camera view, and is fired either by connecting to the main unit (if that is possible, and it isn't always) or by using a slave, which incorporates a photo-cell and triggers the second flash instantly it picks up the light from the main unit.

If you fire the second flash unit directly at the background, it will appear very bright in your picture, and if the flash is powerful enough the pale grey will appear white: don't fire the auxiliary flash at all, and shade the background so that the main light does not strike it, and you will produce a near black appearance behind the subject. Cover the background flash with coloured filters, or pieces of translucent gelatin or plastic, and you will introduce a background hue matching the filter. You can vary the light spread on the

Objects included in a portrait can tell much about the subject. Marie Helvin's great grandfather in his hotel in Shiznoka Province, Japan. Olympus

Double exposure can be an
effective device, as in this shot
of film director Joseph Losey.
Rolleiflex

background simply by angling the flash away from it. And it is easy to break up the flat tone of the background by spraying a few patches of contrasting tone onto it – but don't overdo it, for too much mottling by this method will be very distracting.

If you do your own processing and printing you will be in a position to tailor your portraits very precisely to your own taste. By burning in you can subdue any details of the clothing which are too bright and distracting; and if you begin with having your subject wear a black shirt or sweater it is easy to go on from there and create any shape you wish – and easier still if you work with a perfectly plain white background. All you do is cut paper masks to lay on your printing paper so that some of it remains pristine white, some goes jet black, and your subject's head emerges from the dark mass. Whatever you do, go for plain and simple designs, and remember that your subject's face will be the riveting part of the portrait – or should be.

Getting someone to sit down in front of your camera is only half the battle in portraiture. The real problem is cajoling him or her into a shape you find pleasing, and that does not always mean a shape which shows your sitter's most aesthetic

profile. Hands are often a bit of a problem, so don't be at all afraid of telling your sitter to keep them well out of sight – in his pockets, behind him, on his knees out of camera view. Some people are eternal fidgeters and their hands will wander all over their faces – tugging at an ear, rubbing the nose, supporting the chin, stroking the cheek. To force such people to keep their hands still and out of sight would be to impose quite a restriction, and they would surely show the strain, by appearing self-conscious. So don't do that; instead, go ahead and shoot while they are doing whatever is their habit, and you will be surprised at just how many people insist on covering their mouths with the hand while in front of the camera.

It would be misleading to suggest that there is one combination of photographic equipment greatly more suitable than any other for portraits. But the fact remains that the camera sees with one eye whereas you see with two. Consequently, a lens needs to be further from a human face to see it in the way the eyes do. Too close a camera position will enlarge the nose unduly, and will not show the ears; the face will therefore look disproportionate and unnatural. For that reason it is common to use a lens of slightly longer focal

The Japanese painter Imai photographed in a highly intriguing yet ultimately simple setting in a Tokyo restaurant. Pentax

Artist Brian Clarke is given an
almost surrealistic image in this
shot with a Leica rangefinder

length than normal: from 90mm to 135mm will do nicely. To get the same perspective effect your eyes perceive when you are in face to face conversation with someone, your lens needs to be something like twice as far away from the face – and at that distance a standard lens of 50mm (on the 35mm format) will produce too small an image on film, unless you are shooting full length portraits.

There are styles in portraiture, perhaps more so than in any other kind of photography. Starting with the stark simplicity of the Americans Richard Avedon and Irving Penn (Avedon is particularly austere), the genre runs all the way to the fantastic arrangements of the late Cecil Beaton and Angus McBean, both of whom mirrored the glamorous world of their showbiz and society subjects in equally glittering settings and lighting arrangements. Do not be seduced by style! Remain always very aware that the portrait sets out to be an impression of another human being. By all means add a prop or two for variety, and especially if it has some relevance; but remember that the more you add, the more the viewer has to comprehend, and the more there is to come between him and a straightforward response to the person portrayed.

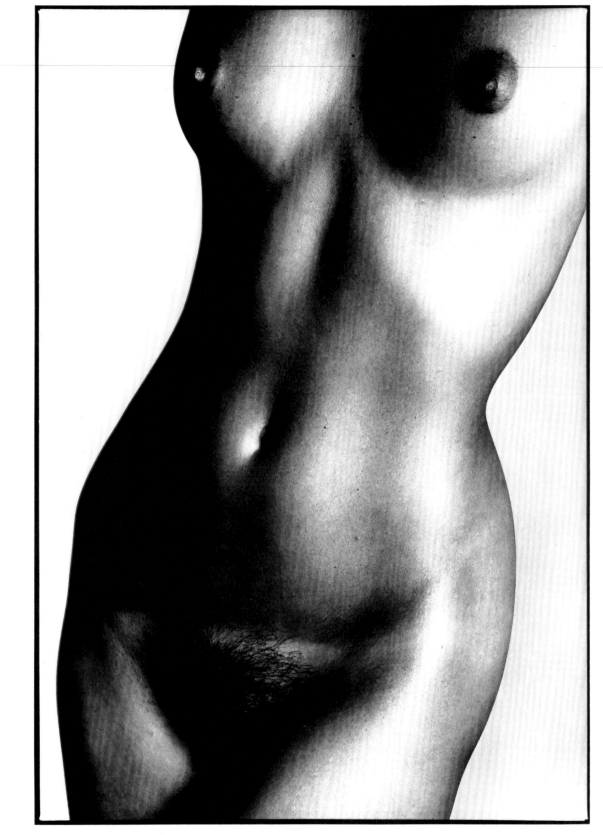

A classic nude, treated
somewhat in the manner of
Edward Weston or Bill Brandt,
who used the human form in an
almost abstract way. Horseman,
6 x 9

Photographing nudes

The subject of nudes remains explosive, and there are more controversial views about it than about anything else in all the creative crafts and arts. Why so? Why should the most basic ingredient of the human race, the body, cause such consternation on the one hand, such ecstasy on the other? Because, surely, the body naked is one of the very foundations of life: from birth and childhood to the beginnings of our own relationships with each other, and on to maturity, the body excites the most powerful emotions.

The question is a genuinely puzzling one, however, because while the answer just offered must have some validity, the fact remains that response to nudity is not, and never has been, consistent. Go back to a time as recent as the turn of the century and you find the idealized female figure, at least the kind the artists sought for modelling, was distinctly more plump than the shape preferred today. And in different parts of the world different parts of the anatomy bring that glow to the male eye. We have all heard the tale of how a twitchy nose turns on an eskimo.

It is not, of course, the body which causes all the problems; it is bits of it. Let us make it plain we are talking here about the female nude. For some reason she has all but obliterated the male as subject, though he had his day. The Greeks idealized him, and produced magnificent works of art, and painters cast him in the role of just about every religious and mythological figure you care to mention. But outside the pages of health magazines he does not get much of a look in now. One theory is that modern man is today less of a warrior, less likely to flaunt his body in glorious deeds: if that is the truth, the inference is that contemporary woman most certainly is a warrior. Cynics may say yes, but it is clearly true that at least woman has not abandoned her role: she is still mother and lover, security and adventure wrapped together in one voluptuous package.

Theories aside, woman unclothed is one of the classic themes of art. And photographers have turned to her with more enthusiasm than most – perhaps because the camera is potentially more capable than any other implement of accurately reflecting the reality of the subject, and of enlarging on the fantasy by that very closeness to reality.

Reality means truth, and in the long tradition of nude imagery there have been many who have strayed far from the truth. For example, those parts regarded as problem areas – the nipples, the genitals – have been hidden in shade, shaved, ignored altogether, and endlessly draped in flowing fabric: imagine, painters were once praised more for their handling of drapery than for the accuracy of their nude paintings. In photography it is relatively recently that the full erotic impact of the whole woman has become acceptable – made so by photographers such as Helmut Newton.

In many ways the idealized nude of photographers of vintage calibre and style, like Edward Weston and Wynne Bullock, seems now little more than a silver chloride version of the marble works of the ancient Greeks: she is classic nude, and photographically important, but far distant from what contemporary climate allows, even craves. Both photographers were, in their ways, pioneers. And both placed the nude within a framework of nature – Weston often picturing her amongst the Californian sand dunes, Bullock delighting in woodland settings. But with their examples enmeshed in photography's gallery of greats it is difficult to tread the paths they trod without feeling self-consciously that one is turning out inferior Westons, or things which are a cross between Bullock and something out of A Midsummer Night's Dream.

What Helmut Newton did was to make it as allowable, photographically, to concentrate on eroticism as to classify woman as but another example of nature's aesthetic handiwork – high art. When a model today strips away her clothes she also peels off guilt and confusion: it is much easier to shoot nudes in such an atmosphere.

The idea of nudity

This does not mean that the modern photographer of nudes necessarily makes a definitive statement every time he shoots a picture or publishes a series, even a book, of nudes. For all its massive power, nudity, female style, the erotic kind, is an everyday condition – it must be, since the world population is split roughly into equal proportions of women and men. If there is resistance to the idea of nudity it exists in ideology, not in the body, certainly not in nature's plan for things. Some critics believe they perceived in the book Trouble and Strife a

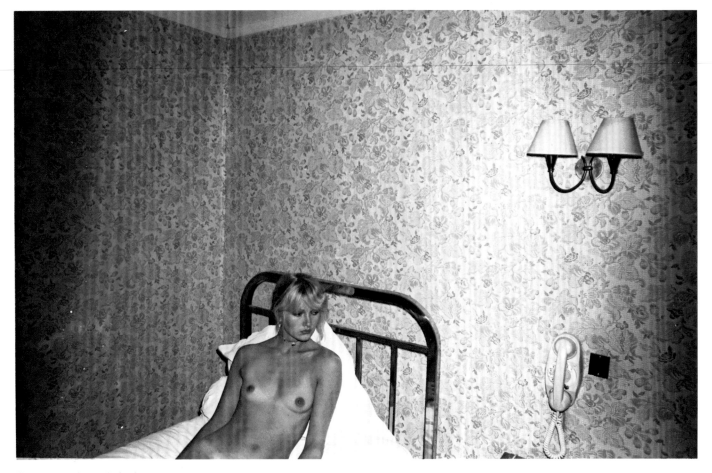

The picture depends for its
effect on unusual composition
and cropping. Nikon

definitive statement, an underlying observation on the
complex relationship between a particular husband and wife.
But the pictures are really a record of two people having fun
with photography. If there is such a concept in art as 'Sunday
painting', then Trouble and Strife is Sunday photography. It is a
collection of pictures taken at different times, in different
places, sometimes in hotel rooms while en route to some
assignment. Sometimes the pictures are conscious attempts
at toying with the old styles, the kind of thing Edward Steichen
produced early this century; at other times they are
photographically aggressive things, brief assaults on the
female form with a 35mm camera, a wide angle lens, and flash
on the camera (often the only light available in a hotel room).

The point is, there is no definitive concept of the nude.
As society changes, she changes: as location and habit and
religion change, she changes; as the photographer's attitude
changes, she responds and changes too.

The biggest requirement for successful nude pictures is a
model with a beautiful body. Simple enough, but what is a
beautiful body? Not so plump as once, but more filled out than
the present fashion models – who are usually too bony. For

the high fashion model large breasts are a disadvantage. They
are, too, for nude photography: to prevent them sagging the
photographer virtually always has to pose his model with her
hands above her head, to pull up the offending mass. Much
more aesthetic is the body which sports relatively small and
firm breasts – it is true to say the smaller they are the easier it
is for the photographer.

The girl should also have an expressive face; without that
we are all reduced to doing nothing but ogle a body. That said,
the body itself, the way it undulates, its textures, the play of
light and shadow on it, has provided more than adequate
subject matter for many a photographer. Not just the body,
but natural forms suggestive of it: Edward Weston created a
number of pictures of the sinuous and sensuous surfaces of
shells and green peppers, and expressed surprise when those
who viewed his pictures insisted they were erotic. And Bill
Brandt, using an ancient camera which provided an
exceptionally wide angle picture, placed the nude in amongst
rocks and pebbles on the sea shore, drawing the obvious
comparisons and exploring natural form more than human
personality. Brandt's series, published under the title

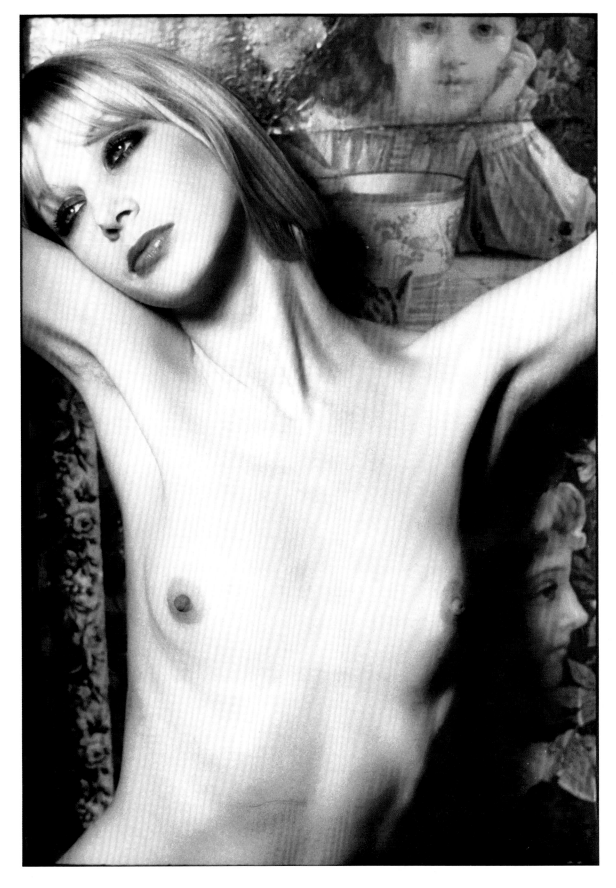

An elegant and serene study of
an unusual pose. Nikon

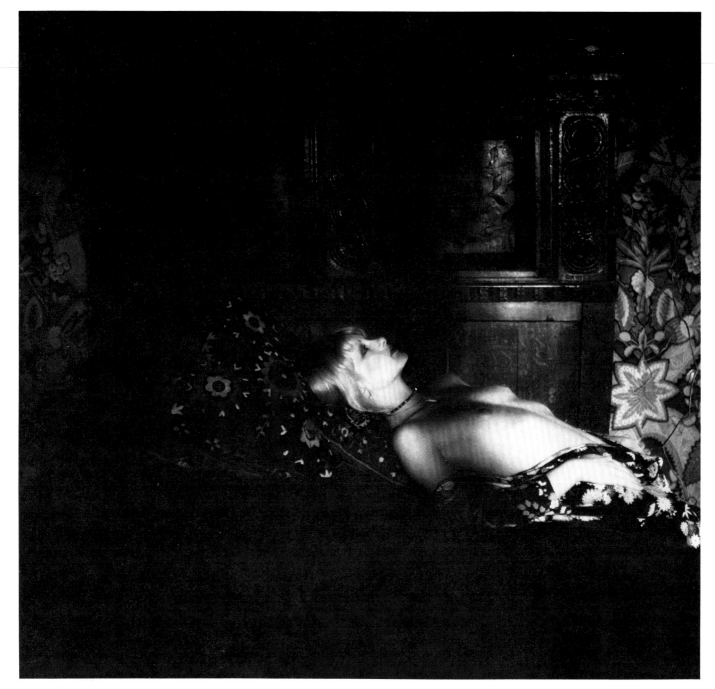

An intimate and atmospheric
nude with strong lighting on the
subject, but relatively little
background detail. Polaroid 195

Perspective of Nudes, is a classic in nude history, though much of its impact comes from the extraordinary distortion of the models, brought about by the wide angle effect. André Kertész is another whose nude distortions count amongst the milestones, though his effects came from photographing his model in one of those fairground mirrors which normally have us bursting with laughter.

It is said that the Venus de Milo represents the classic shape – or would if she had her arms. Her torso and legs parallel perfection according to some artists, who have given us detailed measurements with which the ideal form should equate. Obviously, no photographer is about to go in search of a model with a tape measure in his pocket, but there is no doubt that long legs are particularly aesthetic – and erotic. Photography allows us to stretch them, to distort them in two ways so that they seem longer than they really are.

A simple but striking pose and
dramatic lighting are combined
in this unusual treatment of a
nude subject. Polaroid 195

The lighting in this picture is used to highlight the model against the complexity of her surroundings. Deardorff, 10 x 8

Soft focus effects can be
obtained with a piece of nylon
stocking over the lens, as here.
Hasselblad

But why do that: why interfere with nature, the woman's libbers will demand – why treat woman as an object to be stretched and pushed and pulled to fit your aesthetic? Why not take her as she comes? Fair question, and it deserves answering before we move on to discuss techniques; so we shall deal with the why before the how.

To begin with, nude photography is not reportage photography: it is not the capturing of truth, any more than a novel is a catalogue of established facts. The nude photographer deals in fantasy: he does not record, he creates. And to create he must be free to adapt, to imagine, to exaggerate, to emphasize. In fact, the very crudest photography of woman is that variety which is straightforward depiction of the genitals and which smears the pages of the pornographic magazines, and is a true record of what was before the lens.

In the Western world at least, long legs are much prized; the Japanese go goggle-eyed, so they say, over the nape of a woman's neck, and somewhere around the world there is surely a nation of men set alight by plump thighs. But long legs – and long and slender limbs in general – suggest to us grace, sweetness of movement. As Turner was never chided for dwelling minutely on atmospheric detail, leave the photographer free to bring his viewer's attention to the grace of his model.

Technique

As to how to do it, there are two quite simple ways of interfering with nature's design and apparently stretching a girl's legs to more aesthetic proportions – or, if you like, bringing her more into line with the fantasy men cherish of the ideal woman.

One way is by shooting from a very low angle. Then, if the model is standing up, simple geometry will show that the light rays from her upper half must travel further than those from her lower half in order to reach the camera lens. And the further away any object is, the smaller the scale at which it is rendered on film. By this same piece of geometry you can easily understand why children so often appear distorted when an adult photographs them from standing position – the child's head is nearest to the lens and appears proportionately larger than his body and legs. The effect is further exaggerated when a wide angle lens is used, if the photographer moves closer to his subject to maintain on film an image as large as that provided by the standard lens.

The wide angle lens figures in the second way of putting a lady on the rack – photographically. It is basically similar to the first way, but relies on a pose in which the model is reclining, or lying down. Moving in close with a wide angle lens – which, because of its great view, still encompasses the whole subject – emphasizes the dimensions of the leg. It is a technique not to everyone's liking, for it does result in blatant artificiality; but when made use of by a photographer who can handle it well (such as, perhaps, Jean-loup Sieff), the effect is striking. Naturally, the model's legs must be stretched towards the camera. But if the photographer goes too close he will exaggerate the lady's feet to a quite unacceptable degree, and will produce not elegance but ugliness.

A slightly tongue-in-cheek glamour photograph, with trappings of the girly magazine image. Olympus

Exotic locations are not always
necessary, and this picture of
Marie Helvin was taken in the
photographer's attic. Olympus

Shafts of sunlight behind the model have been used without artificial light, and the exposure take was read from the front of the model to give a soft romantic effect. Pentax, 6 x 7

In theory, a successful nude photograph gives the viewer the impression of peeping for a moment into the model's private world – something the exhibitionist trash of the porn mags does not do, with its important element of 'come on'. But in truth, seldom is there success in voyeuristic photography – simply pointing the camera at an undirected model and firing the shutter when the picture looks good. So finely honed is fantasy that the elements of the picture must contain no distractions, and it is much more productive to set up and carefully control every nude picture.

It is naive to expect any kind of consistency without control: you must direct your model and arrange your props and setting to give an impression of casualness – though now and again highly elaborate and contrived settings, almost surreal, work very well, and only the most fanciful would imagine the result to be a part of the featured model's everyday life. In such images, what is going on becomes the subject, and the girl herself is almost reduced to being a prop. Certainly she exhibits no personality, as she is allowed to do in the carefully controlled and directed artificial pieces of voyeurism.

Nudity is quite different from portraiture: second to fashion it is probably the most difficult area in photography, though perhaps marginally easier to tackle than portraiture.

Of course, a nude picture can be a portrait, but then a different set of requirements comes into play; then it is 'warts and all', and the element of fantasy is no longer necessary. Particularly satisfying is the portrait of a nude mother-to-be, an image which shows the marvellous tenderness of the subject, the atmosphere of the picture far transcending mere nuditiy. And portraits of mother and child, both naked, have a touching quality too, in which the powerful bond between the two obliterates any hint of the woman as fantasy. No doubt a psychologist would tell you much about our response to unclothed women, and how it varies when they are with children.

It seems too obvious to point out, but all nude models get that way only after taking off their clothes. And the clothes leave tell-tale marks – impressions on the skin of where elastic, straps, buckles, have bitten in. How unsightly the marks look in photographs. Time, and warmth, will remove them; but play safe and suggest to any model you intend picturing nude that she should wear only loose clothing before the session – and talk her out of wearing a bra, if you can. Don't worry about the patches left on the bikini zone after a girl has been sunbathing, for the white patterns, against a tanned skin, activate the imagination and add to the fancy – they are very erotic.

A wide angle lens was used on a
Nikon for dramatic perspective
in this picture of Marie Helvin on
an Australian beach

The actual figure occupies only a small part of the total picture area, making this a rather unusual treatment of the nude theme. Olympus

Light and lenses

Just as there is no one correct way to pose a nude, so there is no one way better than all others in which to light her. It all depends upon what you are trying to show in the picture. Soft light, as from a window to one side, or from flash bounced from ceiling or wall, or from diffused floodlamps, will produce soft outlines, and accentuate the model's roundness; it will encourage areas of more or less deep shadow, and will help you build a romantic atmosphere into the picture, using effectively the chiaroscuro (or Rembrandt) lighting which paints in only what is important, leaving the rest in dark tones.

Harsher light, as from direct flash, will let you construct your picture with shapes rather than atmosphere and suggested outlines, so it is worth experimenting with the very useful automatic flash units which measure their own light output – and switch it off when sufficient has been delivered for a satisfactory exposure. On camera, these units will deliver a frontal lighting which is good for making graphic shapes of your nude model. Many of the current units will allow a combination of direct and bounced flash, with the flash tube tilted upwards so that some light is directed towards the ceiling, to bounce back onto the subject, while some spills directly onto her.

You could be forgiven for assuming that every photographer who shoots nudes out of doors is a believer in woman as part of the earth, and that he is constantly comparing her shape with other natural shapes, equating her fertility with that of the land. Mother nature is a woman after all. But think along such poetic lines and you will be overlooking one vital fact: that nudes have to be shot in lonely places, otherwise an awful lot of photographers and models would be arrested for indecent exposure and disturbance of the peace. You would never get away with photographing a naked lady draped across the contemporary sculpture in the forecourt of the local council buildings.

Nudity is, as we said at the beginning, a highly charged subject. It is all right indoors, and will not offend anybody out in the wilds where there is nobody to see. Hence, the nude and lonely places go together. Particularly, woodland, rocks and seashore are common settings, and that suits photography just fine, for all are photogenic in themselves, and almost guarantee some sort of success.

Outdoors, you relinquish a certain amount of control – over the light. But on the coast especially the classic choice of equipment is 35mm camera, wide angle lens (24 or 28mm), and polarizing filter. Together they bring views including nude and seascape or beach or sand-dunes into one frame, and they offer a degree of control over the depth of tone in the sky. Indeed, a polarizing filter can turn a clear blue sky almost black; and, cutting out glare from the sea, it will introduce effects with intriguing textural appearance or deeply saturated colour, depending on which film is in your camera.

The telephoto lens is rarely used in nude photography, as the working distance is too great for effective control of model by photographer. With a 300mm lens, for example, the pair would be something like 60 feet apart, in order to produce full length images comfortably on the negative. But that does not rule out the telephoto lens – there is no technique in photography that cannot be used.

A matter of taste

If you want to try nude photography, you must at some stage consider the question of taste. How much to show and how much not to? Of course, you may find the answer supplied by your model. And if she does decide to reveal all, she may insist her face must not be seen – thus very effectively wrenching control of the situation out of your hands. There is nothing indecent about pubic hair and nipples, but there is in people's reaction to them. Your view may be, should be, that to show all is permissible, provided it is a natural and integral part of your picture, and has no more attention drawn to it than, say, the model's elbow or her ankle. And if you find a model who thinks that way too, value her. For the need to arrange a pose so that the bits and pieces do not show is a great inhibition of freedom – and results in far more pretentious effects than total honesty.

Except for very specialized purposes such as the illustration of record album covers, or calendars, the modern nude tends to be photographed as herself, or as a complementary element in landscape: rarely is she intended to represent a historical or mythological figure. But the painters were always doing it. There must be more canvas Venuses and Helens and Dianas than the heavens could possibly hold. In the early days of photography, before the pioneers became aware of the medium's particular superiorities over paint, there was much aping of painterly styles, though it is doubtful if any cameraman ever found a model bold enough to play Leda. Some of those early pictures do have a certain charm, but ultimately they remain period pieces rather than blueprints for the developing art. Today's nude is much more at home being herself.

The hazy lighting of this smoky and strongly atmospheric morning scene in Paris, against the sun, is emphasized by the deliberate use of heavy grain

Landscapes

If we are to consider the nude as a great and classic theme in photography, then how must we think of landscape? As holy grail. And this is not a comparison lightly made: there is a spiritual quality in the search for the perfect landscape, a drive ever onward to find the light and the land in such harmony that just to view it sends the emotions soaring – and to succeed in capturing it on film is the nearest thing on earth to heaven.

It is worth clarifying one or two points. First, there are two kinds of photographer who might be thought of as landscape hunters, and one group is much larger than the other. For the majority, photographing a piece of landscape is an act of recording: it is a question of representing on film, more or less accurately, that view across the bay or that mountain range, as a piece of geography – an arrangement of shapes and colours, and perhaps including houses and old churches, all assembled before the lens because they happen to be there. And the views are the variety marked on tourist maps and famed far and wide – and usually enshrined in a thousand postcards, a hundred canvases by amateur painters. Such views cannot be scorned; they give great pleasure and this is why they become famed in the first place. By a sort of snowball effect, the more they are appreciated the more they are photographed, and the more they are photgraphed the more popular they become.

The smaller group of photographers contains those who are less concerned with geography by itself. They are the hunters. For a holy grail yes, but perhaps a better explanation might be that they are collectors in the same way as the butterfly collector – there is always another, rarer beauty to be pursued. The rarity is in the combination of the lighting and the lie of the land, or its components, and in the photographer's particular reaction to it all at the time. In this group a man – or a woman – will often photograph the same piece of landscape endlessly, throughout a lifetime; it will never look quite the same twice, for the clouds will vary, the mist will be thinner, the clear air will make the colour more pronounced, the hour of day will make the light warmer or more cool, and the photographer's reaction will cause him to shoot now from this angle, now from over there. And of course, the seasons will bring about their own variations on the theme: a mantle of snow, a coat of fresh spring green, summer's golden haze and autumn's coppered coat – how they change the look of things.

Second point for clarification: apart from the changes wrought in landscape by the seasons and by light and by the photographer himself, through his reaction or by rearranging his viewpoints, there is the ever-present possibility of changing the whole thing by purely photographic means. So much is that possibility real that a photographer of the hunter variety can instantly translate what he sees before him into what he will produce on a print or transparency; and that translation might produce something very different indeed.

Think of it this way: two men, two quite different kinds of photographer, stand gazing at a fine view before them. Suddenly you are gifted, and can see the paths of both light and thought waves – as schlieren photography lets you see vividly the motion of turbulent air. From the view before him, light waves hurtle towards one of the men, and around his head and his camera is a turbulence of thought: he is passive – the landscape is radiating its light to him, and his camera is taking up his entire concentration. Initially, the light waves stream towards the other man, too. But then he becomes active: from him, rays streak out towards the view. It is almost as though he is turning the light rays back and rearranging them to suit himself, putting them just where he wants them – which, of course, his complete control of photography very nearly allows him to do. And from him stream also his thought waves, as he probes the landscape and considers how each part of it will be rendered by this or that lens, this or that filter, this or that process or adjustment to his film-developing technique. He is far, very far, from being passive.

A moment ago you were requested to think of landscape photographers as either active or passive. And if you do not recognize the necessity for one, the inefficiency of the other, there is no point whatsoever continuing to read this chapter. The landscape photographer who truly succeeds is not a child wandering in the wilderness and letting it all wash over him; he is active, he is in command, he dictates the conditions of his image, given the ingredients put on display by nature. Without being at all pretentious, and without condemning the perfectly enjoyable pursuit of shooting picture postcard views, we shall here concentrate on landscape which comes out the way you want it to.

The darkly dramatic character of these shots of sand dunes in Morocco has been emphasized by eliminating most of the mid tones on high contrast printing paper. Here the human form is suggested, whereas in the first nude photograph in the previous chapter the human form evoked the landscape

What, after all, is the purpose of photographing landscape? Surely it is not merely to duplicate a scene – and anyway no camera/film combination is efficient enough to duplicate nature precisely. The purpose must be to effect a translation of sorts, to make what appears on the finished picture as an emphasis on something which appealed to you, which fired your imagination.

Alternatively, you might begin with an idea and then find the landscape to fit. This is exactly what is done every day of the year, by photographers sent out to shoot for advertisements – 'Smoke Wonderweed for a taste of the big country', 'Drink Glengurgle and feel fresh as a Highland stream'. Finding the location for such shooting is one thing, flavouring it with an atmosphere to suit the product is another. Essentially, what the advertising photographer must do is extract a mood from his landscapes – he must mould and cajole until nature gives in and says 'Well, have it your way!' The important point is this: the advertising photographer is paid to do somebody else's translation for them, and his craft must give him a wide enough vocabulary for the purpose. But the photographer whose concern is landscape first, not the selling of a product, makes his own decisions. Like, say, the composer of a symphony, he will set out to construct an image that will be laden with a sense of some quality – grandeur, aridness, freshness, lonely vastness, mystery.

Landscape and lenses

We have spent quite a time getting into stride here, and deliberately so; the secrets of really successful landscape – intent, imagination, and patience – needed to be materialized from their abstract existence and paraded in full view before we could go on to the tools involved.

In landscape, some parts of the subject will always be at a considerable distance from the camera – though now and again any photographer attracted by natural panoramas will also turn his attention to cameo views. He will photograph rocks, and close-ups of grasses and gnarled tree roots. Apart from those close-up views no negative size smaller than 35mm is able to cope with landscape, where distant detail is

often the making of the picture: 110 cameras just do not hold details well enough. Be suspicious too of 35mm cameras with fixed focus lenses, for they are designed to produce their best performance with a subject not too far distant – and wild remote landscape will sometimes take in mountain ranges many miles away.

All lenses capable of being focused have a scale engraved on them, which runs from the closest focusing distance (this varies greatly, according to make of lens and its focal length, and according to the format, for which it is designed) to infinity. This infinity is an important concept in photography. It is always indicated by a symbol which looks like a figure eight on its side, like this, ∞. And infinity is taken to be at a point as far distant as the eye can see. Certainly the moon is at infinity, and so is the horizon when you gaze across Salisbury Plain; the mountains are too, and the far bank of a wide lake almost certainly. In practice, few lenses are engraved with distances beyond 30 metres; sometimes 10 metres will be the last distance marked before infinity, and a few telephoto lenses of 400 or 500mm may have up to 100 metres marked on them. It is the marked distance scale which indicates to you how much depth of field you have to play with.

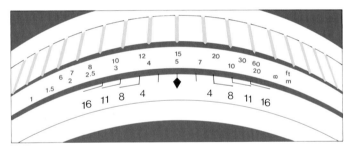

A typical depth of field scale on the lens barrel of a camera

Now is the time when we must boldly step in and deal with an often confusing little phenomenon known as the circle of confusion.

Handle any lens and you will notice that it (or part of it) moves back and forth as it is focused throughout its range of distance. Obviously, it can focus precisely on only one point (or plane) at a time. In front of and beyond that point the image goes progressively out of focus, until it becomes entirely blurred, so much so that whatever is there may be quite unrecognizable. How quickly the image before and beyond the point focused upon goes out of focus depends on the permissible diameter of the circle of confusion: accept that the diameter should be quite large and you are opening the door to fuzzy results; insist it should be small and you will get sharp pictures. But how large, how small?

When a lens is accurately focused upon some point, all the light rays from that point pass through the lens, are refracted in the process, and meet up together to produce a

sharp image at the film plane, behind the lens. Light rays from points before and beyond the focused point still pass through the lens of course, but they strike its surface at differing angles, and thus leave it too at different angles: this means that when they meet up again behind the lens it is not at the film plane – it will be either marginally in front of it, or behind it. Either way, they will pass through the film plane as a cone of light; and the cross-section of that cone, precisely where it is sliced by the film plane, is the circle of confusion. It is a confusion of light rays either on their way to reforming as a point, or having just done so. Provided the point represented by the rays within that circle of confusion can be distinguished from other points immediately adjacent to it (distinguished, that is, in an enlargement), then you will see a more or less sharp image. If individual points cannot be distinguished, then your picture is not sharp. If it is not sharp, what will have happened is that the circles, cross-sections of the cones of light from points close to each other, have intermingled and confused the outlines of the individual points they represent.

In practice, the permissible diameter of that circle of confusion is decided for you, by the lens manufacturer. He knows that by stopping down the lens aperture you will progressively equalize the angles at which light rays from all parts of the subject strike the lens surface – and that means they will all leave it too at angles more similar than when the lens was opened wide. So, the cones of light will all be narrower when they strike the film plane. Provided the

This striking and unusual view in Regents Park was made possible by shooting with a panoramic Widelux camera and using the reflection of the scene in a canal, as may be seen by viewing the picture the other way up

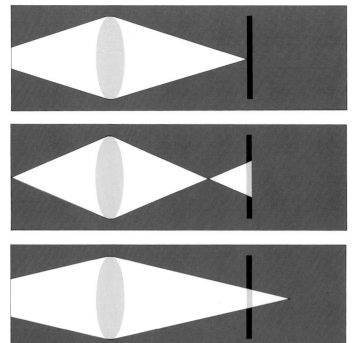

diameter of the circle of confusion is less than a certain figure (and some lens manufacturers are more demanding than others, and their insistence on a smaller diameter than their competitors accept gives the impression their lenses are sharper), the lens maker will engrave upon his lens barrel a set of figures which indicate that the lens will provide a satisfactorily sharp picture (on enlargement) of everything between certain distances when the lens is focused on a point between those distances. The area between the closest distance and the furthest is known as the depth of field; it is always greater when the lens is stopped down, and when the lens is focused upon a distant point rather than a close one.

Now you will understand that by adjusting the lens aperture and the distance you focus on you can control how much of your picture will be satisfactorily sharp. And since landscape is a static subject it is possible to use a very small lens aperture, and to focus on a point which will introduce sufficient depth of field to cover the scene from a few feet distant from the camera all the way to infinity. That ability will be particularly useful when using long lenses, and large format cameras. Makers of 35mm SLRs tend to engrave somewhat sketchy depth of field information on their lenses, but they do compensate by providing a stop-down preview button; by pressing that you stop the lens down to the aperture which will be used for the actual picture taking, and you can then examine in the viewfinder the effect, to help you decide if depth of field is sufficient.

The circle of confusion

With correct focusing, rays of light make a sharp image on the film (top). With incorrect focusing, the sharp image can either fall short of the film

(centre) or it can form beyond the film (bottom): in both cases, the point is rendered as a circle on the film, with loss of clarity

A fairly ordinary townscape is transformed by the rainbow and its dramatic light. Regents Park, opposite the photographer's house, Olympus

By the expedient of moving the camera during exposure, reality takes on another dimension in this panoramic Widelux view of a cityscape in Sydney, Australia

Speeds and filters

Stopping down the lens automatically means slowing down the shutter speed, so to prevent ruining your pictures through blur you would be well advised to buy a good sturdy tripod for your landscape shooting. And get a long cable release too – then you will not need to touch the camera, and you can be much more sure it will remain rock steady while the shutter is open.

In very low lighting, when the sky is dark and thundery, or when evening is drawing in or dawn just beginning (and those are good times for atmospheric landscape shooting), you will find that stopping down the lens requires a compensatory long shutter speed which could stretch to as much as several seconds. We did remark earlier that landscape is a static subject, but this is not entirely true. Leaves move in the breeze, and streams froth along at great speed, clouds scud across the sky and tall and slender trees bow before the wind; at times there is a positive ballet of motion in a landscape. And if you are using a slow shutter speed, some of that motion will show as blur. If you think of that as a problem then you should arrange never to go landscape shooting in frisky weather and low light with anything other than a fast film in your camera – and be prepared to push process it, to keep your shutter speeds higher still. But motion, the way it shows on film, can appear very attractive: in particular, moving clouds drawn into strange blurs with ill-defined edges produce an appealing surreal effect. And moving water takes on a smooth appearance which is full of grace. Leaves in motion leave a feathery trace around the outline and the impression in the picture is dreamlike.

As a matter of fact clouds and their appearance greatly occupy the mind of the landscape photographer. And both in colour and black and white, filters will often be used to emphasize the presence of cloud – which can be a most graphic addition to a landscape composition. When shooting in colour, put a polarizing filter on the lens and the blue of the sky will be darkened, throwing the clouds into stark relief. The filter has other effects too: it will take the sheen off water in certain conditions, and it will also bring a deeper saturation of colour and give to greenery a fine velvety texture.

In black and white photography an orange or red filter will greatly emphasize clouds, a yellow filter less so. All of these filters work by blocking some proportion of the light striking them (red, for example, stops light of blue and green) and that light therefore cannot pass on to the film; where there is, or would have been, much of the colour so halted, the film is thus much underexposed, and appears thin – which translates to a dark tone on the print. But all light reaching a lens is made up of all the colours of the spectrum, though in different proportions; and stopping any of those colours means that extra exposure has to be given. When you buy a filter it will have a 'filter factor' marked on it – such as x2 – which is the amount by which you must increase the camera exposure to keep everything in order. Cameras which have TTL metering, and remember that is just about every 35mm SLR, will measure light through the filter as well, so that no adjustment need be made by you.

Special effects

We are still up in the clouds for the moment – and they really are important. Another dramatic way in which they can be given great prominence is by the use of a wide angle lens, preferably of 24 or 28mm. The impression of very steep perspective this introduces makes the clouds appear to spread out greatly as they near the camera, and a persuasive sense of spaciousness is created. The effect is particularly sensational with a mackerel sky, as you may imagine, and when coupled with a sky-darkening filter it is well-nigh overwhelming.

Going on up the focal lengths from a wide angle will take us away from clouds now. In fact, using a telephoto lens of respectable length, say 300mm, will put you well on the way to losing the clouds altogether. For in telephotography we meet a new condition of light – atmospheric haze. It is a leveller of contrast, a destroyer of detail. It is all around us, of

course, but only shows itself photographically when we probe out to picture a small slice of a scene before us, and have to spread that scene across the same negative area we used for a wide angle picture: the enlarging effect shows up the faults – if they are considered as faults.

Typically, a shot through a long telephoto lens is low in contrast, soft in coloration. Colours are muted, pastel: fine detail is lost in the general softness, but the effect is not displeasing. Filters will not do a great deal to emphasize certain colours when you are shooting with a long lens, for all that haze between you and subject causes the light to bounce around so much, and different wavelengths to intermingle to such an extent, that there is usually one overall impression – of the bluish mist of distance. But it is sometimes possible to snap up the telephoto image by using the contrast-increasing technique of giving extra development. On the whole, though, the best guarantee for good telephotography is – good quality lenses: those which are of poor manufacture will simply pile

A x 4 red filter was used to render the sky and sea dark and thus accentuate the boats. This print was later selectively selenium toned to highlight the rainbow. Mauritius, rangefinder Leica

A shot of minimal townscape relying for its effect on the play of diagonals between telegraph wires and the building. Japan, Olympus

their own defects on top of the sharpness-destroying haze, and the results will be disappointing. You can get away with inexpensive wide angle lenses, but once above 300mm you should look very carefully at 'bargains', for more than a few will have poor correction of the aberrations inherent in every lens, and they may also produce quite unacceptable flaring of the image.

To counteract all the possible evils of telephotography – and to take advantage of all the many possible advantages – you really have to use a tripod. Even quite a small quiver of the lens will spray the light path of the image passing through it, and will cause blur. Remember that distance increases the effect of image movement – however caused – when you are shooting through a long lens: keep in mind the astronomer who chided his assistant for nudging the telescope off a carefully sighted star with the words 'You've just spun off several million miles into space!'

There is no 'best' lens for landscape pictures. It all depends on what you want to show, and how. But whatever you do, remember that all the normal rules of lens behaviour continue to apply. Particularly easy to forget is the simple fact that tilting your camera causes straight lines of buildings to appear to converge as they soar higher from street level – so much so that in really bad cases the building will look as though it is about to topple over backwards. Out in the wilds there are no buildings, of course, and the absence of soaring verticals may put you off your guard. But just you tilt your camera upwards to include all of some rearing mountain, and its flanks – even though already converging towards the summit – will become distorted. Mountains are, after all, architecture of a sort, and any distortion which decreases their grandeur ought not to be acceptable. There is, if you do much shooting in mountainous territory, as much a case for use of a perspective control lens as there is when working in the concrete canyons of a big city. And specialist landscape photographers will often work with a big format camera, which allows use of the rising front control (and others) to prevent perspective problems ruining the effect intended.

Although there is no best lens for landscape, it must be confessed everybody has to start somewhere. Probably the most useful all-rounder to begin with is a 35mm lens on an SLR camera. It takes in a nice panorama, and offers considerable depth of field without too much stopping down of the aperture; thus, it is possible to enjoy landscape shooting on a fairly leisurely walk through the countryside, without the necessity for lugging a tripod along. Indeed, a good quality 35mm compact, with a focusing lens, would bring pleasing results, for the lenses of the compacts are usually 38 or 42mm in focal length – hardly true wide angle, but fine as constant companions.

Light

Out there on the moors, in the dales, amongst the mountains, you are on your own when it comes to light. You have to take what is available and make it work for you. Certainly flash is of no use – except for a few very specialized ideas, like lighting a subject such as driftwood or a strange rock on a beach, with fading evening light beyond to provide a deep blue background. But the variety of natural light is immense, and light variety characterizes different regions of the world. When the French writer Alphonse Daudet observed that 'All this beautiful Provençal countryside would not live without the light', he was uttering no more of a truth than the Glaswegian who insists, 'Oh it's lovely roamin' in the gloamin''.

It is difficult, in these city-bound days, to appreciate fully the influence of light upon life, or to be aware of it as the controlling force. Yet step out into the wilds and evidence surrounds you. The natural world is regulated by the sun; it is the sun which induces the moods and the movements of creatures, and plants will strive and strain from the crevices to

The objects in this photograph
are almost silhouetted, and the
picture relies for its atmosphere
on a formal arrangement of its
components. Goa, Nikon

reach the nourishing light. It affects us too, and impressions of
it in paintings and photographs, though pale versions of the
real, also affect us. A particular lighting effect, seen in a
picture, will still spread some of the influence of the reality.

Curiously, light appears to be at its most influential when
it is being interrupted. The harsh and direct sunlight of midday,
pouring down unfiltered through a clear sky, does little more
for us than make us want to lie down on a beach and doze.
And that too is the least interesting kind of light for landscape
photography. But put some obstructions in the way and the
story is different. When the sun is low in the sky it must pass
through much more of the earth's atmosphere than at midday,
and the light is softer, with a noticeable colouring to it; this is
much more interesting photographically, and the low sun then
also casts long shadows which throw the landscape into
graphic relief. When there are clouds the light varies with the
cloud cover. That soft and golden haze we see when the cloud
canopy is unbroken but thin and watery is so characteristic of
England. In Scotland, in the Highlands at least, the up-currents
of air caused by the mountains and the sea shred the clouds,

and here and there great shafts of gold probe between the
acres of grey. Then, when the sky is filled with moisture drops,
the sun plays his master card and arcs a vivid rainbow across
the land. And finally, at the end of the day, the sun stoops down
beneath the clouds to paint their undersides in pinks and
golds and burning red. Poetic? Of course – that is precisely the
point. There may be a fine suntan to be had on a blindingly
clear day, but there is precious little poetry in it.

While there is light there is a photograph to be had, and
this is true even by moonlight. But in very low light levels there
is a little pitfall awaiting the photographer; fortunately, though,
it is one easily leapt over. It is called reciprocity failure. First of
all, the reciprocity law states that an adequate exposure will
be produced on film as long as the total amount of light
reaching that film is sufficient. This means it matters little
whether the light is passed onto the film in a large quantity for
a short amount of time (large lens aperture, fast shutter
speed) or in a small quantity over a longer period of time
(small lens aperture, slow shutter speed). But in certain
circumstances that law fails to hold good. It breaks down

when the light in which photographs are being taken is very bright indeed, or very weak. What happens is that the film emulsion apparently loses some of its sensitivity.

The failure of the reciprocity law is unlikely to concern you in bright lighting: even at midday in the Sahara it is rarely so bright as to require the ultra fast shutter speeds outside the reciprocity law. But if you shoot pictures after dark, or at dusk, you will discover that your film will require much more light (longer exposure) than its ASA rating would suggest, or the meter indicates. Quite simply, because the sensitivity of the film has dropped, the indicated exposure no longer produces an adequately dense negative or transparency. The solution is perfectly simple: keep the shutter open for longer than indicated. How much longer? At least half as much again, though several times longer if it really is dark. Indeed, shooting by moonlight, or the faint glimmer of a sun which has just set but whose light is still reflected by clouds, you could try exposures of several minutes. Here, though, there is a genuine

need for bracketing – taking several exposures with the shutter open for differing periods of time, in the knowledge that one exposure will be more correct than the others. But do not worry about the reciprocity law failure unless the light is so low as to indicate that a shutter speed of a second or so is required.

Remember you cannot control light when landscape shooting – you can only react to it. And there is one reaction which comes just a little bit close to being actual control. It is limited, but it is there, so should be exploited. And it has to do with the brand of film in your camera when you are shooting colour transparencies.

The descriptions 'warm' and 'cool' are often applied to colour films. What they indicate is that one film will react more readily to the warm content of light than will another, which may be especially sensitive to light of the blue region of the spectrum. This variety of behaviour is probably more useful in landscape shooting than anywhere else in photography

This starkly simple evening shot, where most of the light comes from the street lamp, shows how a picture of great presence can be made with only a few simple elements. Primrose Hill, London, Olympus

Landscape can convey mood, as in this dark, brooding picture of a New Guinea scene. Olympus

(though romantic shots of girls often look more appealing if a film with warm bias is used). By selecting a warm film you may be able to counteract that pervasive blue which clouds transparencies on dull days: on such days a film with a leaning towards cool would turn in pictures with a monotonous and dull appearance – an overall bluish grey. You will need to experiment with colour film brands to find one which you like, and the biggest brands are often subtle in their bias. As a general guide, Kodak films tend to be cool, Agfa's on the warm side. The Japanese brands Sakura and Fuji are relatively cool, but Sakura goes warm very rapidly when the sun begins to drop – at which time the earth's atmosphere filters out much of the blue from sunlight, leaving the red dominant.

The way a colour film renders a landscape cannot really be indicated more accurately than above: so much depends on conditions, time of day – and on the user's concept of what is pleasing and what is not. Black and white film has no such vagaries, but papers for black and white printing do. Some will deliver a warm toned image, others a blue-black, cool image. The choice is yours — as it is from the moment you decide at which bit of a landscape you will point your lens.

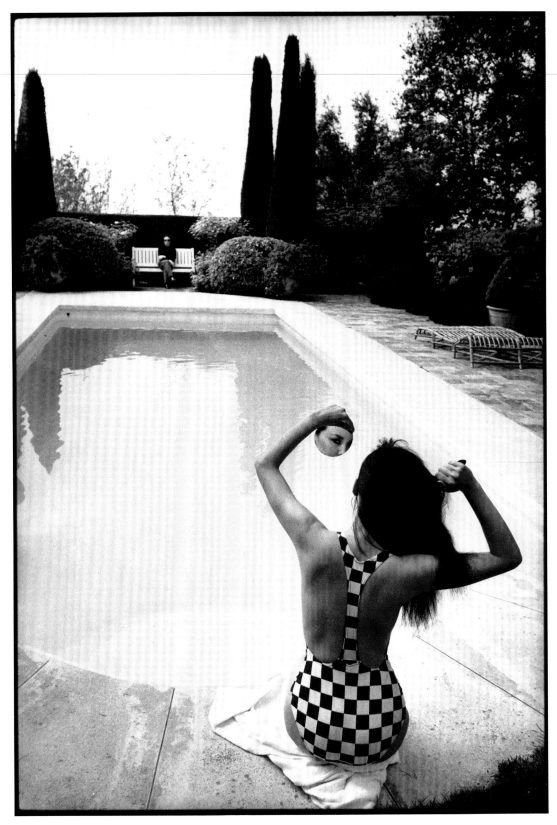

In an unusual location it is a
waste not to show something of
the atmosphere of the place
itself. Marie Helvin
photographed for Ritz in the
South of France. Olympus

Fashion photography

While fashion photography does pulsate with glamour, it is also nearer the common experience than you might imagine. The history books we all read at school were full of fashion drawings and engravings. A fashion picture is a record of a certain style of dressing – and as such it is also a record of certain of society's whims. We should not puncture the fantasy of it all by de-glamourizing fashion, but it is important to remember that, in contemporary times at least, its prime function is to demonstrate how a garment looks, and perhaps how it feels to wear it, so that the audience – of magazine or catalogue readers – will be tempted to go and buy it. A fashion photographer is only as good as his ability to shift frocks off the rails.

Diana Vreeland of American Vogue once put it very concisely: 'You must always take pictures that sell dresses; if it's images you want to sell then get a job with Harper's Bazaar or Popular Photography.' In fashion the client calls the tune, and if the photographer does not like it he should be out on the streets doing what Don McCullin does.

That said, the fashion photographer has quickly to establish his own trademark, so that it is he and not the next man who gets all the plum jobs. Shooting catalogues, and fashion for the women's pages of the newspapers, is pretty straightforward, but on the level of a fashion shoot for, say, Vogue, it is immensely important to get a reputation for continually coming up with fresh ideas while yet retaining a consistency. And even when a photographer is swapping films for different effects, experimenting with different props – or lack of them – and going in for different scenarios in his pictures, there is still something of his essence in every shot.

Strangely, fashion photographers as a breed were frowned on for a very long time. But fashion work actually encompasses the whole of the medium, and the photographer might find himself shooting a difficult piece of action in one session, a very carefully staged studio session in another. And it is the most difficult of all areas in which to succeed time and time again. Everything is against you and it seems a nightmare as you are endlessly trying new techniques. The model turns up with a spot on her chin, it's a bad time of the month for her, she has argued with her boyfriend that morning, the dress doesn't fit her, the fashion editor's hysterical. If you are photographing a can of baked beans it doesn't have periods and a jealous boyfriend on the other end of a phone saying 'Don't you love me anymore?' To handle all this really requires an élite – and there are probably no more than ten of them working around the world right now.

Any photographer needs a suitable climate in which to work; his audience must be receptive. And the French and the Italians are certainly far more receptive to good fashion photography than the English – especially the Italians, who are a very visual nation. They are the world's greatest designers, and they all have an opinion. If an Italian sees a fine chair he will comment on it, and he might observe how well it goes with that lampshade beside it. An Englishman might well pass a Turner on the wall without giving it a second glance.

There are as many different ways of shooting fashion as there are successful fashion photographers – those who are not successful cannot be said to shoot in a way that is valid for the purpose. Particularly variable is the relationship with the model, for models themselves come and go at intervals dictated by the pace of the change in the fashionable look of the moment. On balance, it is better to work with the same girl over a long period of time. And in the course of a lengthy relationship the photographer begins to shoot what are almost portraits of the girl. It is debilitating to work with a model whose name you do not know, whose personality you do not appreciate. A good model in a professional fashion photographer's studio is one who can become a personality in her own right; but that is not so good for the model, because it stamps her in the eyes of fashion editors, and may well affect her chances of getting future work. Once a model becomes too much exposed, people will begin to recognize her, without taking in the dress she is supposed to be helping to sell. It is especially bad for cosmetics advertising: a well-known face will have magazine readers saying, 'I could never look as lovely as her' – what is needed is an anonymous model with whom the public can identify. Many models will, of couse, be perfectly willing to accept this, for they can go on to become well known in other areas too, though fashion modelling may have become less lucrative.

Cornwall provided the rocky setting for this romantic fashion photograph for American Vogue. Penelope Tree's almost Carolingian hairstyle adds to the atmosphere – it is as though we are witnessing part of an unknown story. Nikon

A highly glamorous shot, in the Hollywood mould, for Ritz. The lighting, back and front, is by quartz lights (redheads) and the camera was an Olympus

Shooting fashion

There is a common misconception that all fashion photographers load a 35mm camera and zip through 36 exposures in no time flat, ending up with hundreds of negatives. But you cannot work that way with a 5X4 camera. A sensible average is six clicks of the shutter, and that means 5X4 shooting has to be very carefully controlled. This in turn introduces the need to direct the model to a very great extent: the idea that she just stands there and sways in front of the camera to the beat of the latest rock group is nonsense. The only real reason for shooting several rolls of 35mm film on a fashion job is to bracket the exposures. The way to judge a new young photographer is to look at his fashion photography contact sheets: if the pictures are all more or less the same pose, but exposure is bracketed, you can say he knows what he is doing, and has confidence in his own planning for the session – but merely wants to make sure he is technically perfect too, for quality does matter a great deal when you have to show very delicate textures and sheens. Give a

chimpanzee a motorized Nikon and you might get something now and again – but assuredly by pure accident.

In a studio fashion shoot there will be several people in attendance, and it is important they all contribute. For example, the make-up artist is very important, and the photographer must make sure she (or he) knows what kind of lighting is going to be used. If the plan is to use very soft and diffuse lighting then the last thing that is wanted is very hard make-up; but if the intention is to burn-out the skin tones, then what is required is make-up strong and hard enough to maintain the shape of the face against the white of the paper when the picture is printed.

Make-up is a particularly precarious area, for style changes so speedily that the girls themselves may be unrecognizable from one year to the next, so many changes do they go through. When a model in the studio, prepared for a fashion shoot, looks in the mirror and does not like the way her make-up has been arranged, then the picture has scant chance of succeeding; the model must like herself – and if the mirror displeases her she will not like herself much in your

lens either. So, requirement number one for the fashion photographer's make-up artist – make the model happy. If she is happy, the photographer is already twenty-five per cent of the way there.

Probably the biggest hurdle a fashion photographer has to clear is his relationship with the people he will work for, his clients. It is a sad truth that many fashion editors have not been near an art gallery for twenty years and could not tell a van Eyck from a Rauschenberg. They are writers and editors and not visual people at all. If a photographer has been working for the last thirty years to get a picture right, he needs to be very constrained when someone with no appreciation says 'I don't like it'.

The other arts do, and should, influence photographers. Photography is still a relatively new medium and there is much the early artists could have done had they been able to employ its unbounded flexibility. In a way, today's

A straight glamour photograph of Patti Boyd, taken in the studio with electronic flash bounced off umbrellas. The asymmetrical composition makes the eyes the focal point in this dramatic shot. Nikon

photographers are recreating the old images all over again, in modern settings. But even designers of bathroom fittings can set an imaginative mind working, with their clean chromium lines, and their elegant areas of plain tiling. Helmut Newton particularly appears to respond to modern design, somehow contrasting it all with the softer contours of woman and coming up with pictures which are highly erotic; in Newton's pictures the girls are not vulnerable – they are having the time of their lives in amongst all the harsh but pristine trappings of modern living.

Flexibility and control

So much of photography's flexibility comes from what the photographer can do with his film. The control he can introduce through simply changing to films of higher or lower ASA rating is extended so much that he can play the whole tonal scale from pure white to densest black whatever the lighting conditions. And when you consider that a fashion photographer usually has the lighting under control as well, you will realize that there is virtually no effect which cannot be created.

The fashion photographer will be very cavalier about contrast. It is his palette – his only one – if he is working in black and white. In the subtlety, or the harshness, of his switching from grey to black he can create mood as effectively as if he had all the colours of the rainbow in his camera. And there is probably not a film in the world to equal Kodak Tri-X for the range of image quality it can be induced to yield. It can be rated at anything between 25 and 2000ASA, and development suitably adjusted, and it will still yield marvellous results. Indeed, once you have become familiar with Tri-X it is soon evident it can produce an image of just as wide tonal range, and as little grain, as Ilford's FP4. Its best characteristics show up on the larger formats – 2¼ square and 4X5. But liking for one film should not prevent you now and again shooting with another. Infrared film – which can be processed perfectly satisfactorily in D76, classic developer for Tri-X – will turn in an interesting range of tonal effects, and especially if you experiment with it over the span of 125 to 400ASA.

It is currently much in vogue for photographers to posture, to don the mantle of total artist and to profess disdain for the technical matters of the medium. That is pompous, and remarkably shortsighted. Photography is a medium stuffed to the ears with techniques, all capable of being bent to the photographer's creative desires. To exploit these techniques to the maximum is to be in command, and to open up a million opportunities for expressiveness of different mood. Never be too proud to try the techniques of the pioneering amateurs who fiddled with evil-smelling brews at the birth of photography. Even a technique so thoroughly obsolescent as gum-bichromate could still be stunning today when used with the right subject.

Most fashion magazines insist
on the photographer showing
every stitch of the garments
very clearly. A few, such as Ritz
for which this picture was taken,
afford more freedom

This shot, for British Vogue, relies for its success on the simple but strong geometry of the composition and the out-of-focus space in the window reflection. Honolulu, Olympus

Marie Helvin wearing an Yves St
Laurent swimsuit in Mexico. The
back view makes for an unusual
image and draws attention to a
key feature of the costume's
design. Olympus

The highly complex, even cluttered, setting of a Turkish barber's shop provides an unusual backdrop. British Vogue, Nikon

The choice of props and accessories for glamour and fashion photographs is very important. In this studio shot for Ritz they have been kept to a minimum, with the toy lion adding an element both humorous and suggestive.
10 x 8 Deardorff

Unlike, say, landscape or natural history photography, fashion work cannot be considered a separate compartment of the image-making business. Certainly it is not seen in isolation by those at whom it is aimed. In a magazine, a fashion feature may be slotted between an interview with an actress and an article on travel. It is, by its very nature, a reflection of the contemporary. Crazes are mirrored in it – remember all those pictures of girls roller-skating and skateboarding, and remember the Egyptian look which flared briefly when the Tutankhamun exhibition created queues a mile long. But those were clumsy influences, so obvious you would be able to forecast them. There are influences much more subtle, but just as indicative of social change. That may all sound rather too deep when all we are discussing is the illustration of a frock for the express purpose of selling it to the fashion-conscious public; but even though photographers work to the brief of an art or fashion editor and an art director, this does

not by any means suggest they are mere button-pushing automatons. Photographers live and breathe and experience everyday living just as intensely as anybody else; and as certain words periodically become 'smart', so do influences show in fashion pictures. Go back to the days before Vogue used photographic covers and you will find a positive pocket history of the era. The painted covers reflect the popularity of such things as oriental prints, Aubrey Beardsley's highly stylized drawings, art deco, the tail end of art nouveau, and there is a whole world of patriotism in some of the painted references to the two world wars. On the cover of the French edition of Vogue in July 1934 there appeared a bronzed maiden sunbathing topless: in Britain and USA she sported a sober two-piece. And in photographs surrealism came to Vogue, with the pictures of Horst, images as eyecatching as anything by Dali.

Lighting

When it comes to lighting fashion pictures there are just no rules. Keep in mind the fact that the prime requirement is to sell garments, but beyond this there is no limit to how the public may be persuaded to yearn for the garb on the glossy pages. Light, for the landscape photographer, and the portraitist to a certain extent, is part of the natural order of things; it is the atmosphere he needs to capture, it is a condition he must evaluate and decide how to capitalize upon. Of course the studio portrait photographer will make his own decision as to whether or not he should use flash, window light, reflectors, or whatever; but the fashion photographer, more than any other, considers light as much a tool of photography as his camera and the film in it. And for that reason he will often jaunt to some exotic location where he can guarantee finding the right tools – the clear air he needs, the perpetual bright sunlight which will suit the kind of clothing he is to photograph, the misty evening haze to set off romantic wear. Flash is very much a tool, whether as a small and portable unit or a big studio console blasting out as much light as the midday sun.

The thing to remember about flash is that it does precisely the photographer's bidding: he presses a button whenever he wishes and out streaks the light, coloured or not as he chooses (filters over the light source) and travelling in whatever direction he chooses, in a straight harsh beam or diffuse as he prefers. And he can, too, control the shadows – by bouncing the flash off some light-spreading surface, by shielding some of the light by clipping cards to the flash head, and by using a flash tube designed to eliminate shadows altogether. There is a small portable unit designed for use by dentists, which has the flash tube arranged in a ring. It is supposed to be used at close quarters, when the ring flash distributes light all over the subject, so that nothing is unlit. It is fitted around the camera lens, and the picture taken through the ring. The unit is also favoured by natural history photographers, to picture insects and flowers. But its curious light can be used for fashion work when the greater distances involved bring about a rather odd but interesting effect – a thin black line all around the model, brought about because with a large subject there is more light throwing the shadows than there is killing them.

There is no suggestion that ring flash should become anybody's standard equipment for fashion photography, of course; it is discussed here merely to highlight the fact that flash is a tool, and all its oddities should be explored. And doing so has become very much easier today, thanks to the abundance of computer flash units on the market. The old necessity of having to work out exposure via the guide number (describing the power of the flash unit) has all but vanished, at least where portable units are concerned. A computer unit – or automatic flash unit – has a sensor on the front, which measures the light bouncing back off the subject:

The T10 Ring Flash 1 helps to eliminate shadow by giving all-round light and gives greater automatic control when used with the Olympus OM-2 camera

when the computer assesses that sufficient light has been produced to make a satisfactory exposure, it simply switches off its light output. Simplicity! And when working close-up, less light is needed than for distant subjects, so that even a small modern unit will recycle – or recharge – very quickly indeed, and will be ready for another exposure within a second or so. Many of the disabilities once associated with flash have now vanished, and the contemporary photographer should explore to the utmost the range of effects now open to him.

Flash units have a colour temperature, just as all other light sources do, and it is usually about 5500 K, matching its performance with daylight colour film to that of noon sunlight. Thus no filtration is needed. But it is easy to convert electronic flash to match the sensitivity of artificial light film, by putting a filter over the flash tube. And coloured filters, or gels, are often used to introduce certain aesthetic effects.

There are still tungsten light sources used in studios, of course, where portability matters not a jot. But a modern compromise is to use a unit which has both tungsten light and electronic flash. The tungsten light serves as a modelling light, while the flash tube is used for the actual exposure: this overcomes the objection that the brief burst of light from electronic flash does not allow the photographer to evaluate his lighting balance and to check for unsightly shadows. The use of Polaroid film to check exposures and balance in advance serves the same purpose.

Versatile though electronic flash is, the range of atmospheric effects in natural light far exceeds it. But not all those effects will be to everyone's liking, and there are other considerations to be taken into account too. Very early morning light is fascinating – but your model's looks may not

Even old denims can look
glamorous if the right person is
wearing them! Taken for The
Sunday Times on a Nikon, using
ring flash light

be. She will probably still have a rather puffy appearance about her face, which will not wear off until later in the day. And the midday lighting is high and harsh. After 4pm is a good time to start shooting – but you will quickly run out of light in certain parts of the world, and you will have to cope with a speedily dropping colour temperature, which quickly introduces sufficient red to make your model look like a boiled lobster unless filtered away. Fashion work in black and white is a feasibility in the morning, but do not try to beautify any lady on film – outdoors that is – until after 1pm at the earliest.

Composition and effects

What do you do with a girl once she is in front of your lens? This question can no more be answered than can the business of how Rembrandt and Vincent van Gogh succeeded on composition alone. It is no good replying that there are things you should not do, for there are photographers who can put a girl in a sackcloth, stand her straight and rigid in front of the

camera and still produce a great picture. And the answer is not simply to stick on a wide angle lens and go for extraordinary shapes and much-stretched legs. It all depends on the girl, and on what she is wearing, and for a professional photographer at least it may also depend on the shape he has to fill. A single column picture for a newspaper's fashion page will require a very different kind of posing from that needed if the picture is to be used for a horizontal poster for hoarding display. But what is necessary is rapid cultivation of the ability to look beyond the immediately obvious. And to be able to do that you will need an awareness of all the tricks you can play with lenses, with techniques, with accessories.

For example, one piece of accessory equipment you will find in just about every professional studio is a wind machine – a giant fan. It is used to blow the model's hair and clothes about, to introduce an exotic impression. But a girl with very long hair obviously raises fresh compositional possibilities with a wind machine turned on her: instead of an upright and narrow shot you could create a square composition, with her

It is not always essential to own a sophisticated camera in order to take good photographs. This shot for British Vogue was taken on Worthing Pier with a long-since obsolete 1920s rollfilm camera using 120 film

A relaxed, casual photograph
for British Vogue taken in a
square in Nice, and lit by direct
electronic flash. Nikon

Here the photographer was himself the subject of a documentary film, and he decided to capitalize on the film crew's presence by including them in this photograph taken for British Vogue. Zambia, Nikon

hair streaming out to one side, and her long loose dress swirling around her body – perhaps flaring up to give an erotic peep of thigh. Or the model could hold a brolly, and could lean into the artificial wind, with a rain coat flapping around her, to give an immediate impression of conditions for wearing winter clothes. But nobody should rely on a wind machine to solve problems, nor should they rely totally on any other artificial trick. The first line of attack should be through your own imagination: then the simplicity of outline, subtlety of texture, and quality of expression on a model's face will, even though they are basic ingredients, prove perfectly adequate for a successful picture more times than not.

Whenever you start searching your mind for the different effects photography can bring you, be careful not to get stuck in a predictable rut. Do not limit your mind's ranging to the conventional. Remember always that what is coming off the model and towards your camera lens is a form of energy, light rays which can be interfered with. For example, let's suppose you are faced with a model who is particularly graceful, tall and slender. In the back of your mind may be the idea that you should somehow capitalize on that, dramatize it even. You could visualize the effect through lenses from 20 to 500mm and not come up with a jot of difference other than the stretching induced by shooting from low down, exaggerated by going close with the wide angle lens. But if you then opened up your thinking, and considered how you could actually mould those advancing light rays to your advantage, you might just come up with the thought that an anamorphic lens would do the trick.

An anamorphic lens is most often met with in the cinema, where it is an integral part of the wide screen system. It works by squeezing an image laterally, reducing the horizontal scale in relation to the vertical scale. The result is that whatever it images onto film appears tall and thin: the image is usually projected through another anamorphic system and so brought back to correct proportions for the cinema audience to enjoy. But when used in still photography the anamorphic image can be printed as is – to give you your curiously but effectively elongated lady. The more you explore techniques in this way the more readily you will recognize circumstances in which they can again be valuable, but do not simply discard one limitation for another by becoming totally dependent on some gimmick or group of gimmicks.

Of course there is little justification for shooting out and out fashion pictures unless you are being paid to do so; it is a particularly professional pursuit. But the hobbyist may go through all the motions – except receiving the cheque at the end of it – and still gain great enjoyment. The difference is that his is the taste to be pandered to, and not that of a fashion editor. As a matter of fact some of the very best portraits have been remarkably close to fashion photography in concept, with the clothes the sitter is wearing playing a great part in the overall design of the picture. The border line is a fine one, constructed more of intent than appearance. And it is no

accident that the photographers who are successful in fashion are also of high reputation in the field of portraiture. Yet it does not work the other way round. Perhaps this is because the photographer who sets out primarily to shoot portraits is very much more concerned with the placing of lights to accentuate a face than is the fashion photographer, who will use texture, make-up and shape to 'paint in' his faces, but whose initial concern is the overall design of his pictures. Design if pleasing can be adapted to anything – otherwise there would be no traditions of interior decor, with a motif carried over from furniture to soft furnishings and accessories around the room. It may well be too that the fashion photographer can be compared to the art student who must study anatomy before he can convincingly draw the figure: the fashion photograph is nearly always concerned with the whole body, sometimes in motion, whereas portraiture has the face as focal point.

We have been talking of the kind of fashion photography which portrays the whole lady – and which really is glamour photography too. It sets out to create a glamorous desirable image. But there are many fashion pictures in which only the hands or feet are seen, as when it is jewellery or shoes or stockings which are being advertised. And in cosmetics work the emphasis is on face, lips, eyes. It would be wrong to insist that all of those are variations on still life shooting, for of course there is still a human being involved – though not always – actually to model the product. But the approach is certainly different from that brought into play when the whole body is subject. Modern make-up, with its sometimes hard and glossy colours, opens up the opportunity for some striking effects, as does the photography of hair styles. But they are rather specialized fields, for both photographer and model. The message is ultra simple, and the impact has to be immediate; there is little room for subtlety, though the photography of shoe fashion is fairly fertile in graphics. The fact that when hobbyists shoot what they think of as fashion they go for the whole body is indicative enough of the popularity of the whole model over her assorted parts.

A leaping Jerry Hall
photographed on Primrose Hill,
London, for The Sunday Times.
The camera here was a
Horseman 6 x 9 and a small fill-
in flash was added to stop the
action and keep the lighting
clean

Action photography

The logical way of showing movement, or action, is to show it happening, by using one of the moving image mediums. Cinephotography, television, video, can all show, say, a sprinter pounding through an entire race, and they do it by the straightforward means of a camera operator keeping his lens pointed at the runner, following him from start to finish. This might seem to make still photography inadequate, but it does not. Consider how many times TV goes into slow motion replay, a technique designed to give the relatively sluggish eye and brain time to comprehend the several components of movement, and to appreciate what has happened. The still camera gives endless opportunity to examine what happened. But he is an unwise photographer who goes in search of action without first establishing exactly what he wants to show.

In athletics, competitors will scorch along a 100 metre track well in excess of 20 miles an hour. What is to be the picture? Will it show what was happening to one competitor during one minuscule fraction of the race? Will it show the state of the race – who is beating whom – at one moment? Or will it give an impression of the tremendous speed of the athletes? Perhaps it may set out to suggest, in facial expression and straining muscles, the immense output of energy and adrenalin involved in pushing the body to its maximum speed? Each time you frame a piece of action in your viewfinder you should have asked yourself all such questions. For the answers will suggest what equipment you should use, and what technique. And all moments of action will offer different impressions when photographed in different ways.

It has become normal for action photographers, covering sport, war, demonstrations, to use a camera fitted with a motor drive. The Nikon F3 single lens reflex camera can expose up to 6 frames per second (FPS), though most motor drive units expose up to 4FPS. Slower than that, and they are considered as power winders rather than motor drive. Remember that with the introduction of the first Leica, 35mm photography was born of the cinematograph system, so that motor drive units are not new – they are merely taking advantage of 35mm film's evolution. The film still has 'sprocket holes' along each side, which makes it relatively easy to transport it rapidly through the camera. There have long been models which automatically did this. In fact, back in the mid-1960s there was the very popular little Canon Dial – a half-frame camera with a clockwork motor built in. It could be used once in a while to introduce a feeling of action photography into fashion work. But it is important to understand the essence of the modern motor drive: it is there to transport film quickly, so that no time is lost in advancing the film manually for the next exposure. However, a reasonably agile photographer can, without a motor drive, shoot perhaps two frames a second: what the motor drive does is remove the need to advance film manually, and it prevents the jerking and fuss of advancing, allowing the photographer to follow action smoothly, using only his trigger finger. His motor drive may advance his film by just one frame at a time, or it may be set to advance non-stop all the while his finger remains pressing the shutter release button.

Does this motor drive help produce better action pictures? It can, but in no way does it guarantee them. It can in the sense that it eliminates certain mechanical actions, leaving the photographer free to concentrate on timing and composition; but when allowed to run on by itself it can actually inhibit good picture taking.

Motor drive dictates the instants at which the shutter opens, thereby capturing on film particular moments of a continuous process such as a race

In strong sunlight recording action becomes much easier. The exuberant feeling in this fashion shot for British Vogue, taken in Zambia, is all down to the movement of both the model and the tribespeople. Nikon

In the available light in a sea-life park in Honolulu, use of a flash would have been a disturbance and given undue attention to the figures in the foreground. The quiet action of the rangefinder Leica was a considerable benefit

Let us consider again our athletes sprinting that 100 metres. The race will be over in less than 10 seconds, and a motor drive firing at four frames per second will zip through an entire cassette of 35mm film in that time. If the camera's shutter speed is set at, say, 1/500th of a second (the motor drive does not control that), then the 36 pictures taken will cover only 36/500ths of a second of action. This is less than 36/5000ths of the race, not even a hundredth of the action. And for every one of those 36 exposures the exact fraction of a second for firing the shutter will have been dictated by the motor drive, not by the photographer's sense of what makes a good picture.

The motor drive is a gem of convenience, but it does not decide when the elements of a photograph are well arranged, or when the time is precisely right to fire the shutter. So why use it? For sequences: for sets of pictures which illustrate something developing – a racing car crash, a goal being scored, a boxer going down. Even faster sequences than 6FPS are not unusual in 'still' photography, especially when a high

speed stroboscope is used, but they have little to do with the action photography we see around us in newspapers and magazines. By all means use a motor drive, but let it keep your mind and your eye free for choice of timing and composition. Don't let it take over the aesthetics.

Shutter speed

Back now to what impression an action photo will give. At its simplest it will be a frozen tableau. It will show something which happened too quickly for the eye to see. Shot at a high shutter speed (upwards of 1/500th of a sec) it will show an athlete's muscles rippling, his flesh quivering along his body as his foot strikes ground after each pace, or when he touches down from a long jump: it will show sweat flying, teeth gritted, dust spraying. It will depend for impact on the glimpse of what is never seen with the naked eye, and on arrangement of shapes. In particular, photographs taken at boxing matches tend to be spectacular: the photographer sees a punch

coming, presses his shutter release, and – since he works with a high speed powerful flash – gets his picture just as the blow lands. His picture shows the unhappy victim with his face pushed completely out of shape: it is absolutely factual, yet it seems unreal. And it seems unreal because the scene shown is, outside photography, over so quickly that it never registers in the human eye. That kind of frozen action is, though, perfectly valid, and the newspapers are full of sports action. Indeed, it is almost a major ambition of photographers covering Wimbledon to get shots which show the ball flattening on impact with a tennis racquet. The important elements are timing and a high shutter speed. You should either set the shutter manually to 1/1000th second (or 1/500th or 1/2000th, depending on the light available) or, if your camera is an automatic of the aperture priority variety, set the widest lens aperture which will force the shutter speed high enough. If you do go in for frozen action you will certainly find that you need to use film of 400 ASA at least, but you can push the sensitivity to 1600 ASA or more by forced development.

The question of timing has nothing to do with the camera; it is entirely your responsibility, and it requires anticipation. There is a certain time-lag between making a decision and acting on that decision – the Highway Code refers to it as 'thinking distance'. It is a tiny slice of time, but it is there; and it means that if you decide to photograph something only when you see it happening, it will be over by the time the shutter opens. For example, at 60mph a car will travel 60 feet between the driver's decision to brake and the moment he actually presses his foot down hard – and it will take about 2/3 sec to cover that distance. Of course, this applies to braking in an emergency, an unanticipated event. So we can assume that if you are anticipating an action your reflexes will be 'tuned up' and you will react more quickly, but

With this sort of shot there is no second chance. Lighting conditions under the station awning were far from ideal but an exposure of 1/60th sec was sufficiently fast to keep the slowly moving man sharp.
France, Pentax

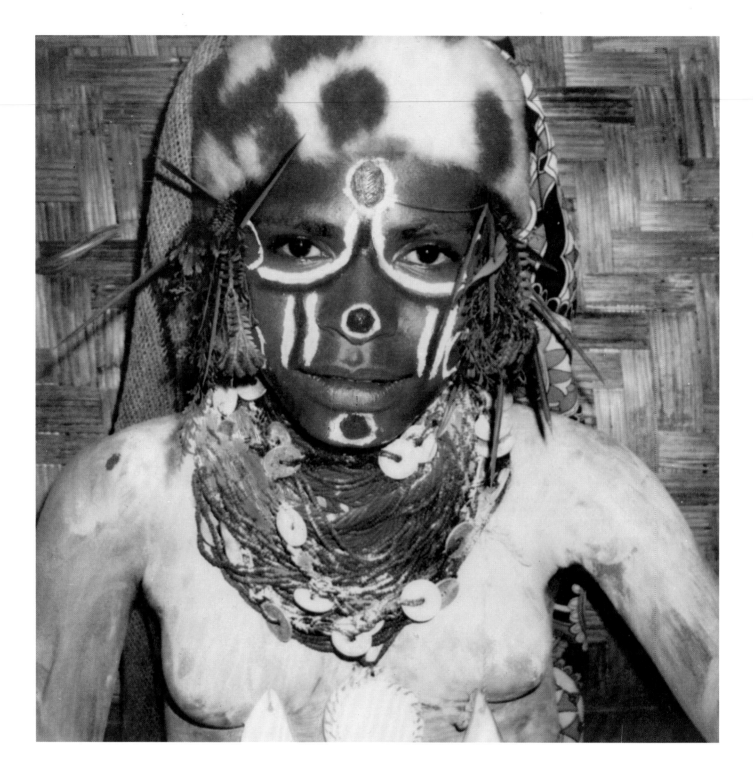

there will still be a time lag. And photography introduces yet another lag, though again a short one: it is the time taken for the camera to operate through its mechanical or electronic linkage between the release and the shutter and the lens diaphragm blades.

Obviously, it will help if you know what is coming so that you can judge how much in advance you must press the release button to get what you want on your film. You may think we're making a lot of fuss about fractions of a second, and that it doesn't really matter as long as you get some sort of action picture which is sharp and well exposed. Think on in that way if you're not genuinely concerned with rising above mediocrity! But consider an illustration first. You are photographing a steeplechase, and somewhere around the exact moment a runner reaches a hurdle you fire your shutter. If you've been too hasty you may find you've caught him with his trailing leg still on the ground: too tardy and perhaps his

leading foot has just touched down. Neither image is going to give any kind of impression of speed or grace: they will, instead, look distinctly odd – as though the hurdler is actually doing leg stretching exercises! But get it right – press the button as you see he is about to take off – and you have a picture full of action and flowing rhythm.

Panning and blur

Unless an action subject plainly is in motion – hair flying, wheels blurred, arms swinging – you may fail to produce any impression at all of the action when using very high shutter speeds to freeze a subject. But there is a way round this – at least with subjects which are actually travelling (cars, bikes, runners, speedboats) as opposed to those in action on one spot (such as boxers, wrestlers, weight lifters, dancers). The method is known as panning, and it depends for effectiveness

In this unusual fashion photograph for Ritz the figure of artist Brian Clarke about to pounce on Marie Helvin and the dark backdrop of trees give a slightly sinister feeling, redolent of De Chirico. South of France, Olympus, 1/250th sec.

Sometimes movement can be best conveyed by having the subject slightly blurred. In this photograph the slight movement in the trees, and the lady in the foreground are emphasized by the static solidity of the tower block behind. Hawaii, Olympus, 1/60th sec.

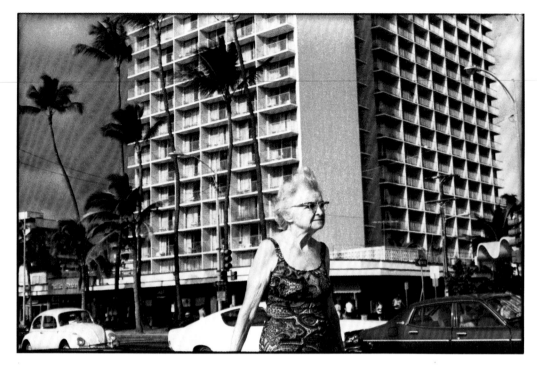

on your choice of shutter speed and your ability to swing a camera smoothly from side to side while it is up to your eye.

The idea of panning is that the subject should appear sharp (though some blurring is allowable, and sometimes is introduced deliberately) while the background is rendered as a series of blurred streaks – perhaps even one smoothly flowing streak. The crisp details of the subject stand out starkly against the soft blur of the background and give a remarkable impression of motion, which is particularly effective in colour. The very best results from panning come when the subject is moving straight across your field of view: when the target is moving diagonally towards you the swing of your camera is lessened, and the streaking of the background is not so evident.

In panning, the order of operations is to pick up the subject in the viewfinder, swing with the moving subject, fire, and follow through

Panning brings results through the subject being motionless, but motionless only in the camera's viewfinder. The reason it appears motionless is that the camera swings with it, so that it occupies the same place in the viewfinder – and thus on the film throughout the time the camera shutter is open. Obviously, the smoother the swing of the camera the less will the image of the subject move on the film during the exposure, and the sharper it will be. At the same time, the swinging camera will cause the background to appear to move across the viewfinder – and thus across the film – and that background will be blurred in the picture. How much the background is blurred depends on the shutter speed selected, and how much the camera swings while the shutter is open. A photographer who is really proficient at panning – one who can swing the camera smoothly and keep the subject steady in his viewfinder – will get perfectly good results even with a shutter speed as slow as 1/15th of a second. With very fast subjects, such as racing cars and motor bikes, a much higher shutter speed will still give good results. As for focusing, it is easy: you pre-focus on one point of the track or circuit or whatever, across which the subject will pass; fire when the subject is just about to move over it.

If you don't trust your ability to swing an unsupported camera smoothly you should rest it on a fence or tree stump. Better still, use a tripod with a special pan and tilt head: this allows movement in all directions, but it can be locked to limit certain movements.

With the panning technique and a slow shutter speed, there is no possibility of producing a perfectly sharp picture of, say, a racehorse, a runner, or cyclist, a swimmer, a rioter running from the police, or a streaker invading a soccer pitch.

Using only available daylight, it was necessary to opt for the fastest possible shutter speed – in this case 1/250th sec – in order to freeze the action in this fashion photograph, where the coat was required to be perfectly sharp. Cornwall, for British Vogue, Nikon

The intensity and short duration of the electronic flash will arrest any movement. Here movement is implied in the pose, but the detail is sharp. Jean Shrimpton, for British Vogue, Paris, Hasselblad

All of these subjects display movement in several different directions at the same time – movement of arms and legs – yet the technique is still much used, and a certain amount of blur allowed to show. The simple fact is that blur itself suggests movement, and its indications will say much about speed and effort. The results may often be bizarre, particularly when a very slow shutter speed is used: a panned shot of a Derby runner, for instance, would give a fairly crisp rendition of jockey and horse's body, with the horse's legs blurred into a whirl almost like cart wheels.

Choice of lens

Besides the presence or absence of blur, your choice of lens will have considerable bearing on the impression you put across with action photographs – at least in colour, for it is no trouble to pull up (or enlarge) a section of a black and white negative to such an extent that it matches in image size and perspective a picture taken with a lens of longer focal length. Colour transparencies may, of course, be enlarged too, or sections of them converted into greatly enlarged colour prints, but these are more expensive processes than blowing up black and white negatives.

The basic element of sport is competition; and the basic element of action is the changing juxtaposition of the component parts of the picture. We can look at sport first.

Stand close by the side of a track, photographing any kind of race, with a wide angle lens on your camera. With, say, a 35mm lens – a modest wide angle – a runner will fill your frame when he is a couple of yards from you. Another runner only two yards behind the first will appear to be only half as large, and will give the impression of being a long way behind, though the race may be nowhere near decided. But switch to a telephoto lens and shoot from the far side of the bend as the runners move towards you, and that six feet between them will vanish, or will seem to. They will seem almost as if glued together, according to your impression.

The ability of lenses of varying focal lengths to affect apparent distances between objects and people – the juxtaposition, or relationship between them – is a weapon with which you can put a certain impression into all action pictures; indeed, into pictures of all sorts. One example: the photojournalist working on magazine stories tends to work most often with a wide angle lens, for it is the one that gets most of the subject in, and it is always easy enough to crop away unwanted areas of the picture at a later stage. But

When you must use only the
available artificial light and yet
there is action to render sharp,
then you may have to increase
the rating of your film speed.
This shot of ballroom dancers in
London was taken on an
Olympus camera, using Tri-X film
rated at 800ASA

because it apparently distorts perspective (it actually doesn't,
as explained in the chapter on lenses) it makes objects or
people close to the camera look disproportionately large. The
result is that when one person is the main subject, and the
photographer has moved in close to get a big image of him or
her, that subject dominates; in this way the domination can
easily make the subject appear sinister or overbearing.
Consider a photographer covering a rowdy demonstration
during which he moves close to photograph a policeman
arresting a suspected rioter. You can easily see that depending
on whether the policeman or the suspect is closer to the
camera, the impression of who's bullying whom will vary a
great deal. Always 'read' wide angle pictures with caution –
things are seldom entirely what they seem.

A variation on the theme of the holiday snap. The lady taking the sun at Nice has been rendered more interesting as a subject for the camera by the use of an unexpected viewpoint. A snap does not have to be a hurried affair – though some of the best ones are, of course – and it can often benefit from a little thought given to the composition and background. Olympus OM2

Snaps

At Christmas, in 1968, a brief argument resulted in what is probably the most famous snapshot ever seen. Apollo 8 commander Colonel Frank Borman was much taken with a sudden view of earth, apparently rising above the horizon as his craft orbited the moon. But every frame of every film on board the spacecraft was scheduled for use in scientific experiments, to picture the various phenomena met with out there in space. Borman's crew photographer was unwilling to waste an exposure on anything unscheduled, no matter how appealing, and it was only when the commander pulled rank and took over the camera himself that the most stunning view of our earth was recorded. It was, of course, a pure snapshot. But NASA was besieged by requests for the picture; it was splashed across double page spreads all around the world. Within weeks it had been seen by millions more people than had ever seen the works of any of the conventionally famous photographers – or even the paintings of Rembrandt.

That little tale serves to underline that the snapshot is not to be considered in the same light as other photographic works; it matters little who takes it, for the important elements are where, when, and of what or of whom. And though Frank Borman used a Hasselblad camera, specially adapted for work in space, a snap taken with the simplest 110 camera could find itself the centre of just as much attention.

The snapshot could be said to be an eye witness account of something, with all the reliability that the reality-mirroring of photography offers. But for every snap as significant as Borman's there are several million of events as ordinary as, say, somebody's child taking a first paddle in the sea. That, though, is an altogether insufficient reason for holding the simple snap in any kind of disdain.

There is probably no all-embracing and satisfactory definition of what the snapshot is which will please everybody. Make no mistake, for some photographers 'snap' is a term of abuse, and for others it is an affectation. But for our purpose here it is to be taken to mean any picture shot without the careful planning and attention to detail which characterize just about every other kind of picture we have discussed in these pages. We shall therefore be considering pictures taken 'on the run'.

The essence of snapshot photography arrived with the more sensitive film emulsions which allowed the pioneers to begin snapping life actually happening. Before the faster films, pictures of street scenes would show people and horses and carts blurred, because they moved during the lengthy exposures – or absent altogether because they moved so much during exceptionally long exposures that they failed to register on the film at all, since their image did not stay in one place long enough on the emulsion to create any effect. The early bulky cameras were used on tripods, of course, and continued to be so used even when the snapshot became possible; for a quite low shutter speed – of, say, 1/4 second – might well suffice for a street scene on a plate of around 10 x 8 inches, but if the camera had not been supported on a tripod even the buildings would have been blurred, through camera shake.

Camera shake is familiar enough, and you hear about it wherever photographers get together. It is a wrecker. One small dose of it can make nonsense of the price tag on the most expensive camera or lens, and it can invalidate the most careful processing of film by the most conscientious laboratory technician. And it has affected camera design and film technology. So let us square up to it right now, and make a resolution to banish it for ever.

Shutter speeds

Think of those straight lines of light rocketing out from every point of your subject, through your lens and onto your film: you can see that even a quite small quivering of your camera will be matched by a relatively large movement across the area of the subject. And once there is camera shake on a negative nothing can remove it – it ruins the definition qualities of your lens, and negates the precise machining of your camera. We all shake, of course, and if you try peering through a pair of high powered binoculars without supporting them you will see by how much. Even if you are not yet into your dotage you will still quake – because of the blood pumping through your veins. It will help to a great extent if you use as high a shutter speed as possible – 1/125th sec or faster

Personalities are often used to
being photographed and will be
less inhibited by the presence of
a camera. Yves St Laurent
kissing Diana Vreeland. Paris,
Olympus

– and support the camera against something steady, such as a
wall, a tree, a gate. Always press the camera firmly against
your face too, and whenever possible rest your elbows on
something firm as well.

It is quite a boast amongst photographers that they can
(or say they can) 'hand hold' a camera rock steady at speeds
down to 1/8th or 1/15th sec; but even they would produce
camera shake if they opened that shutter just at the moment a
surge of blood pumped along the forearm. It is most certainly
unwise to shoot pictures at slower than 1/30th sec without
support – and even 1/60th sec is risky.

In the old days there was often no speed faster than
1/25th sec available on cameras for snapshot photography
(the Kodak box cameras and similar). But do not forget that
contact printing and not enlarging was the order of the day
then, and without enlargement camera shake can actually
pass unnoticed. Today, with a good deal of enlargement
required to make tiny 110 negatives, and even 35mm, fit for
viewing, there is a move towards higher shutter speeds;

probably the slowest in common use is now 1/80th sec where
there is only one speed on the camera.

Remember that speeding up the shutter reduces the
amount of light which can pass onto the film unless the lens
aperture is opened wider. And since the very simple cameras
do not allow wide apertures, something else had to be done.
And what was done was to make 400ASA films (thought of as
super-fast not so long ago!) generally available, even for ultra
basic cameras. As a result, camera shake is now more likely to
affect the owner of a sophisticated camera than the person
who uses the most simple equipment. For it is the complex
camera which is most likely to be used in tricky lighting
conditions demanding slow shutter speeds; almost
automatically, the simple camera will be used with flash
indoors.

Fortunately, even a modest SLR is a good deal more
sturdy and weighty than the very tiny plastic-bodied
110 models, and the greater size and weight add to stability;
but you should still take precautions the moment a need for

Tina Chow at a party, taken on an Olympus Trip and lit by electronic flash. The balloons add as much to the feeling of gaiety and spontaneity as Tina Chow's smile in this snap

anything slower than 1/30th sec crops up.

You may not have thought of a complex 35mm camera as being even remotely connected with snapshooting, but it very often is used in that way. Certainly it is so used by the documentary cameraman or photojournalist when shooting in the midst of something going on while he is unaware precisely what is going to happen next. In fast moving events he may not have time to focus, or make any decision about exposure: he must shoot and hope for the best. And so he will go one step nearer making his camera as simple to use as the simplest box model, by adjusting his lens so that it operates in fixed focus fashion. For example, by stopping a modest wide angle lens of 35mm focal length down to f/8 and focusing it on 15 feet the photographer finds that everything between 7 feet distant to infinity is satisfactorily sharp; and if he really wants to shoot closer than 7 feet he can focus the lens on 10 feet and stop down to f/11, when the range of satisfactory sharpness will extend from just over 5 feet distant to infinity. And other arrangements are possible too – as you will see by examining the depth of field scale engraved on top of a lens barrel.

The wide angle lens is much appreciated for its great depth of field, and also its compact dimensions. Both of those advantages fit it exceptionally well for service with the very popular 35mm compact cameras, most of which have a lens of 35 to 42mm. And as the name indicates, the 35mm compact really is just that, making it an ideal snapshot camera in the sense that it can be tucked into a pocket and carried just about everywhere. We must not, however, leave you with the impression that snapshooting equipment should consist of a wide angle lens, or a very simple camera, or indeed any other particular kind of equipment. As was made plain earlier, the important elements are where, when, and what subject. A snap is the result of a snap decision to shoot; and it is whatever is happening, or whatever photogenic sight has caught your eye, that causes you to make the decision. Thus the snap represents your spontaneous reaction to a stimulation.

Two snaps taken at a Halloween party in London. For this type of indoor photography, where the light is liable to be very poor, a flash attachment is essential. Both of these were shot on Tri-X, using an Olympus Trip camera

Doyen of French photographers,
Jacques-Henri Lartigue,
snapped at Maxim's in Paris.
Available light. Leica rangefinder

Snapshots of children

If you were to examine all the snapshots in the world you would probably find two subjects predominating – children and holidays. Children are of course a great subject for formal photography too, and the high street shop windows of professional portraitists are full of examples. Technically, the studio shot may have the edge, but for exuberance and a reflection of the natural you will almost certainly do better with a snapshot – a picture grabbed while a child is not in Sunday best, with hair slicked down and his whole being in awe of the studio surroundings. And more importantly, the high street portrait photographer in his portrait studio is dealing with a child away from home, out of his environment, surrounded by people and things with which he is unfamiliar. The portrait specialist has to be very good indeed to get the best out of that situation. Some are, of course, otherwise the traditions of formal portraiture would have died long since; but for pictures of a child of your own acquaintance you have the advantage. And photographing children can be done in straightforward snapshot fashion.

Do not direct children, or prepare them specially for a photograph session. Certainly never fill them with the idea that there is a bit of an ordeal ahead. Instead, quietly pick up your camera while your young subject is involved in some interest of his own. Ideally, work without flash – though you will need it if you are working indoors with a very simple camera. People have to be quite well trained to continue to act naturally in the face of a barrage of flash light – and that is one reason for the existence of professional models, who can carry on amidst floodlights and flash, busy camera operators and assistants, and an entirely unreal ambience, as if they were all by themselves in a nice cosy setting. Children, curious always, will be distracted by flash.

We hope that by this time we shall have persuaded you to be in possession of camera gear which will allow you to shoot in dull lighting without resorting to flash. This means having a camera that opens up to a lens aperture of f/3.5 and allows you to shoot as slow as 1/30th sec without ruining everything with camera shake. The 400ASA films now so abundant for hobbyists (there were only two or three available a couple of years back) will allow shooting in ordinary room

Dan Donovan, Bailey's current
assistant, finds a rare moment
to relax while on location in the
Tuileries. Canon Dial half-frame.
Film: Tri-X rated at 800ASA

lighting with exposures in the order of 1/30th sec at f/3.5. And even the little 35mm compact cameras now so popular will set themselves automatically to such exposure levels. Snapshot photography is possible everywhere – and flash is always there as a reserve when it really is necessary to shoot the proverbial black cat in a coal cellar.

It is a bit of a cliché – one much used by proud mothers – to insist that children are never still. Of course they are still – when reading, doing a jigsaw puzzle, examining minnows they have just caught, making sandcastles, playing with dolls and other toys. And snapped at such times they make very

appealing pictures indeed. But they do move too, and how! Try to shoot them playing in the garden or on the beach and you will need to brush up your action photography.

If you intend that your snapshooting should encompass both those extremes then you really ought to be prepared to work with an SLR camera. A compact, with its more or less wide angle lens, will accomplish a great deal, but it will always force you to work very close to the subject so as to produce a good sized image on the film. And working very close to action is not always possible – or desirable. It is not that you need a telephoto lens of 300 or 400mm for snapshot action – leave

Jordan Kalfus shot in California
with an Olympus Trip. It is clear
that Mr Kalfus was fully aware of
the camera, but the figure in the
background was not and it is he
who provides the necessary
element of naturalism

that to the landscape photographer and to the man in the
sports stadium – but for everyday action, people and children
going about their business, you will find a modest telephoto
lens an advantage (an advantage – not a necessity!).
Remember that at ten feet distant an adult will fit comfortably
into a 35mm frame when a standard 50mm lens is being
used; but at such a close distance any kind of action at all will
have you perpetually swinging the camera and perhaps
refocusing. Stretch your lens to, say, 80 or 100mm, even
135mm, and you immediately have more room in which to
manoeuvre. Perhaps the very best lens with which to begin is
one of the short range zooms, with a variable focal length
running from around 35mm to 70mm; it will allow you to
move in close for the quieter shots, then to back off
immediately things begin to warm up. But only the single lens
reflex camera permits you flexibility of choice throughout such
a huge range of focal lengths; there is a lens for every
purpose.

Weddings and holidays

That short range zoom would be a fine lens, too, for
snapshooting at a wedding. The professional who is hired to
take the wedding shots for the commemorative album will
know precisely what pictures he is to take – groups, bride
arriving with her father, cake cutting – and he will have a
routine developed over years. That will include knowing to a
tee the image size he requires on film, and he will have all his
focal lengths worked out in advance. Indeed he may very well
work throughout with one camera, a twin lens reflex or a large
format SLR, which will allow him to blow up sections of the big
negative when required, and will ensure maximum retention of
detail – very important, when the bride wants to be sure that
all the finery of her wedding outfit will show in the pictures. But
if you, as a guest, are merely snapping the occasional picture,
then you must be ready for anything. And with the wide angle
end of a short range zoom you will be able to go in close for a

shot of bride and groom toasting each other after the ceremony, or to shoot from further back while you are all sitting around watching the cake being cut. In snapshot photography – really nothing more than quick reaction picture taking – the last thing you want is a spell of agonizing over what to do next with what bit of equipment!

For those holiday pictures a pocketable 35mm camera really comes up trumps. First of all because it really is so pocketable, and it will not intrude on your relaxation by weighing down your shoulders as you lug a bag full of photo gear around; secondly, because the wide angle lens is as good for candid shots in restaurants and on beaches as it is for landscapes and shots of quaint streets and exotic buildings and busy little harbours. For the general view, a wide angle lens is made to measure. One word of warning, though: a wide angle lens will, because it takes in such a wide field of view, cover all the brightness of a scene, and if that scene is in some sun-scorched location you may find that the exposure required is so short your camera cannot handle it with one of the 'all-purpose' 400ASA films loaded. For holidays in the sun it is a better bet to load with 100ASA, and rely on flash for the indoor shots of parties and suchlike.

While it is never a good idea to make distinctions which are too fine, it is important here to refer to that major division in photography, between art and documentary, both of which may be greatly pleasing and satisfying to look at, but which start out from different principles. In between the two is our snapshot, which only ends up as an indeterminate jumble between the two when the photographer himself is indeterminate. The snapshot is much closer in spirit to the documentary tradition, and it results when you react to something pleasing and stimulating which you would like to remember and share with other people.

Sharing your experiences with other people is what civilization is all about – it is communication. Yes, you may reply, but what sort of experiences am I to share? Not necessarily anything fancy, but remember subject is all. Consider, for example, a weather report on the radio. The announcer may well promise 'sunny spells, hazy clouds; fog later, especially near the sea . . .'. We then know what to expect. Now look at a painting by the great English water colourist Joseph Turner: you will find he too is describing the weather, but in what a different manner! A Turner picture glows with luminosity, and moisture hangs in the air: the sun's rays are so

Man feeding seagulls. Nice,
Olympus

One of the world's leading 'art' photographers, Ralph Gibson, caught fooling around in an uncharacteristic pose at Cap d'Antibes. Olympus

suggested you can almost feel their thin warmth on your skin. In one case a factual description, in the other pure visual poetry.

We are not all Turners, of course, but we are capable of asking ourselves questions; and it is easy enough to ask speedily and precisely what your subject is. In snap shots, the subject is what you reacted to in the first place. Show that clearly and you are half way home. Of course, nobody can teach you sensitivity – and what you react to will dictate how impressive your pictures are to others. If you are a little slow on the uptake you could turn out to be a crashing bore – as

are so many who inflict a meaningless jumble of holiday snaps on their friends.

Let's say it again: it matters not who is taking photographs when it comes to snapshots, nor does it matter with what equipment. The secret of success lies in the way the picture taker presents his subject, not on equipment or technical knowledge or being present at world-shattering events. What must be driven home is that producing pictures which say what you want them to say is not a hit or miss affair; it is a matter of having an immediate appreciation and a clear idea of what you are trying to show. And that annual picture-

himself, while he is dishing up the meal, and show his smile. Our galleries are full of portraits of people, and not all of them famous; some have been portrayed simply for an interesting face or curious mannerism, and if people you meet genuinely interest you or amuse you, try to show in your pictures the reasons. Including yourself or your family in every picture tells nothing other than that you have been on holiday – and everyone will know that anyway.

Even Spain, drowned in British tourists, still has something of its own character to offer. What is it? Colour? Blazing sunshine? Those things can be shown in pictures. Sunshine? Its effect shows in the tanned and wrinkled face of the old lady who sells flowers, and it shows when a peasant in the fields stops to mop his face or swig his lunchtime wine.

Choice of subject

Asking yourself what it is you want to photograph is such a sure and simple formula for better pictures that once you begin it you will never abandon it. It adds so much to the delights of using a camera that what is added must surely spill over and please other people too. For, simply, your answers will indicate how you should take your pictures.

We can advise you on techniques and equipment, but the questions and answers which will lead to interesting choice of subject will come from you. And if you do not brush up that aspect of your picture taking you will become like one of those unbearable bores who babble endlessly on without ever actually saying anything which interests anybody else.

Even a professional – perhaps especially a professional – has to be ever alert to the subtle divisions in photography. Some will have their favourite ways of labelling the different approaches, and only one of such ways is to consider that there are 'seeing pictures' and there are 'construction pictures'. When you are shooting seeing pictures you are really dealing with people and places and things which go on existing undisturbed in their own particular piece of space; they are not rearranged by the photographer and the resulting photographs can legitimately be referred to as snap shots – they have an atmosphere of innocence about them. But fashion photography, for example, is of constructed images, as is much nude photography. There, control abounds, and it is so often the photographer's very interference or rearrangement which makes the picture. When shooting landscape pictures a seeing picture would be a Capability Brown, while a construction picture would be a sixteenth-century Florentine terraced garden. The snapshot is the epitome of innocence, of the unadulterated speedy reaction to a sudden stimulation.

The greatest single inhibition standing in the way of successful snapshot photography is being mean with film. And if you approach photography with the impression that you will get great enjoyment from it while shooting as little as three or four films a year you might as well forget it and take up

taking bonanza, the summer holiday, need not be boring.

What so often happens is that holidaymakers photograph themselves in the hotel, on the beach, at the local beauty spots, having a picnic. Subject dominating – the holidaymaker; information transmitted about where he has been – nil. And why is there a compulsion to have pictures of yourself arm in arm with friendly waiter Manuel, or with the couple you met in the bar each evening? By all means shoot snaps of these people, but ask yourself why you want to remember them, or tell other people about them. It may be Manuel really did have a big smile: then fire off an interesting portrait of him, by

painting instead, for there the rate of image production should be just about right. Photography is a medium of speedy and plentiful reproduction. But the crotchety George Bernard Shaw attacked that view when he compared the photographer to a fish – producing a million eggs in the hope that one might survive and prosper. This negative response certainly encourages introspection and the harbouring of one's experiences rather than the sharing of them. To be fair, Shaw's attack may be taken as having been directed at those photographers who photograph one subject endlessly, from different angles and with different exposures, in a positive barrage of shooting. But even that is legitimate more often than not. For such profligate shooting occurs when a subject is ever changing – and certainly some fashion photographers who work with 35mm cameras may find it guarantees at least one or two frames in which model and dress look just right.

It definitely pays off when shooting fast moving sports action: for there the story is ever changing, and each exposure does indeed cover a separate slice of action. How is the sports photographer to know that just because he has a magnificent shot of a player scoring a goal there will not be another, even more spectacular goal along in a minute or so? So, in spite of Shaw's undoubted reputation in other fields it seems he was a bit pompous when discussing photography at least. And if his attitude were to rub off on photography in general, then he would be guilty of doing the medium a great disservice.

To adapt slightly an old saying, you get out of photography only as much as you put into it. And if you hardly use your camera then you cannot show any results. Often you will hear people talk of using the camera as a visual notebook. All that means is shooting sufficient pictures to provide genuine and accurate recall of what you saw and experienced.

With the sophisticated equipment widely available today it becomes difficult to take a bad snap. Pictures such as this one of Shovo Kawazao raise the question of defining just where a photograph stops being a snap and starts being something more. Pentax

When you are out and about with your camera you will often come across the opportunity to shoot sequences of pictures, selections of several exposures which tell a more detailed story than could just one exposure. While the single still picture can tell a very great deal, a sequence adds that little bit more: it displays something unfolding, an event happening. Do not let that have you thinking only of action photography, for a sequence of a child building a sandcastle, or painting a picture, can be just as entertaining. And in apparently static subjects there is opportunity for sequence too: the sun goes down, the tide comes in, the seasons change, the garden flowers grow. We have touched on sequences elsewhere, but they are every bit as valid in snapshot photography as in complex professional or scientific assignments. All you need do is shoot as things progress. And if that means shooting your favourite landscape in springtime, then again in summer and autumn and winter, fine – your resulting sequence will be very informative indeed.

You will have gathered that it is no easy matter to divide photography into different divisions as we have done: the divisions are better made by the photographer himself, who will be quite clear in his own mind as to the different approaches he adopts, and may deny altogether anybody else's interpretation. And there is also the fact that even the simplicity of snapshot photography conceals within it elements from all other branches of picture taking. But in discussing snapshooting we have tried to impress that it is subject which matters. In fact, the snapshot approach might even be said to be photography's highest level; for in climbing to that high plane you abandon all worries and concern about equipment, and involve yourself entirely in subject – and that, in the end, is what matters most.
And experience can be pretty elusive if you lock it out while you compute whether or not you can afford to press the camera's shutter release. If cost really is a major concern, and especially if it has become so through those bills you face when picking up from the shop a package of colour prints, then the wisest course is to have contact prints made at first, and then choose the best pictures for enlargement later. That way you do not pay for any prints which are not of sufficient standard to show what you intended. However, film processing and printing is a huge industry, and the prices of individual prints tumble regularly as one firm offers a better deal than its rivals. In reality, the cost of an enprint is a relatively small proportion of the whole cost.

A striking picture from an unusual assignment – to show the work of a Salvation Army Home. An evening shot using fill-in flash. Horseman, 6 x 9

Reportage

Great photographic documents abound. And there is perhaps a more stable tradition of great documentary photographers than anything else, except landscape. Neither one of those two great themes is particularly susceptible to changing fads, as are other kinds of picture making. It is true that the contemporary reportage photographer is very likely to be armed with a wide angle lens, but his subject matter is what it always has been – life going on. Reportage, or documentary shooting – which most magazine and newspaper photography is – can be thought of as the writing of history but with lens instead of pen.

And how effective can it be? Does a picture really demonstrate its content as clearly as do a thousand words, and can one picture, or even a series, illustrate an incident in development as informatively as prose? Of course. But the camera is not a substitute for the pen or the typewriter; each tells its tales in different ways, sometimes better and sometimes less effectively than the other. Certainly the camera is more factually accurate when describing things physical – like the explosion of a volcano, the effect of bombing on a village, the desolation of a drought. On the other hand, a story of political intrigue may be more fully documented by a writer, and merely hinted at by the reportage photographer, who almost caricatures the main characters in the story in order to indicate to his viewers the relevance of each. Any politician – any person – can be made to appear benevolent or evil by the reportage photographer, depending on when and where he presses his camera's shutter release.

The most important element in reportage is that of choice, of editing the images to be contained in the camera. That is a monumentally significant factor, for it makes plain the undeniable fact that bias can be brought to bear, and the implication of an event entirely changed. But that possibility exists in a written description too; and since bias is a characteristic of the human mind we just have to live with it.

It was important to get that question of bias aired straight away, for the photographic image is so very powerful that when used as propaganda it can be much more effective than words. The photograph is very emotive. One news picture of a few years back showed a seal cub just about to be clubbed to death during the annual cull: so much did it stir people that it raised discussion in the House of Commons and strongly influenced the legislation concerning culls. And the gripping thing about the picture was the child-like expression on the cub's face.

Not all reportage photography, however, deals with major issues. A series of pictures depicting the life of a shepherd in some remote district is just as much a valid essay as is a picture report from the latest war front. One may concern itself with a dying lifestyle, the other with outrage; but both fully occupy the story-telling powers of the photographer and his camera. And a record of the customs of the countryside may in a hundred years from now be thought actually more valuable than pictures of, say, a brief local skirmish in which a few soldiers were killed, but which otherwise left the world unaffected.

Reportage photography is not some esoteric matter, it is a straightforward business of recording things which are to be related to other people – it is a report of something, in pictures. And each and every person capable of holding a camera is equipped to produce reports, however unimportant these may seem to be.

Photograph as record

Why should you shoot documentary pictures? It is not a question of why; you cannot avoid doing so. Every single picture is a record of how something was, for one short fraction of a second. But what makes certain photo documents great and memorable is that they are records of a particularly significant something, and the fraction of a second in which they were taken was the right fraction – though do not be too much seduced by the notion that there always is a right time, a time more perfect than any other.

Let us be bold and say that documentary photography is snapshot photography. Certainly it is life being lived, caught in the act. It is not the posed photography of the fashion studio or the portrait salon, nor is it the long and leisurely considered and carefully arranged study of the landscape artist. It has had many influences which one would have thought should make it more identifiable, easier to understand. Yet the essence of

what documentary photography is cannot be given a precise definition: we can skirt around it, identifying roughly what we mean to other photographers as much aware of the medium as ourselves, but they too are as far from any universal meaning as we. Some will talk of reportage, others of documentary shooting, and some will say it is photojournalism, and then along will come someone else who insists we are all talking of news photography, or of snaps which have become news because of circumstance and will go on to become history. But we should not get too scornful of photography's confusion over the proper labelling of its photo-story-telling; the writers will talk of news paragraphs, magazine articles, novels, short stories, essays, parables, prose-pieces, and so on, and we know that one incident could give rise to any one of those. Description is one thing, the content of the thing described is another: it is content and association which matter.

On 24 January 1955 there opened at the Museum of Modern Art, New York, an exhibition of photographs which has possibly had more influence on modern documentary photography than anything else before or since. This is a strong claim, when one recalls the huge respect in which picture magazines Life, Paris Match and Picture Post have been held. But the theme of the exhibition was the 'Family of man'. It took Edward Steichen three years to prepare, and it spawned statistics as staggering in their scale as was the exhibition in its impact.

Steichen toured Europe – twenty-nine cities in eleven countries, he recalled – and cajoled photographers to add their contributions to pictures already available in America. Over two million photographs were examined, and whittled down to ten thousand, then halved; the process went on, and a final shortlist of a thousand was reduced to the five hundred needed to illuminate the 'oneness of the world we live in'. Going on around the world, Steichen's exhibition was seen by more than nine million people, and copies of the book of the

A reportage photograph will often include a good deal of background detail to give a sense of location, but it would only have distracted in a shot like this one of an Indian razor-blade eater. Nikon

Window reflections can help to make a disturbingly effective image where events happen on two planes. India, Nikon

show have sold (and still sell) in excess of three million.

What was it about one exhibition that could be so influential, so pure documentary? In his autobiography A Life in Photography, published in 1963, Steichen put it this way: 'My mother . . . talked to me quietly and earnestly for a long, long time, explaining that all people were alike regardless of race, creed or colour. She talked about the evils of bigotry and intolerance. This was possibly the most important single moment in my growth towards manhood, and it was certainly on that day the seed was sown that, sixty years later, grew into an exhibition called the "Family of man" . . . the most important undertaking of my career. . . . Although I had presented war in all its grimness in three exhibitions, I had failed to accomplish my mission. I had not incited people into taking open and united action against war itself I had been working from a negative approach; what was needed was a positive statement on what a wonderful thing life was, how marvellous people were, and, above all, how alike people were in all parts of the world I ran across a speech in which Lincoln used the term "family of man": here was the all-embracing theme for the exhibition . . .'.

From this you can see that Steichen's exhibition was positive: it told its story through simple arrangements and sequences showing love, birth, people at play, at work, at war, grieving – but always the triumph of continuing life bubbled through the themes in which the pictures were presented. Although there were many memorable individual pictures, it would be more truthful to say the show was a great collection of pictures rather than a collection of great pictures. And that is the point: the people who saw the show could identify with the pictures; it was, they knew, possible to take such pictures oneself, for each image showed ordinary people doing mostly ordinary things.

Years after the 'Family of man' exhibition, Kodak organized an exhibition, first seen in Cologne, which was nothing but an assembly of snapshots from all sorts of sources – anything but professional photographers. And that too proved a great hit: the collection was essentially nostalgic, and in an astonishingly cohesive way each simple snap held together with its neighbours to create a survey of a vanished society, the times when the twentieth century was in its infancy.

Four shots showing the plight of refugee Cambodian 'Boat People'. All were taken on a Leica rangefinder camera and lit by direct electronic flash. One is a semi-formal group portrait, but notice the effective use of diagonals in the arrangement of the others. Hong Kong

We must be careful here, and guard against the danger of building an impression that documentary photography works best en masse. That may be true much of the time, but there are sufficiently many one-off gems in the archives of the genre to prevent it ever becoming the rule.

The great vehicles of documentary photography were always the news magazines, particularly those mentioned earlier. But television and economics have put paid to their effectiveness: huge increases in the cost of sending a photographer on an extended reportage assignment half way round the world, and diminishing impact because television was bringing the goings-on of the globe into people's homes the day after the night before – and increasingly the same day – have defused not only the magazines but the newspapers too. There are now more reportage photographers than there are magazine pages for them to fill. So with what do they occupy themselves? One answer is they sit tight and hope things get better: after vanishing for a while Life magazine was resurrected in 1979, though it may be many years before it hits its old rhythm. Another answer is in books, and many

powerful publications have appeared. A book gives a photographer the chance to expand on his subject, to explore at great length – as Swedish photographer Lennart Nilsson explored the interior of the human body, including the development of the human embryo inside the womb, in Behold Man, published in 1974. Then, too, the documentary photographer can exhibit, and most do. The many galleries in the developed countries encourage this, but it is always incongruous to see opening night visitors quaffing champagne and making small talk at a gallery in which a photographer may be displaying the highly sensitive outcome of many years of work in highlighting the poverty or misfortune of some distant section of the world's population.

Once someone gets the taste for telling his tales in a series of pictures, it is not easy for him to revert to the one-picture statement: hence, newspaper photography is rarely a viable outlet for the best of documentary photographers. And newspaper photography is, anyway, a somewhat different kind of communication: there, the topicality is all, the long-term impact less important.

The decisive moment. The tail of
the cat and its outstretched
front leg complete this carefully
composed photograph.
Olympus

Don't be afraid to try unusual cropping when composing photographs in the camera. This enigmatic shot was taken in Zambia using a Nikon

The documentary photographer

What exactly does a documentary photographer do, assuming he has a choice? He explores thoroughly something in which he is greatly concerned. And sometimes the concern is a lifelong one. Don McCullin is a particularly well-known war photographer, whose output is phenomenal. For McCullin, the first whisper of strife is sufficient to have him packing his camera bag and heading for yet another theatre of war. But there are subjects a good deal less sombre than war which occupy the minds of the reportage photographers, and some of those subjects are extensively dealt with in a concentrated burst of a few months, or a year. Young photojournalist Homer Sykes has now moved on to other things, but a year or two back he visited just about every corner of Britain to document the odd traditions, ceremonies and festivals which go on.

All of that makes documentary photography seem highly organized. Your impression may be that it is only for the dedicated, who will be assured of a gallery exhibition or a book publication or several pages in a high-paying magazine at the end of the assignment. But that is not necessarily so: there is scope and subject in plenty for the hobbyist, or the professional with some spare capacity on his hands, to delve deeply into documentary. And the subject certainly does not always have to revolve around man's inhumanity to man – as Steichen's 'Family of man' so resoundingly demonstrated. Life viewed from the streets has been the life-long subject matter of Henri Cartier-Bresson, reckoned the world's greatest photojournalist. At such a high pitch is the Cartier-Bresson performance in this sphere that he has taken his talent to many countries, from which the resulting pictures have appeared in books one may consider as compound portraits of the countries visited. In his view, 'For everyone, space extends outward from the eye to infinity over a scene which strikes us with differing degrees of intensity, only to pass at once into our memory and there be modified. Of all forms of expression, photography is the only one which seizes the instant in its flight . . . '. And the instants Cartier-Bresson seizes are those which the less perceptive might ignore. He is not a seeker of the world's sorrow: on the contrary, huge slabs of his

The masks which form a
backdrop to the two
enthusiastic and self-absorbed
Tokyo photographers seem to
be saying something about the
art of seeing. Olympus

photography drip with good humour. Perhaps his most
famous picture is a 1938 shot of a French family enjoying a
picnic on the banks of the River Marne, their boat below them,
fishing rods sprouting across the water; nothing at all serious
about that, except perhaps the determination with which the
picnic family are enjoying their leisure.

There are no rules about subject matter in documentary
photography, nor are there really any about what kind of
equipment is most suitable. The wonderful old
Czechoslovakian Josef Sudek, who lost an arm during the
1914–1918 war, still managed to lug around a big old plate
camera to make the most sensitive studies of Prague.
However, it must be said that the choice of far and away the
majority of the mobile documentary photographers is a
35mm camera. Since documentary shooting of a subject in
which unpredictable action plays a large part suggests that the
photographer will never actually know when the action is over,
he must therefore be prepared – with plenty of ammunition.
Not only that, reloading a camera takes time, no matter how

efficient one's fingers. So, for most documentary work out in
the field it has to be 35mm. The camera holds plenty of film,
and can be made to hold more, by using a special back which
accepts a long length of emulsion on which up to 250
exposures may be made. Of course, attempts have been
made to extend the number of exposures on 120 film, and the
lengthier version, known as 220, helped some. But 35mm
seems always to stay in front: Ilford recently introduced their
400ASA emulsion, HP5, in 72 exposure lengths, to provide
twice the shooting capacity of a normal 35mm cassette, a feat
they achieved by putting the familiar emulsion onto a very
thin base. This version of HP5 is known as 'autowinder', the
idea being that it is suitable for fast shooting with a motor
drive, where conventional 36 exposure film would be through
the camera in no time.

There is a penalty to pay for every advantage, it seems:
the use of a motor drive unit requires power, and there are no
battery shops in the middle of the jungle, or halfway across
a desert. In the days before motor drive became more

common, and before through the lens metering was the norm, the rugged SLRs were thought of as professional models and made their reputations; requiring no battery power, they would work anywhere, for any length of time. Do not misunderstand. This does not mean that electric power is always a nuisance, for today's sophisticated through the lens metering cameras make poor exposures much less likely than before, and are indeed very welcome. But the photographer working in either tropical zones or antarctic conditions may well be unable to get fresh batteries, and even if he can get them he may find they fail to function in the extremes of temperature. In all fairness, though, at temperatures sufficiently high or low to affect batteries there could also be a camera failure, caused when the materials of the body shrink or expand, and jam, or when lubricants fail to do their job. Not for nothing did NASA generously fund Nikon's research into a camera (the Nikon F3) to beat abnormal temperatures and conditions found in outer space.

Reliability is therefore the big requirement in documentary shooting. A fool is he who spends a huge sum and endless effort to be in a remote place for a once-in-a-lifetime event, only to find his camera folds on him. The obvious response – apart from looking for an infallible camera – is to carry more than one. And since you are carrying more than one camera body you might as well put lenses of different focal lengths on them, so that no time is wasted switching lenses and there is almost certain to be at least one camera loaded at any one moment. To some extent zoom lenses do away with the frequent changing of lenses on the camera body, but if you are likely to encounter unique subject matter you should choose your zoom with great care, for there is great variation in quality. You will probably not be disappointed if you stick to the zooms made by the reputable manufacturers specially for their own cameras – like Nikon, Pentax, Olympus, Canon, Leica.

The random composition of a 'found' still-life is often more effective than the most carefully contrived studio version. The quiet simplicity of these commonplace objects seen in Tokyo underlines the point. Olympus

Wares on a market stall in Goa undergoing careful scrutiny. The three figures each present a different and intriguing focal point. Nikon

A spare and open composition of three carefully selected elements, whose relationship exists only on the visual plane. Honolulu, Olympus

This picture relies entirely for its effect on the relationship between the geometry of the window and the organic line picked out in the mosaic-tiles.
Japan, Olympus

Format, lens and flash

There are, of course, documentary photographers who go out on location armed with a bigger format than 35mm, but their subject matter tends to be immobile, or at least not dependent on the unpredictability of humans. To go around Britain photographing all the follies which have been built, or to collect pictures of old steam engines, would be a perfectly valid piece of documentation, and would possibly benefit from the leisurely working and high quality image associated with a 2¼ square negative.

Henri Cartier-Bresson has become something of a legend, and perhaps a cult figure too, representing to aspiring documentary photographers all they should aim for. This is a pity, because documentary photography is not at all like motor racing, in which you might be inspired by the race successes of a particular driver in a particular brand of car, and might reasonably expect some of that car maker's technical expertise to gravitate down into the working of his road models. You cannot, simply by emulating one documentary photographer's choice of equipment and technique, guarantee

any kind of parallel with his results. Great photographs begin primarily in the mind – though it would be quite a stroke of luck to be around when a volcano blew, or the Empire State building tumbled down.

The success of Cartier-Bresson, with his Leica and its standard 50mm lens, and his insistence that the negative must never be cropped, has led impressionable young photographers to be equally Spartan. But they do so without reason: at least Cartier-Bresson made a conscious decision to limit his equipment, and to become thoroughly familiar with the performance of a 50mm lens over many years. And his 'no cropping' rule leads to an awful lot of irritation and headaches amongst those who publish his pictures. Yet it has to be said that he has become so aware of the design requirements of the 1 x 1½ proportions of the 35mm negative that he can instinctively fill it with subject matter which is not at all superfluous.

That 50mm lens could, however, become a stumbling block for any devotee bent on following in the French master's footsteps. The simple fact is that lenses are there to solve problems, not to augment one's belief in oneself as an artist.

The long shadows are deceptively important in the success of this photograph, for they relate the half-obscured dog, foreground tree and empty chair into a resolved composition. Tuileries, Paris, Nikon

The same might be said of the modern enthusiasm for using a wide angle lens for all reportage photography – except for one thing: the wide angle does get a great deal of subject area into the picture, and when stopped down beyond f/4 it does offer great depth of field – provided you do not crop away huge slabs of the negative. If you crop too heavily, you will have to over-enlarge what is left, and that will bring depth of field back into line with the performance of whatever focal length would have been required to cover only the area you have left after cropping. With that in mind, it is worth exploring the effects produced by 30mm or 35mm lenses (anything wider on the 35mm format really is a bit too dramatic for consistently acceptable results).

The essence of reportage is that it tells an accurate tale of what was there. And that should include an easily understood impression of the atmosphere at the time. Flash changes what was there – or, rather, it changes the atmosphere which prevailed, and it may even (by redistributing shadows and sharpness) change the expression of a face. For that reason you should quite early begin to get to know the workings of the 400ASA films, which will help you get a result in almost any lighting. But do not discount flash entirely. The paparazzi photographers, whose style is to stalk the famous and snatch shots which will have the rest of the world ogling, would not be without flash, nor would the newspaper photographers who are sent to track down the names which are suddenly in the news.

The point is, flash guarantees sufficient light for a good exposure – by producing its own supply. And it also (if it is powerful enough) allows the use of a small lens aperture: that in turn extends the depth of field within which you can get a sharp picture, so that your chances of success when someone dashes out of a restaurant or hotel and across the pavement and into a waiting car will be very much greater. All of the reproduction processes affect the original sharpness of a picture, though the process used for printing newspaper pictures – and the paper they are printed on – affects it more than anything else: if you know you are going to lose sharpness, you just have to start out with some to spare. In the newspaper world the business of catching pictures that way is known as door-stepping, because the photographer literally stands outside his quarry's door with his camera aimed ahead waiting for someone to appear. It takes all sorts

You do not actually pick a subject in documentary shooting: in a sense it picks you. If you have to sit and consider what you should photograph, then you have missed the point of documentary photography. On the other hand, documentary shooting is not just for the dedicated fanatic. Don McCullin, of course, is in the dedicated category, for he has brought more awareness of the futility of men shooting each other than has anyone else, except perhaps Larry Burrows and Robert Capa, both of whom paid the ultimate price for their concern with warfare.

Choice and bias

Interest in taking documentary pictures is sparked off by interest in something else – within which the need is perceived for a pictorial record. That need may be – though it does not have to be – identified with a view to educating a mass of people towards a certain truth; it may be equally important for the simple reason that you believe one day the pictures you are to take will prove valuable and of some interest to at least some people. One just thinks of all the great subjects which could have been documented with a camera if photography had arrived sooner. . . .

Of course, effective photographic documentation ought to kill speculation stone dead. The pictures should show what really took place, or how things actually appeared before they stopped happening. But earlier we raised the subject of bias. We really mean editing when we speak of bias, for a photographer has the choices – to shoot now or later, to shoot or not to shoot, to shoot from this angle or that angle.

He determines, even if without considered intent, what impression his pictures are going to give. Take, as a fanciful example, the building of the pyramids. Our ancient cameraman may have taken his pictures only when he saw an overseer flick a lash across the back of a poor worker struggling with a block twice the size of himself, with perhaps an occasional quick snap when somebody collapsed in the sand, wilted by heat. This suggests that slavery and cruelty erected those extraordinary monuments. But what if the cameraman had photographed the craftsmen smoothing rough stone surfaces, painting intricate decorations, adjusting whatever strange machines were used to haul the materials and raise them? This shows the pyramids as built by craftsmen pouring out loving care and attention.

That is a simple example, but the same kind of bias is to be observed throughout contemporary photojournalism, especially if there is a political or moral point to be made. Take a riot. Turn your lens on that policeman with an armlock on that young man, and turn away from that rioter smashing

The three Indians who posed for this photograph took on a sinister aspect with their dark glasses, which the use of direct electronic flash accentuates.
Nikon

Not all reportage shots need necessarily be comments on the human condition. In this instance it was precisely the absence of people which made for a striking image. Japan, Olympus

windows. Never mind that poor girl knocked into the gutter with her face streaming blood, focus instead on that guardian of the law with his eye blackened. Different pictures, different impressions.

The photographer whose concern is with documenting the inanimate can, of course, show bias too. That he rarely does is due to his fondness for the subject – greater than his desire to make points. And yet, exaggeration does creep in, though perhaps we should call it emphasis. Certainly Ernst Haas (he once photographed prisoners of war) has stamped his style in his photography of things natural, which cannot really be categorized as either landscape or natural history shooting. Though he does both, his hallmark is a kind of mixture of both, best perceived in his series 'The creation', widely exhibited, and published in book form. Through his choice of emphasis on particular colours, and his sensitive use of the right lens, Haas concentrated attention on the spiritual and the magical in nature, neglecting to show the ugliness and the struggle for survival which goes on, even in the back garden.

We keep veering close to the idea that documentary photography is entirely factual, total truth; then we are forced to back off and confess it is as much subject to whim as – portraiture. This is an important point: for example, a photographer fond of photographing anything to do with railways might give to someone in another country the impression that Britain's tracks are full of majestic steam trains – simply because he goes off each weekend to photograph commemorative steam journeys and totally neglects electric and diesel engines. If you do go in for documentary photography, make it very plain what it is you are documenting.

Often, there is little choice of viewpoint or background when shooting documentary pictures, simply because the required subject is there – just there, in that position, and nowhere else. But you still have the choice of moment. And it must be admitted that exercising your options will make for a more readable document, a set of pictures with more attraction perhaps than you would allow if you merely fired your camera unthinkingly. So you will find that mastering all of photography's techniques, even though several may add a sugar coating to some of your documentary work, will on balance raise the aesthetic value of what you are doing. But do not over-glamorize; stay as close to actuality as is consistent with the story. Just ask someone like McCullin to shoot aesthetic pictures of a rotting corpse in some desert war. . . .

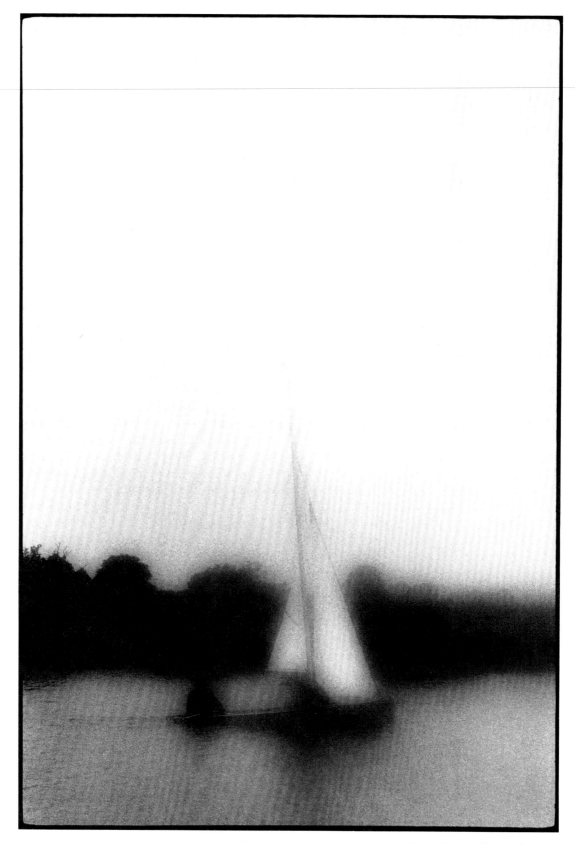

An ordinary sailing boat on a
dull day on the River Thames is
tranformed into a dream-like
image by the use of a fog filter.
Pentax

Mood and special effects

Time and again throughout this book we have treated photography as a means of communication, as a way of getting an impression from one mind into another. And how well it fits that role. But if we are to treat photography in that way, then we must also consider the varying levels of literacy one may find in it. And we can with justification use as a yardstick that other very efficient means of communication, language.

With only a few hundred words you could make yourself understood well enough for all your everyday needs. But get to know a bigger selection of words – and especially the adjectives, the descriptive words – and your powers of communication soar. It is worth labouring for a moment the point that photography is, too, a language; and to enrich it you must expand your vocabulary and your descriptive powers.

This is fine, but how do you go about it? In one way: by quickly embracing the certainty that light passing through a lens and onto film is but a natural act, and only the beginning.

Photography mirrors what appears before the camera, but your final representation of what was there can be a very long way indeed from being a mirror image. It can add all sorts of overtones, and it can simplify: it can entirely alter the original impression, and it can powerfully force conclusions. That really is a very important concept: you are in control.

We did say that photography mirrors what is in front of the camera; our first step along the way to complete control over the medium must be to modify that statement. For remember that the camera and the eye perceive things in different ways. Depending on which lens is used, the camera will suggest that perspective was not at all what you thought it was – simply because eye and camera may take in widely differing fields of view; yet the eye and the mind together concern themselves with what they think of major interest, and with what they can comfortably embrace.

Nor does the way a colour film records things equate with the way you interpret them: indeed, precise recording of

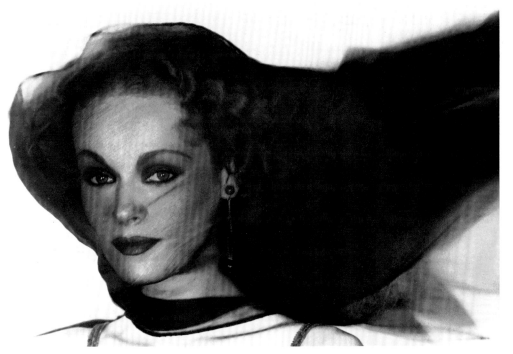

Lighting and soft focus are only two of the ways to give a picture a certain mood. In this photograph of Kim Harris, for Ritz, the dramatic effect is due to the feeling of movement which comes from placing the model's head to one side of the picture-frame and from the careful use of the black veil. Olympus

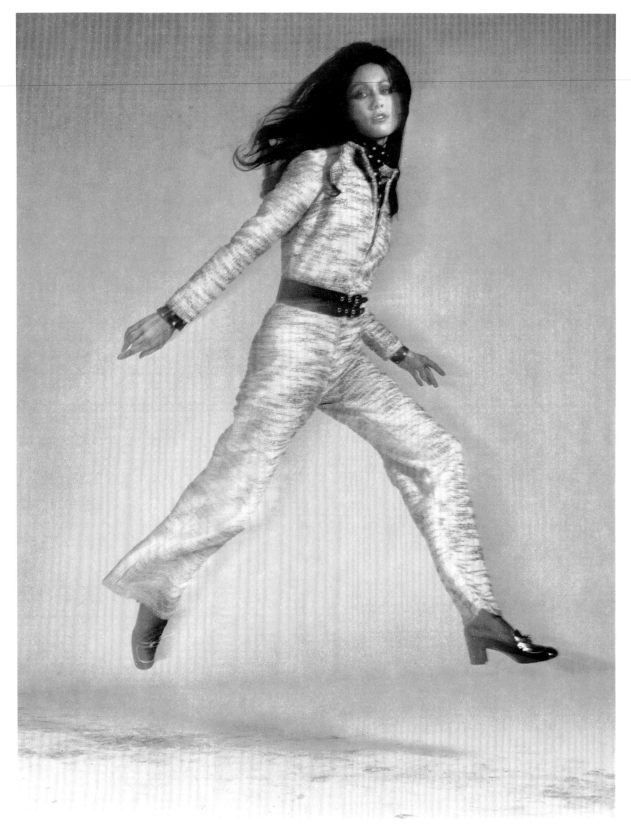

For this shot of a leaping model, for British Vogue, it was necessary to show the suit clearly and yet include enough blur to convey the feeling of movement. So the lighting was a mixture of tungsten light and electronic flash, the former being built up to a level where it would just record the blur at an exposure of 1/60 sec. Hasselblad

nature's colours is so rare as to be almost non-existent. Further, depending on how your film is processed, its structure may vary; in particular, the tiny clumps of silver, which make up grain, may be more or less evident when your pictures are enlarged. That will affect the textural appearance of the image, and quite possibly the impression it conveys.

Now those departures from mirror image truthfulness can be relied upon: their extent can be predicted with a certain degree of accuracy. And that makes them potential controls. (Use of an SLR allows total accuracy in predicting the effect different lenses will bring.)

Lenses, film and grain

Elsewhere we have examined how different lenses create different effects, and how different colour films react in different and subtle ways. We have, too, spoken of grain, and how it may be exaggerated. So, by choosing your lens deliberately, electing to use one colour film instead of another, and by over-developing – or enlarging greatly just a tiny piece of the negative image – you can ring a number of changes, and all at your discretion. That is true control, and already enough of it is there to allow you to vary considerably the mood of your pictures.

The wide angle lens produces an image which is a long way from normal experience – and the wider the lens the bigger the gap. The effect is sufficiently odd to persuade us this is not part of everyday life, and it thus looks a bit surreal; certainly it introduces a kind of tension, almost anxiety – it must be something to do with our sense of balance, our spatial awareness. On the other hand, the telephoto effect, with its flattened perspective, is visibly odd only if the subject is such that objects within it look disproportionate – as would a group of people, those at the rear actually appearing to be larger than those nearer the lens. But distant landscapes, which also tend to be recorded in softer coloration than when shot wide angle style, present a peaceful appearance. By going close to a ruined castle and picturing it with a wide angle lens, you could introduce a sinister mood, especially if you produced the picture in dark and sombre tones; by shooting from a distance with a telephoto lens you would be more likely to make the ruin take on a gentle romantic appearance – and you would have to stick with the softer colours too, since telephotography also flattens contrast, and to attempt to darken the image would lead simply to murkiness.

Our lives are so bound up with colour that it is difficult to prevent some impression being built in when you use colour film. Without even trying we feel at peace and relaxed in the

A very unusual shot of Venice, seen through the spray of a speedboat from which the picture was taken on Tri-X, rated at 800ASA. The film was deliberately over-developed and printed on high contrast paper to achieve this strongly graphic result. Nikon

warm glow of sunset, and any film with a bias towards warmth will create an equally relaxed atmosphere. But you do not have to rely simply on the characteristics of your film; by using filters over the lens you can create any effect from the cold glint of moonlight to the exaggerated warmth of sunset. Add the mysterious blue of a moonlit scene to the tension of a wide angle image and you are beginning to distort reality, and to substitute your own impression, in a really significant way. And keep the grain of your pictures ultra-fine to heighten that moonlit and wide angled scene further towards the unreal; the enhanced impression of detail brought about by ultra-fine grain adds to the dreamlike effect. But blow up a tiny proportion of a negative, even one produced with a standard lens, and you not only introduce a telephoto effect, but the grain also becomes more apparent, breaking up detail and obliterating it so that the effect is immediate and requires no nervous motion of the eyes all over the picture. The effect then is quite different from the wide angle image – and true control requires the ability to alter an effect entirely.

Mostly, control of the appearance of grain is a weapon of black and white photography. It is quite difficult to exaggerate grain in colour unless you enlarge small bits of the image, for even the present 400ASA films are sufficiently fine grained to present a smooth image appearance when enlargements are made from an entire 35mm negative – and there is no chance grain would show in a 4 x 5 or 10 x 8 image from a plate camera (though it might if the picture were blown up to huge proportions, for a poster hoarding perhaps).

Other than the three controls we have just discussed – via lens, film, grain – there are not many you can apply without doing your own processing and printing. But double exposure and the use of filters do remain available to you.

Filters have cropped up a number of times in our conversations in these pages, and you will be familiar with the idea that what they do is stop light of certain wavelengths while allowing that of other wavelengths to pass through. In black and white photographs the filter, by stopping a proportion of light, causes certain areas of the picture to go darker – to be underexposed. Thus, a deep red filter will stop blue and green light, and will darken areas of those colours, making a blue sky appear almost black, and green foliage very dark too. To compensate for cutting out some of the light – absorbing it instead of letting it pass through – each filter has a filter factor, such as X3 for the red. That means you must set your camera to provide three times the unfiltered exposure; but remember that a camera with through the lens metering will also be metering through any filter fitted, and no adjustment will be required by you. The red filter is very dramatic, and is not one for frequent use; better for general purpose shooting is an orange or yellow, both of which still darken the sky, throwing clouds into greater relief. For colour, do not use these filters unless you wish to impart an overall tone of the filter's colour. The only 'legitimate' filters for colour photography are the correction filters for adjusting colour

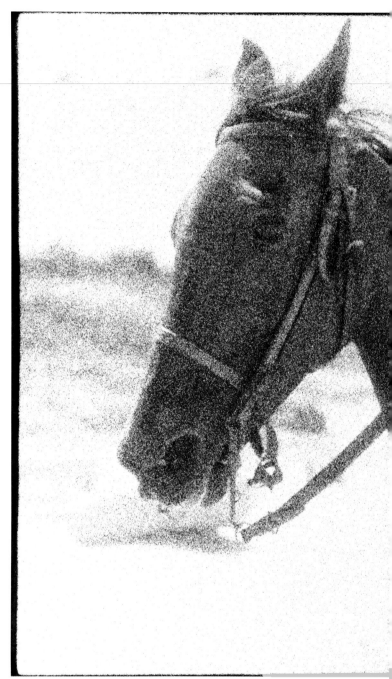

temperature sensitivity, the UV filter which absorbs much of that excess blue and makes colour look more natural, and the polarizing filter, which darkens skies in colour pictures, increases colour saturation, and cuts out glare from smooth reflective surfaces such as water.

Using filters does, of course, add up to genuine control, but if you use them for that purpose too often the effects become repetitive. It is therefore better to consider your filters as corrective measures, to be pressed into service when things are not quite as you would like.

Double exposure is a different matter. It is very much a departure from the norm, and can introduce bizarre effects. Yet double exposure was once so much considered a fault that

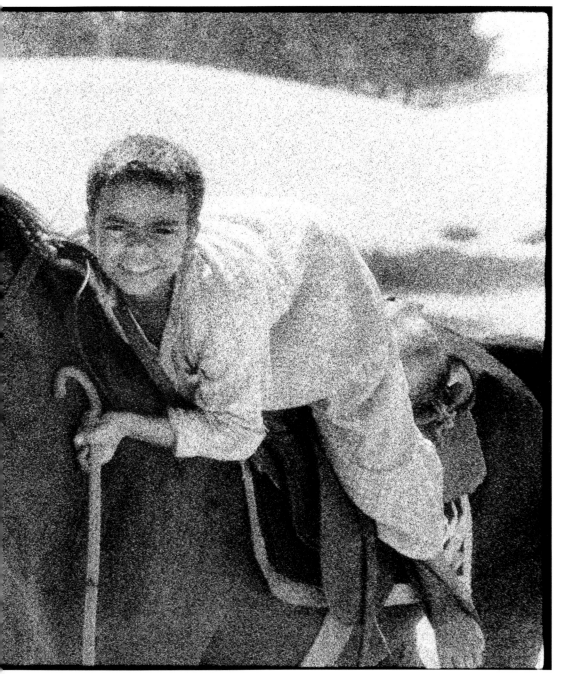

For this picture of a young Egyptian boy clinging to a horse the texture of the grain was required to be a dominant feature. Tri-X film was used, rated at 1600ASA and developed in print developer. Nikon

contemporary cameras mostly have a preventative device built in, to stop you making double exposures. So universal is that preventative device that when it is absent the fact is hailed as being a special feature of the camera – as on the Pentax LX, which allows very precise control of the effect. However, all that has not stopped the progress of double image photography. Especially in transparency shooting, it remains as easy as blinking: all you have to do is mount two transparencies together and there is your new picture. It helps if the transparencies sandwiched together in this way are on the thin side, as two pictures of normal density would produce a sandwich a little too dense for satisfactory projection. Two images can be printed together quite easily, from negatives,

and the commonest example of that is when a negative containing a fine sky full of clouds is overprinted onto a landscape which has a bald sky – no clouds at all, perhaps because it was taken on an overcast day, when the sky displayed a uniform white or pale grey.

On those cameras which do allow double exposure, and that includes just about all models designed for professional use, especially the plate cameras, much is possible. It is, for example, very simple to portray someone sitting having a chat with himself – just by having him change position for the two exposures. With a plate camera the photographer will mark (using a Chinagraph pencil) the outlines of the first image before beginning the second, so that he has a reference to

Subtle double exposure technique using a special Cokin filter. The intention was to have the model become part of the backdrop, which was specially painted for the photograph in the Rome studios of Italian Vogue. Horseman 6 x 9

help him with precise positioning: that is not practical with a 35mm camera (but it can be done with a 2¼ square TLR or SLR) and it is then a matter of remembering precisely where the first image fitted into the camera's viewing screen.

Usually, a double exposure is perfectly obvious – it can rarely masquerade as reality, and is thus most often to be observed in fantasy pictures. Particularly common, and mostly a product of sandwiching slides rather than direct in-camera double exposure, is an image of a girl; often she is seen rising from the sea (Botticelli's Venus!), but sometimes she is superimposed upon flowers, tree trunks, things natural. The inference seems always to be the same – that woman and nature are one, and equally primeval. But there is another use for more than one image on a film, and that is when the image is allowed to roam over the film, as one continuous blur, to give the impression of motion, or of time passing, or simply to augment a weak original image.

A simple example of beefing up a weak image is the trick just about every experienced photographer pulls when photographing fireworks. By itself, one rocket bursting in the sky is a pretty unsensational spectacle: what you would get on film would be a tiny orange or yellow splodge, with a few lines of light arcing out from it. But set your camera's shutter mechanism to B, which means the shutter will stay open as long as you continue to press the button (with a cable release, and the camera must be on a tripod), and your film will go on recording successive rocket bursts and golden rain fall-outs and so on, until your picture is positively filled with light. What you will have recorded never actually happened, of course, at least not all at the same time, but your impression will not lose a jot for that little bit of deceit.

Only a garment as simple as this would lend itself to such a grainy treatment for a fashion photograph. Taken in Zambia for British Vogue on a half-frame Canon Dial camera, using Tri-X film rated at 1600ASA

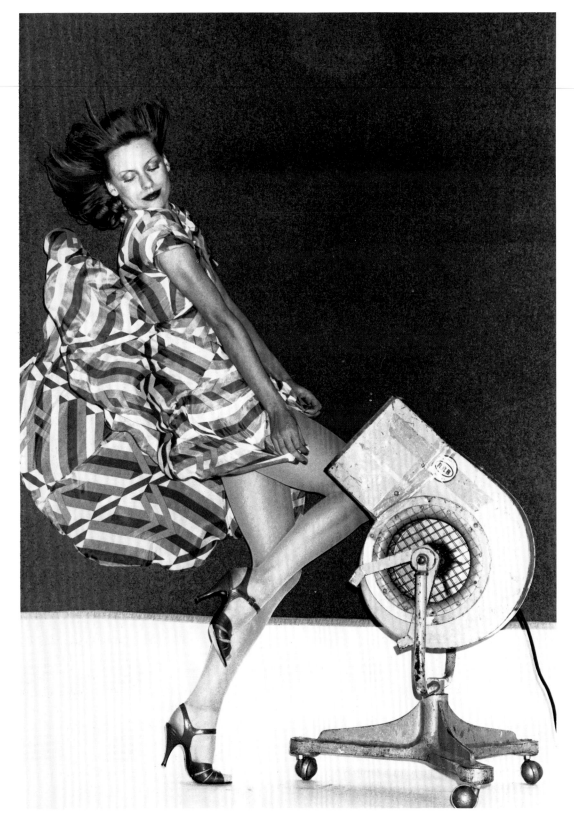

If a wind machine is used to give a dashingly windswept mood to a picture, it is usually excluded from the picture frame, but in this shot for British Vogue it became a component of the photograph in its own right.

If you don't have a wind machine, a helper wafting a piece of stout card is a useful substitute. Pentax, 6 x 9

The peaceful and relaxed mood of these old-timers taking the sun in a Paris park was emphasized by the use of a fog filter. Film: Tri-X rated at 800ASA. Pentax

Zoom lenses and movement

Keeping the shutter open works well at other times too. It is often done while some tricky dancing is going on, so that the participants seem to dissolve into a swirl of motion. And that – motion – is, after all, what you set out to describe in your picture.

The zoom lens has brought a spectacular and particularly exciting effect when used in conjunction with very slow shutter speeds (which is actually nothing more than keeping the camera's shutter open for a while, though for a limited while). It depends upon altering the zoom lens' focal length while the shutter is open, so that the subject is portrayed all the way through a smooth transition from large to small image size – or the other way round, whichever is easier with the particular zoom you are using. What happens is that the subject seems to explode – if it is a still life subject. When there is action going on, there is a different effect to be had. Suppose, for example, an athlete (or a Grand Prix car) is racing towards

you: you will be able, after some practice, to pick up the subject at the longer focal length end of the zoom, shortening the focal length as the subject moves towards you so that its image size on film remains constant. Your end result will show the subject in constant proportions, and therefore relatively sharp, while the background zooms outwards (or inwards) in a whoosh of colour and line.

In the chapter on snapshots we mentioned briefly that it is possible to make a moving object vanish altogether, by keeping the shutter open for a considerable time, so that the image of the moving object never has time to record on film; but that effect requires a very small lens aperture and quite a lengthy exposure. Plainly, those requirements are best met when a relatively slow film is used, one of low ASA rating, such as 50 or 100. And the trick is often used by architectural photographers who do not want passers-by messing up their nice pictures of buildings: even in a crowded street, it is possible by this technique to produce an impression that the place was deserted.

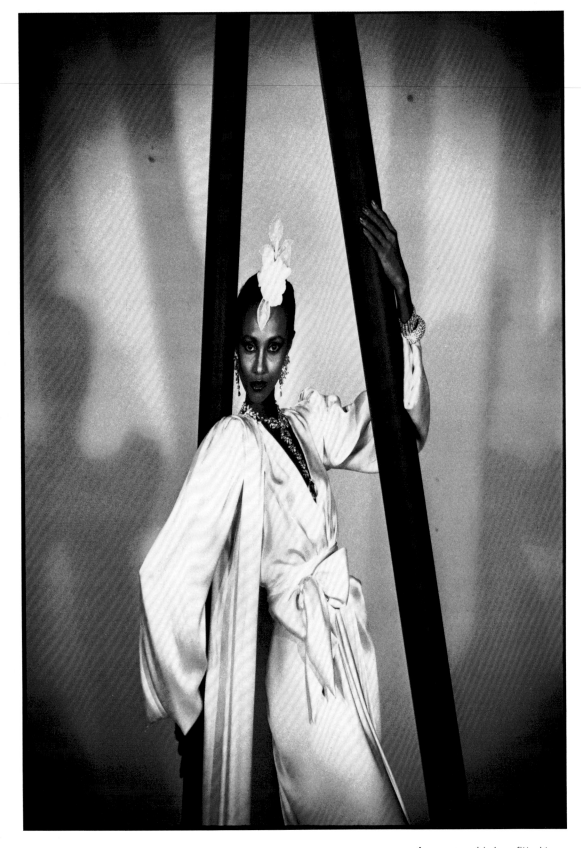

An anamorphic lens fitted to a Horseman 6 x 9 camera was used to create this unorthodox studio shot of Iman for Ritz newspaper

Occasionally, movement is introduced by sliding the printing paper, either very slowly or in stops and starts, through the enlarger's light beam while printing. It has been done quite successfully with pictures of city skylines, when the paper has been moved in such a way as to stretch the images of skyscrapers, increasing their height. And by varying the rate at which the paper is moved, so that some parts of the image are more dense than other parts (through receiving more exposure), the subject can be made to appear gradually to fade away into nothing. There is an endless variety of effects to be achieved by having the image move over the sensitive surface – paper or film – during the exposure: you could, for example, revolve the printing paper, or even the camera.

You will now begin to understand how it is that handling your own processing and printing opens the way to so much influence over the final effect. Producing transparencies does, of course, allow a great deal of control, but nothing like as much as in printing – where fine adjustments of everything from colour to image size and shape can be made, and even the picture content can be altered. But remember that transparency shooting does not rule out the ability to make your own prints: both Ilford, with their Cibachrome process, and Kodak actively market kits for making prints direct from transparencies. And throughout the summer of 1981 Ilford have been experimenting with a large machine for installation in stores, which allows the customer to make Cibachrome prints direct from his own transparencies in just eight minutes – and that includes giving the customer the facility to make alterations such as cropping and colour corrections. As we suggested elsewhere, instant darkroom prints will certainly be with us before very much longer. In April 1981 Kodak announced the Ektaflex system, which produces an 'instant' enlargement from either negative or transparency. The popularity of the print, encouraged by massive emphasis on sales of negative film, is now such that the addition of darkroom working to one's hobby interest is merely a matter of when rather than if. Right from the word go, even (especially!) when using the simplest of instant photography cameras, the newcomer is familiar with prints – so it is not at all a major change of direction when he begins to want to make his own in the darkroom.

To a considerable extent (certainly every bit as much as by choosing a particular film for its colour leaning) it is possible to influence your prints by adjusting their colour. And that is true in black and white photography as well. To some degree papers for black and white printing exhibit different tones: you may come across the descriptions blue-black, neutral black, warm black. And the purity of the white paper base is variable too, from warm creamy white to the crisp white of fresh snow. Obviously, the paper upon which you print will, though in a subtle way, impart some impression to the viewer – just as the combination of typeface and paper surface are subtle influences in high quality books. But you can be even more obvious with your influences, through the use of toners. Sepia is a particular favourite, and is very easy to apply, involving the dunking of the print in chemicals. However, Terence Donovan, a very inventive photographer, has been heard to insist that some of his fine sepia effects come literally from soaking his prints in coffee. This is hardly a permanent effect, but it does underline that virtually anything goes when you are in pursuit of methods of influencing the end result. Some papers, such as Autone, start out life coloured, the emulsion being laid onto a paper base of vivid colour or tone – red, blue, green, gold, silver. Such strong colours would demand careful use, for the colour could easily take over from the image in importance, but they are yet another weapon in the photographic armoury.

It is very important to approach the use of any special effect with one question etched big in your mind – the question 'Why?' Photography is so full of special effects potential that nobody could explore every trick; but the prime reason for introducing any effect must always be to add something to the image – indiscriminate use of effects is nothing more than indulgence in gimmickry.

In the past year or two we have seen a positive explosion of gimmicks, as several companies have introduced special filter sets. These consist of a holder, which screws onto the camera lens, and a set of coloured and multi-coloured filters, and some which create starburst points of light around every bright spot in the image, others which multiply the image several times on film. Now certain of those effects could indeed be very valuable, for very specific photographs, but when used for every picture (and those with two colours are used particularly often) they blunt the senses and become boring. Presently, there must be more pictures with tobacco coloured skies and green foregrounds than there are unadulterated pictures. An exaggeration perhaps, but do be wary of 'instant success' promises; the best instrument for success is your own mind, not a piece of coloured glass on the front of your camera.

Mood and soft focus

Having just delivered that broadside, we are certainly not suggesting that the image passing through the lens is sacrosanct, not to be tampered with. It is indiscriminate tampering which is the crime: adulteration of the image for a quite deliberate purpose is indeed valid, as is interference which disturbs the direct flow of the light paths. Consider, for example, the oh-so-simple but immensely valuable technique of soft focus. It depends on nothing more than interrupting the light rays passing from subject to film (or from negative to printing paper) and scattering some of them. Depending on how much scattering is done, the image is thus overlaid with a layer of light which slightly fogs it, obliterating fine detail and lowering contrast. The effect may be so mimimal as to pass unnoticed, though still introducing its typical cosmetic effect; and it may be so total as to render the subject recognizable

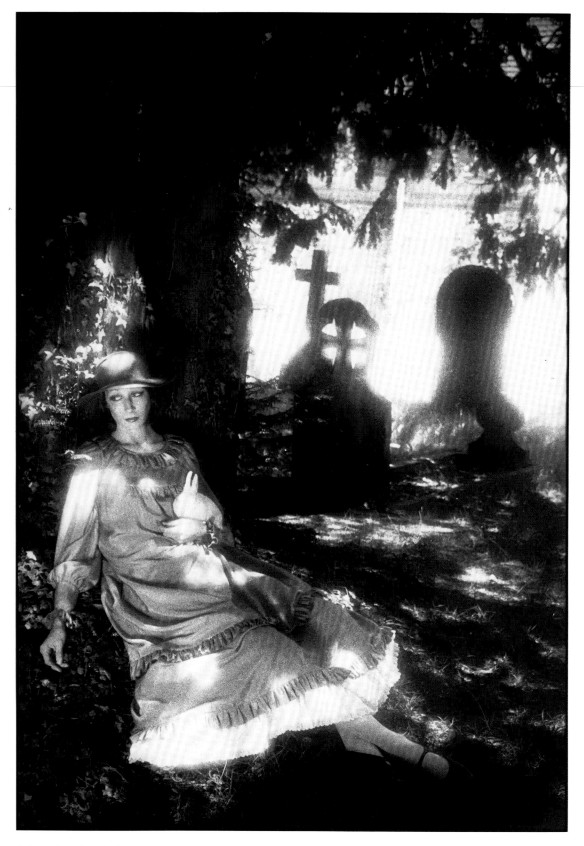

Actress Angelica Huston
photographed for British Vogue
in the dappled sunlight of a
Buckinghamshire churchyard.
Pentax

A very striking example of double-exposure for this portrait of singer Tommy Steele. Rolleiflex

only by its very bold shapes and outlines. Between those two is a gradual softening of the image which is most certainly a tool for control; perhaps more effectively than any other control, soft focus is a setter of mood.

What, though, is mood, at least in photographic terms? Let us dwell on that a little before returning to soft focus.

If you were to go into the woods on a wild autumn afternoon, with the sound of rustling leaves all around you, the wind whispering and whining through the branches, the soft crunch of already-fallen leaves sounding beneath your every step, perhaps a dog howling on a farm away across the woods, then your blood would surely quicken! The place would have a sense of atmosphere – strong enough perhaps for you to believe for a moment in the old stories

If you were then to shoot a picture, you might well end with a smudge of sky and a tangled mass of twigs and branches: without the sounds and all the sights, and perhaps the smells, where would be the magic mood you felt while actually there? Your picture could be quite empty of atmosphere, or mood as the photographic language has it (though bear in mind that mood can be joyous just as much as

sinister). If, in those woods, you had used a wide angle lens from low down, emphasizing the tall tapering trees, a slowish shutter speed to just catch the fluttering of the leaves, and had then broken up the image with an excess of grain, or used a soft focus attachment, your picture would be awash in a mood of the mysterious – it could even be alive with menace, for twisted tree trunks are astonishingly liable to suggest a world of ghosts.

Mood is the overlay you introduce; it is the photographic adjective which grabs the attention of the viewer and makes him think of your pictures as you wish him to think. Softening the image, taking away distracting detail, and overlaying what almost amounts to a gentle mist, simplifies the information content and makes the remaining, bolder elements the more persuasive.

Now back to the practice of soft focus, and in with a bang too – a resounding bang, to emphasize without limit that soft focus is not at all the same thing as out-of-focus. Whatever else, there must be, for the best effects, a bitingly crisp core of sharpness, otherwise the entire image would dissolve into a mass of nothing but differing areas of tone. You will thus not

be surprised to learn that you can actually pay quite a lot of money for the ability to degrade (in contrast, in detail rendition) the image your lens passes. Special soft focus filters are made, which are of the very highest quality of glass, so pure that certain areas of it pass light quite unaffected, while a few small areas do the soft focus work: the idea being that the unaffected light will go on to build the sharp image, the soft focus areas will provide the overlay.

A special soft focus filter will have a pattern engraved on it, the etched glass being responsible for the scattering of part of the light. The pattern may be of virtually any design – concentric circles, wavy lines, cross-hatching; and you can make your own design by drawing a pattern in glue (which dries clear and hard) on a good quality skylight filter. The arrangement of the pattern will control where the light is scattered, and by what degree. Quite often the central area of the filter is left unmarked, so that the picture edges are markedly in soft focus, the centre much less so. Two or more of such specially made soft focus filters may be used together, to give precise control over a substantial range of image softening.

Particularly in portraiture and landscape photography, the soft focus effect is appealing. In portraits it obliterates minor skin blemishes – so that if you want to show that here is a lady who is glamorous and soft and feminine, there is no sign of wrinkles and pimples to deny it! In landscapes the soft focus effect is reminiscent of a mist – and in colour especially its softening effect is most attractive.

You can use anything which is more or less transparent – even Vaseline or crumpled Cellophane – in front of your lens to create soft focus and hazy effects of dramatic extent. The more light scattering that takes place, the more the highlights (bright areas) of the picture will appear to spread, the effect being very marked when such bright areas are adjacent to dark areas. And exactly the opposite happens when you introduce soft focus at the printing stage (printing negative films, that is) by putting any of the soft focus attachments between the enlarging lens and the paper on the baseboard: then the shadow areas (clear on the negative, thus passing most light) appear to spread into the highlight areas.

Infrared effects

If you are after a surreal effect, a dreamlike mood, then photography is entirely at your bidding. With the right lenses, and with a whole variety of accessories, you can produce images of the unreal which look so very convincing because of photography's great reputation for essential truthfulness! But there is one spectacular effect which is entirely unreal, and which no unaided eye has ever seen: it is the infrared view of the world. Infrared rays are beyond the visible spectrum, but can be recorded on specially treated film, both black and white. The film is much used for scientific purposes; especially when used in aerial surveys, it distinguishes between healthy

The softly romantic, almost high-key, effect of this photograph for Italian Vogue was obtained by using black and white infrared film. Olympus

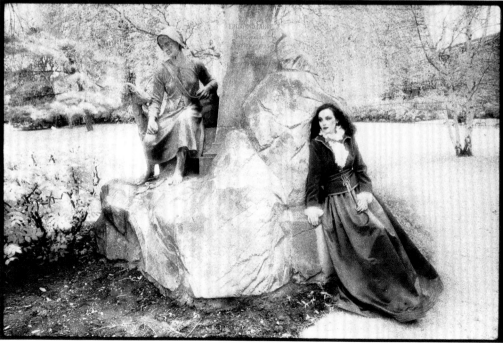

Because of the high infrared content in green vegetation it will record as almost white on infrared black and white film. It was used in these shots of Marie Helvin, for French Vogue, to evoke a gentle, dream-like atmosphere. Paris, Olympus

and diseased or dead vegetation, so is of great value in monitoring food supplies and forestation. But it has qualities which equip it exceptionally well for landscape photography. To begin with, infrared photography makes mincemeat of haze, and distances seem crystal clear, destroying the ability of the human mind to estimate or appreciate distance – yet introducing a quality of fantasy. The fantasy is heightened by the way black and white film for infrared shooting records foliage: since greenery is rich in infrared radiation, the negative is much affected, becoming very dense where foliage records – and thus printing white. The resulting snowy white appearance of trees is very delicate and very beautiful – especially since it contrasts so powerfully with the rich dark tones of a blue sky, recorded as almost black when the camera is loaded with infrared film. It is necessary to use a special filter over the camera lens, which keeps out all visible light wavelengths, passing only infrared radiation. There is no other special provision when using this spectacular material – it can be processed just like normal film, in ordinary developers.

Introducing mood and atmosphere to a picture is rather like a musician composing, say, a tone poem: it is intended to create a very clearly defined impression. But you cannot create that unless you first decide what your impression is to be. As we have so often pointed out, you must continually examine and question your motives when shooting; the answers should dictate your tactics and techniques. If you are to make emotional impact on those who view your pictures, you must simplify; a welter of emphasis on several different elements of your pictures will lead to confusion, so be very clear about your intent.

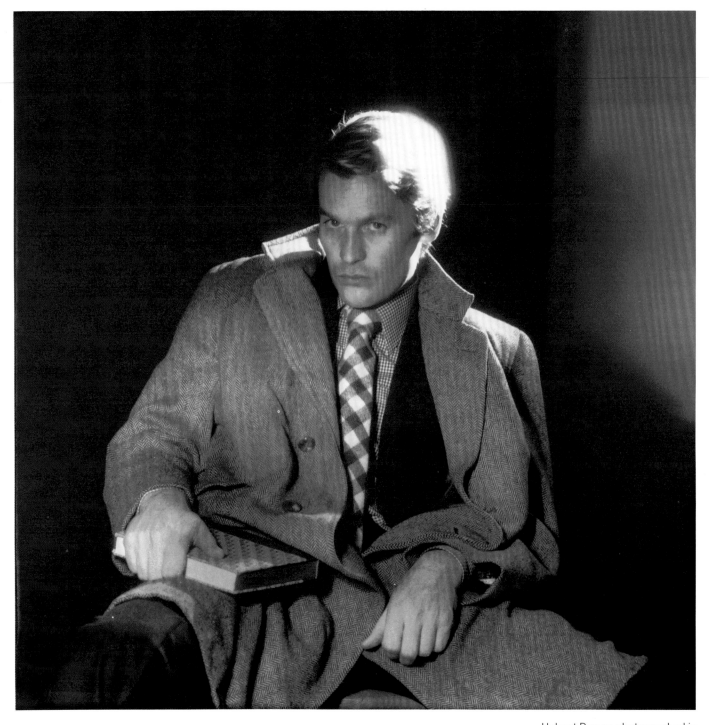

Helmut Berger photographed in
a manner which deliberately
imitated Sir Cecil Beaton's
famous 1950s portrait of the
young Marlon Brando.
Hasselblad using Polaroid
105 negative/positive film

Instant pictures

Every two years Photokina, a worldwide fair of photography, takes place in Cologne, West Germany. There, the industry unveils its new products, and developing trends are discussed and observed. And though the first Polaroid cameras went on sale in 1948, it was at the 1980 Photokina that Polaroid's International President Dr Richard Young previewed the 1980s in this way: 'Although it has long been regarded primarily as fun photography – the party camera, reserved for special occasions – Instant photography will, in the 1980s, be perceived as a viable alternative and complement to conventional photography.'

There are many to testify that Instant photography is already those things, at least in some areas. A viable alternative? Of course, for passport pictures, for portraits, for snapshots for the family album, for estate agents' windows, for certain kinds of art photography. Complement to conventional photography? Yes, there is hardly a professional's studio in which Polaroid photography is not used – to check exposure, lighting balance, subject arrangement, photogenic qualities of a model, before shooting begins on conventional materials.

According to Polaroid, one picture in every twenty shot in 1970 was Instant; by 1980, they claim, that had risen to one in ten. The growth must be credited to Polaroid's highly inventive developments within the Instant process, for nearest rival Kodak has not yet moved beyond offering less than half a dozen Instant cameras and just one film, whereas Polaroid equipment is available for almost any need you can devise. You can even produce a finished portrait, in full colour, as large as 24 x 20 inches, within 60 seconds of pressing the camera's shutter release. Do not, however, let Polaroid's lead make you assume Kodak either is not interested or does not have the knowhow: there have been problems with patent rights, and in any case Kodak has enormous interests in processing machinery and chemistry for conventional photography. Whatever the economic involvements, it should be said the Instant system has so many obvious advantages for certain purposes that it must, as Dr Young predicts, continue to expand.

Dr Edwin Land, founder of the Polaroid Corporation, began his original experiments in the early 1940s. His first success, the type 95 Polaroid Land Camera, was demonstrated in February 1947. It made use of what is known as the peel-apart process, in which a negative/positive sandwich assembly is pulled between two close-fitting rollers, so that the rollers burst pods containing the image-forming chemicals. The sandwich is then peeled apart, to reveal a positive print. That system is at the very heart of latter-day Polaroid developments, and some peel-apart films provide the photographer with not only a positive print there and then, but also a re-usable negative, so that enlargements may be made later by conventional photographic processes. But in 1972 Dr Land introduced another system, referred to as one-step: it produces a colour print which begins to develop by itself immediately the camera ejects it, which happens as soon as the exposure is completed. The current one-step film, SX70 Time Zero, develops to full colour in about one minute, and there are no pieces to pull apart or discard. What comes out of the camera is, within a minute, the finished picture.

Pros and cons of Instant

Even now, the world of image making has not fully come to grips with Polaroid photography, which we should really refer to as Instant photography, since Kodak and others are treading a similar path, however shyly. Make no mistake, Instant photography is here to stay, yet suspicion surrounds it. 'Too costly', say some, forgetting that no processing and print-making costs are involved as in conventional photography, and very little time passes between shooting and seeing the finished result. 'Too low in quality', say others, who may perhaps never have seen a large format Instant picture – a 24 x 20 colour print of impeccable quality produced within sixty seconds of the in-camera exposure. Then there is the suspicion which does have some foundation: Instant photography takes away much of the tedium, a lot of the mystery – and could put darkroom technicians out of work.

Of course there are genuine shortcomings in the Instant system, as there are in all systems, photographic or not. For instance, unless he uses one of the films which provide him with a negative, for conventional printing later, the photographer's control over his image ends the moment he

presses the camera's shutter release. But even this is not entirely true, since certain photographers greatly alter the SX70 image by intermingling the colours of the dyes used, which they achieve by pressing on the surface of the SX70 print with a blunt stylus, or ballpoint pen, before the picture has hardened sufficiently for the dyes to become immobile. That, though, is just one side avenue leading off straightforward photography, and there are many of those in the conventional processes as well. In essence, the Instant image permits no control after exposure (other than when used with a negative, as we must make plain). Is this limitation, this absence of control, such a serious one? For snapshot photography not at all: most hobbyists are perfectly happy either with en-prints straight from the processing houses or with transparencies, and in neither case can there be any after-control. But how about really 'serious' photographers, do they find it frustrating to have the end result controlled by a machine? Some might, but it must be very firmly understood that the end result is always, without exception, controlled by the photographer. And if you are given a guarantee that after a certain point (in this case the exposure) the progress of your photograph will follow a consistent path in terms of development and quality, then the obvious thing to do is consider the moment of exposure as your end result, relying on the Instant process for the rest. And that is just what American photographer Marie Cosindas does.

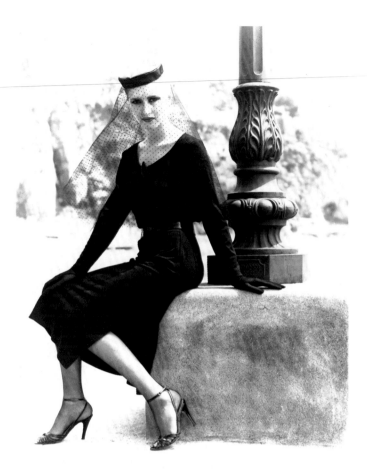

A Cosindas original today costs a very large sum of money, since it is often a unique object, as when made on Polacolor film, with which she began experimenting just before its public launch in the early sixties. She shoots on 5 x 4 Polacolor film, and spends days seeking out all the props for her pictures, including the clothes her portrait sitters will wear. She then takes just as much trouble with lighting and background. Finally, she will often use a technique she has made her own: with the 5 x 4 film she is able to use a view camera, and can consequently adjust the exposure very finely. She has found that long exposures, of several seconds, give her a particularly muted effect in her Polaroid images. The effect, she says, is reminiscent of the lighting in a Rembrandt painting. She can also use filters for fine adjustment of light content. When Cosindas makes her exposures, all the controlling that needs to be exerted has been exerted. Instant photography's so-called shortcoming therefore need not be a shortcoming after all.

It is easy to be bowled over by Instant photography, and to see it as the answer to all the photographer's economic ailments – of time, model fees, processing costs, and so on. And it is easy to view it as artistic magic. One American critic (the Americans have gone for Instant photography much more readily than Europeans, perhaps because Europe is the very cradle of conventional photography) whose pronouncements regularly appeared in such publications as The New York Times, The Village Voice and a number of photographic journals, once remarked that 'SX70 as an image-making

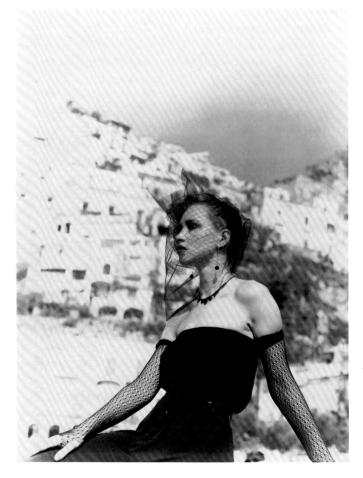

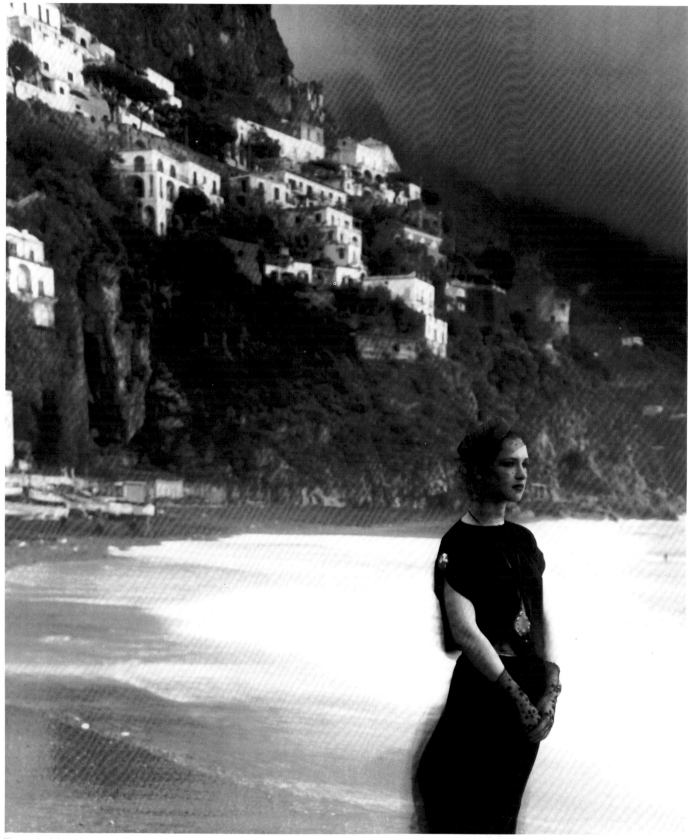

These fashion photographs were made from 4½ x 3½ inch Polaroid negatives. One, against the distant hillside town, is powerful and romantic, the others more intimate and casual. Positano, Italy, 5 x 4 Cambo, using a Polaroid adaptor

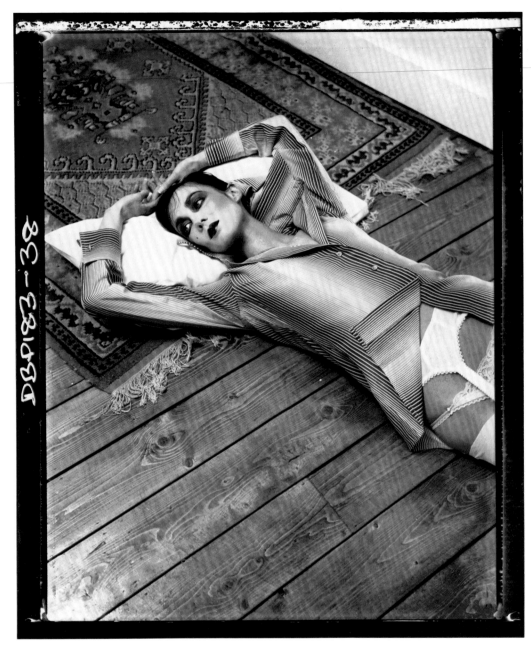

The Polaroid 195 camera gives both positive and negative on 665 film. These shots for Ritz are both enlargements made from the Polaroid negatives

device is uniquely challenging precisely because it is so restrictive . . .'. Unique perhaps, but not magic; challenging yes, but no more restrictive than many another process.

Dr Land's process depends on the diffusion transfer system. In the black and white films silver is transferred by diffusion from a negative sheet to a positive sheet, the process being set in motion when a pod of activating (or developing) agent is burst, and spread through the two sheets, by being pulled between two rollers in very close contact. Polacolor film begins in the same way, but instead of silver it is coloured dyes which are diffused into the positive sheet to make the finished colour picture within sixty seconds. In both cases (except where black and white negative sheets are on transparent base, and are recoverable for later use after cleansing treatment) the two sheets are peeled apart, and the

negative sheet discarded. SX70 film (in colour only) has no parts to be discarded, everything remaining within the one sealed unit.

New trends

As do other film manufacturers, Polaroid maintains a constant research programme, and the latest developments in Polacolor have been concerned with improving the magenta dye incorporated. As an extremely valuable side effect this has extended the exposure latitude of the film, now labelled Polacolor ER (for extended range), and much improved the accurate rendering of flesh tones. Polacolor ER is produced in packs for the hobbyist, and in professional sizes of 5 x 4, 10 x 8, and 24 x 20 inches.

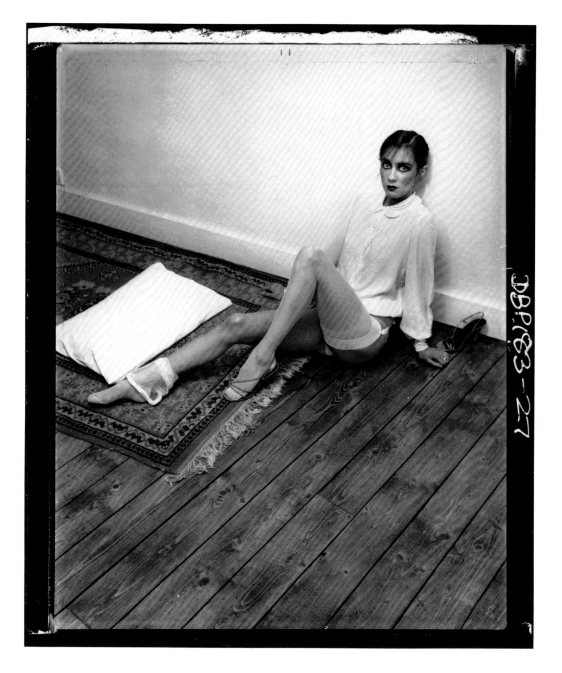

Polaroid cameras, and especially the SX70 Sonar Autofocus single lens reflex, are highly sophisticated machines, so much so that you can hardly go wrong. Now that takes us right back to a man who is considered the father of photographic historians, Helmut Gernsheim. He is amongst those who failed completely to understand what was happening when the Polaroid star began to rise. Giving Instant photography scant praise, though conceding that it freed the amateur from the need for technical knowledge, Gernsheim called up an ancient phrase, inscribed on a coin of the sixteenth century: 'Of what use are lens and light to those who lack in mind and sight?' It is perhaps a little unfair to chide him so, for it is true that any photographer needs 'mind and sight' if he is to move beyond the ordinary; but Gernsheim's fault was to ally himself so squarely with the camp that scorned the simplicity of Polaroid's approach to photography. As we now know, the system is capable of just about everything the cameraman demands from conventional picture-making processes, provided he is prepared to adapt to its requirements. After all, the photographic art world will tell you there are few makers of fine prints as quality conscious as Ansel Adams, and Adams will happily work from recoverable Polaroid negatives, which are available from types 55 and 105 black and white film.

What Polaroid has done in pursuing the ultimate in simplicity is to create in that aim the ultimate in technological complexity. The SX70 one-step process is now the one being vigorously marketed to the hobbyist and snapshot market, while peel-apart films are now more widely used in professional studios. And special backs, designed to accept

Marie Helvin. Hasselblad, using
negative/positive Polaroid film

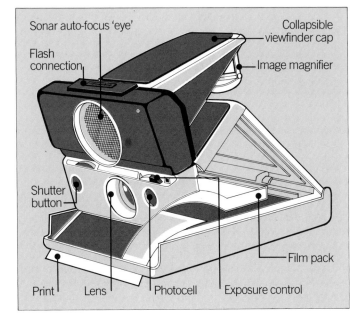

Sonar auto-focus 'eye'
Collapsible viewfinder cap
Flash connection
Image magnifier
Shutter button
Film pack
Print Lens Photocell Exposure control

Cross-section of the Polaroid
SX70 Sonar Autofocus camera,
in which the complete process
uses only a single sheet of
material for exposure and
colour print

Polaroid films, are available to clip onto just about every studio camera, including the universally used Hasselblad. The flagship of the SX70 system is a single lens reflex camera, the SX70 Sonar Autofocus. It can shoot ultra close-ups, and it can accept a number of accessories to increase its versatility. But its versatility is limited, and this is only to be expected, yet the fool-proof capabilities of the camera make it a thing to be trusted. The technology in the Sonar Autofocus is astonishing. The camera sends out high frequency sound signals, and measures the time they take to bounce back from the subject; it then computes the distance from subject to camera – since the speed of sound is constant it can do that with ease – and sets a built-in electric motor into action to focus the lens. It goes without saying that the camera has fully automatic exposure measuring facility; and when the camera has done its bit, the film ejects itself – all powered by the battery built into each film pack. All this sophistication very nearly cancels out any possibility of error, and frees the user to concern himself only with the subject and its arrangement; but it leaves him little to do other than select, arrange, push the button, see the result. Some of the earlier cameras did allow scope for an imaginative mind to take over.

An enlargement from a Polaroid negative of Twiggy. Hasselblad

Tricks in technique

Polaroid models between the mid-1960s and late 1970s, labelled Swinger, Colorpack, and Square Shooter, with no double exposure lock, could be used for such tricks as picturing the same person twice in the same picture, just by using flash and posing the subject against a very dark background for the first shot, then moving him or her in the camera's viewfinder for the second shot. And by shooting from different distances it was possible to have the two images of very different sizes, provided the smaller one was not too far away for the flash to provide adequate illumination. It would even be possible to take a hacksaw to those early cameras, to lop off the front and substitute a new panel, converting them into pin-hole cameras for Instant ultra wide angle views.

SX70 photography, with its host of fail-safe devices, allows little tinkering. But the system's inexpensive model 1000 seems not to have suffered any disadvantage: it is said to be the world's biggest-selling camera, so simplicity plainly does have appeal. Naturally, when a Polaroid film pack is fitted to the back of a studio camera all the conventional tricks the photographer can pull remain open to him. And it is possible that he could even fit a texture screen over the Polaroid film to help him create 'moody' images. Certainly he can employ all the usual soft focus techniques which depend on lens attachments – but even those are available to SX70 users. More inventive techniques are sure to be devised to exploit Polaroid's 10 x 8 system, which uses sheet film in a special lightproof holder that is popped complete into a processing unit, to deliver a finished colour print of impressive size only seconds later.

Is instant photography about to make conventional processes redundant? At the present stage of development of both, the answer must be no: both have yet to weather the continuing search for the ultimate – a 3D image, in natural colour. And we are on the fringes of the era of electronic image-making systems. Continued exploitation of electronics is paying off in still photography, though, and Polaroid's new 600 system incorporates circuitry within 'point and shoot' cameras which does tricks previously only open to mathematical minds. Automatically the circuits prime built-in flash guns to deliver fill-in-flash in precise proportion to ambient light. Contrast in harsh light has therefore been conquered.

Ritz newspaper, for which this shot of Kim Harris was taken, is all black and white – apart from the cover. So in this case the medium dictated the form, and the accent is on a clearly-read image and simplified tones. Lighting was by a bank of diffused electronic flash. Hasselblad with 150mm lens

Monochrome or colour?

Throughout your photography you will be making choices. Right from the beginning you will have to decide between a variety of options – starting with your equipment. What camera and what lenses you choose will affect much of your shooting, of course; but perhaps nothing will so decisively influence the impressions your pictures make on others as the films with which you elect to load your camera. There is, simply, a world of difference between black and white and colour photography. And very rarely indeed do you find any of the great cameramen equally comfortable with both.

This is not an easy concept to float without encountering the danger of pomposity, the possibility of beginning to elevate either colour or monochrome (or mono, as most photographers refer to black and white) to the status of being 'truly the artist's material', condemning the other as snapshot stuff. For colour has now become so much used that it may, to the layman, be thought of as the normal way to take photographs, the best way to show the world as it is. Yet it is very seldom indeed that a colour picture will be a perfect rendition of nature. There is always some colour drift away from reality, sometimes caused by the colour temperature of the prevailing light, sometimes by objects within the picture taking on the colour of other objects nearby, due to light reflecting from one to the other. The truth is that in what it does colour film is no more capable of real accuracy than black and white film.

Colour film reacts to light of different wavelengths reflecting from the subject before the camera: it translates those differing wavelengths into some chemical approximation of the colour our eyes and minds together perceive, and it does it as best it can – though the range over which those wavelengths may vary is such as to make it obvious there is immense room for error. And some colour films are happier when handling certain wavelengths than when handling certain others.

Professional photographers know the quirkiness of colour film, and appreciate how subtle changes in the condition of its ingredients can cause it to render colour

Black and white was the obvious choice for this shot of Victorian workers' grimy housing in Stratford, East London, painting a grim picture of the monotony of such an environment. Pentax

falsely – and so for the very best (most accurate) results they store their colour film supply in a refrigerator until it is exposed, and then have it processed straight away. A roll of film in a hobbyist's camera may stay there for weeks, during which time it may have gone through numerous temperature changes – especially at holiday times. How can the poor chemical contraption be expected to behave at its very best?

All that is not a hatchet job on colour. Indeed, in the circumstances modern colour film performs exceptionally well. But the fact remains, its task is to record a varied array of different wavelengths of light. On the other hand, black and white film specializes in recording the quantity, not so much the quality, of light coming off different parts of the subject. It records brightness and darkness. Of course, monochrome is a bit varied in its response to different wavelengths too, but nowhere near as much as colour film: essentially, its job is to outline shape, by recording tones in a range from black to white, representing darkness to light. You will see that,

potentially at least, monochrome is the more graphic material of the two: it is more capable of being used to create controlled designs. And especially is that so when you consider how much control the photographer has over contrast.

Those differences in the natures of colour and mono dictate different approaches – which are especially brought to bear in the more elegant areas of photography, such as landscape and portraiture. There, manipulation of overall design by control of tones of black and white and grey is a very fine craft indeed. But by choice of his grades of paper the monochrome photographer continues the subtle process right into his darkroom. What he is looking for is harmony of shape and tone, a balance so fine that no tone of black leaps out of the paper ugly and heavy, and no highlight of gleaming white so distracts the eye that the overall effect is jeopardized.

Of course there are masters of photography who can play the range of colours with great subtlety; and there are

Mick Jagger on Primrose Hill, lit by electronic flash, against a late summer evening sky. The shot could have worked in colour but would surely have lost some of its graphic impact. Nikon

Another example of an image more successfully rendered in black and white. The stark silhouette of the cow against the distant hillside would lose much of its power in colour. Wales, Olympus

some too who can so juxtapose strident colours that the shock effect produced introduces its own impression – and actual subject is almost secondary. But the greatest evil waiting for the inexperienced is the impression that because there is colour in plenty before the camera, a pleasing colourful picture must follow. It does not happen that way! The more colour there is in a picture the more likely it is that what will result will be a restless, irritating jumble of shapes without a central point on which the eye and mind can focus to begin unravelling the mess. With few exceptions, the great photographers in colour go for muted effects – pictures which are almost monochromatic, or which make use of one major hue, with a counterpoint of something contrasting. An example in fashion might be a girl in a red dress, photographed at some distance from the camera, and completely surrounded by sand; she would undoubtedly be the focal point.

The quality of light does, it is true, contribute much more to the end effect in colour than in mono – for you must be always aware of the immense control the photographer can

exert in black and white printing. And it is the delicacy of light at morning and evening which is most likely to prove fruitful in colour: harsh daylight bouncing directly off brightly coloured subjects is inclined to the garish, whereas softer, low-level light makes greater play on textures and the actual atmosphere – dust hanging in shafts of sunlight. Colour, to be successful, needs to be kept strictly under control!

In the end, the majority of hobbyists will turn to whatever is most convenient for them. And that will almost certainly be the use of colour negative film, with some processing house providing the prints. But some who have read this book will go on to delight thousands of others with their imagery. If the pages which have gone before have encouraged an inquisitive nosing into all the corners of photography, and have helped you find your abilities in something very satisfying, then that is sufficient justification for laying those pages before you.

Index

Bold numbers refer to illustrations